D0506877

SISKIYOU COUNTY MUSEUM
YREKA, CALIFORNIA

Caring for Photographs

Display
Storage
Restoration

TIME
LIFE
BOOKS ®

Life World Library
Life Nature Library
Time Reading Program
The Life History of the United States
Life Science Library
Great Ages of Man
Time-Life Library of Art
Time-Life Library of America
Foods of the World
This Fabulous Century
Life Library of Photography
The Time-Life Encyclopedia of Gardening
The American Wilderness
The Emergence of Man
Family Library
 The Time-Life Book of Family Finance
 The Time-Life Family Legal Guide

LIFE LIBRARY OF PHOTOGRAPHY

Caring for Photographs

Display
Storage
Restoration

BY THE EDITORS OF TIME-LIFE BOOKS

TIME-LIFE BOOKS, NEW YORK

© 1972 Time Inc. All rights reserved.
Published simultaneously in
Canada. Library of Congress catalogue
card number 72-84344.

ON THE COVER: Aspects of the three subjects covered in this volume are shown—aluminum frames specifically designed to display photographs, a carousel and a straight tray for storing slides, and a mid-19th Century ambrotype restored to its original clarity.

Contents

TIME-LIFE BOOKS

Founder: Henry R. Luce 1898-1967

Editor-in-Chief: Hedley Donovan
Chairman of the Board: Andrew Heiskell
President: James R. Shepley
Chairman, Executive Committee:
James A. Linen
Editorial Director: Louis Banks

Vice Chairman: Roy E. Larsen

Editor: Jerry Korn
Executive Editor: A. B. C. Whipple
Planning Director: Oliver E. Allen
Text Director: Martin Mann
Art Director: Sheldon Cotler
Chief of Research: Beatrice T. Dobie
Director of Photography: Melvin L. Scott
Assistant Text Directors:
Ogden Tanner, Diana Hirsh
Assistant Art Director:
Arnold C. Holeywell

Publisher: Joan D. Manley
General Manager: John D. McSweeney
Business Manager:
John Steven Maxwell
Sales Director: Carl G. Jaeger
Promotion Director: Paul R. Stewart
Public Relations Director:
Nicholas Benton

LIFE LIBRARY OF PHOTOGRAPHY
Series Editor: Richard L. Williams

Editorial Staff for
Caring for Photographs:
Picture Editors: John Paul Porter,
Adrian Condon Allen
Text Editor: Betsy Frankel
Designer: Arnold C. Holeywell
Staff Writers: John von Hartz,
Johanna Zacharias
Chief Researcher: Nancy Shuker
Researchers: Sondra Albert,
Helen Fennell, Lee Hassig,
Peggy Jackson, Ruth Kelton,
Don Nelson, Carolyn Stallworth,
John Conrad Weiser
Art Assistant: Patricia Byrne

Editorial Production
Production Editor: Douglas B. Graham
Quality Director: Robert L. Young
Assistant: James J. Cox
Copy Staff: Rosalind Stubenberg,
Barbara Quarmby, Ricki Tarlow,
Florence Keith
Picture Department: Dolores A. Littles,
Gail Nussbaum
Studio: Robert McKee

LIFE STAFF PHOTOGRAPHERS
John Dominis
Bill Eppridge
Henry Groskinsky
John Loengard
Michael Mauney
Leonard McCombe
Ralph Morse
Bill Ray
Co Rentmeester
John Shearer
George Silk
Grey Villet

Director of Photography:
Ronald Bailey
TIME-LIFE Photo Lab Chief:
George Karas
Deputy Chief: Herbert Orth

Valuable aid was provided by these individuals and departments of Time Inc.: Editorial Production, Norman Airey, Nicholas Costino Jr.; Library, Peter Draz; Picture Collection, Doris O'Neil; TIME-LIFE News Service, Murray J. Gart; Correspondents Elisabeth Kraemer (Bonn), Margot Hapgood (London), Maria Vincenza Aloisi (Paris), Ann Natanson (Rome), Mary Johnson (Stockholm), Ann Callahan (Washington).

The upsurge of concern for the photograph as art has stimulated an interest in photographic technology that until recently seemed arcane, if not trivial. The delicate methods of restoring old pictures have assumed fresh importance now that the pictures of the pioneers are assessed at their true value. Concern lest deterioration spoil masterworks of the present era has spurred the refinement of two quite different techniques: processing to guarantee maximum life for photographic images, and storage to help prevent harm from external dangers. In addition, when photographs are recognized as art, they must be given the display art deserves, in properly mounted print exhibitions and intelligently planned slide shows. These concerns have been the province of a small band of laboratory specialists and museum curators —archival processing, in fact, is the term used for the techniques that guard prints and negatives from chemical destruction. Yet every photographer has old pictures he would like to restore, new ones he wants to preserve, some he hopes to display, and many others that he must index and file away.

Most of the techniques of restoration, storage and display are no more difficult than common photographic procedures. But they are special. Worked out largely by archivists and research scientists, they have been little known outside a small community of experts. This volume brings them together for the general photographer, showing in text pieces and easy-to-follow picture sequences how they are used. Walter Clark, former director of Applied Photographic Research at Kodak, explains why photographs are potentially so durable—and why this potential is so seldom realized. Eugene Ostroff of the Smithsonian Institution demonstrates how to restore original quality to pictures made by half-forgotten processes of the past: calotypes, daguerreotypes and ambrotypes. Procedures worked out especially for this book by the Time-Life Photo Lab show how to put back the colors lost from faded transparencies. And George A. Tice demonstrates ways to preserve images with some special printing techniques—including a version of the seldom-used platinum printing process. The book also demonstrates the basic steps that are used in archival processing.

The object of restoring and preserving photographs is to keep them available for people to see and enjoy. A special photo essay shows the classic effort to bring the enjoyment of fine photographs to the public: the famed Family of Man exhibit prepared by Edward Steichen. Such an elaborate show may never again be attempted, but the principles that made it so successful can also guide the planning of smaller exhibits; they, like the other ideas outlined here, help all photographers to make more out of their pictures.

The Editors

Restoring Photographs 1

How "Lost" Images Are Recaptured 12

Sometimes sliding a new black backing behind an ambrotype that appears to be damaged is all that is needed to restore the image. The reason is that an ambrotype, a kind of photograph popular in the 19th Century, is actually a glass negative that looks like a positive when viewed against a black background. When the image seems to have vanished, the fault in many cases is merely a worn-out backing that when replaced will restore the picture to its original beauty.

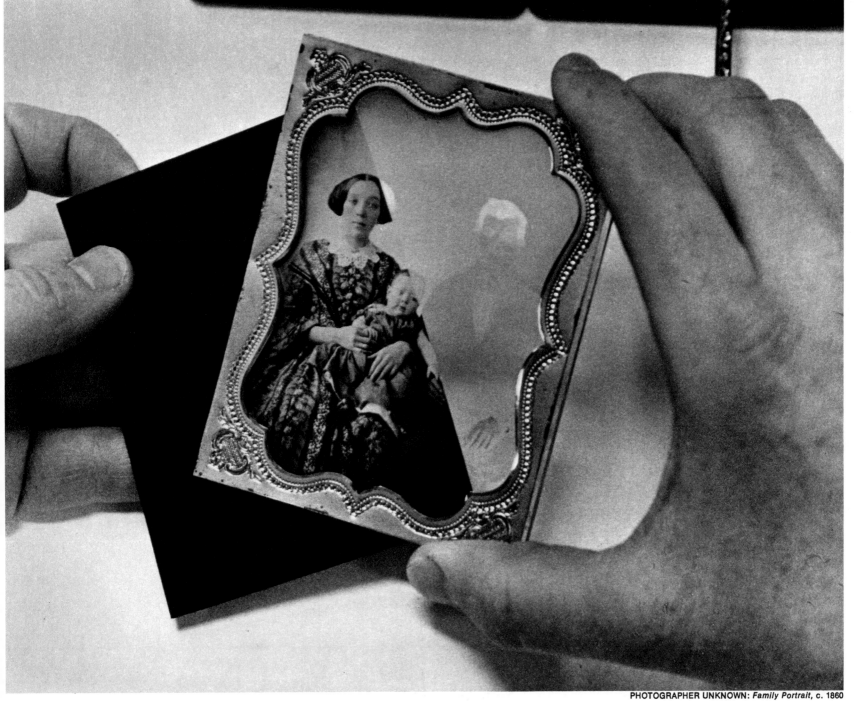

PHOTOGRAPHER UNKNOWN: *Family Portrait*, c. 1860

11

How "Lost" Images Are Recaptured

In 1933 an old and famous photograph came to grief. Made in 1840 by Dr. John W. Draper, chemist, scholar, as well as pioneer American photographer, it was a daguerreotype portrait of his sister, Dorothy Catherine Draper, and it had been exhibited here and in Europe as the earliest surviving daguerreotype portrait. Like many daguerreotypes it had tarnished with age and an expert restorer had agreed to repair it. But the restoration went awry: instead of emerging bright and clean, the Draper daguerreotype came out completely blank, its image totally destroyed. For 36 years it lay untouched. In 1969, a young curator of photography at the University of Kansas Museum of Art, James Enyeart, thought he had hit on a way to revive the image. His thinking was based on speculation that the ghost of such a "lost" daguerreotype might still be etched as an image in the plate's silver surface. After weighing the risks, Enyeart immersed the blank and once-again badly tarnished plate in a solution of thiourea, a tarnish-removing compound, and left it there. After several minutes the blackened silver was clean, but there was no sign of an image. Seven or eight minutes later, however, for reasons not yet fully understood, a faint image began to appear. In another five minutes Miss Draper's image, though much paler than the original, could be seen.

Not all recoveries of "lost" photographs are so dramatic—but then, not all photographs are so badly damaged. Tucked away in thousands of attics and desk drawers are thousands of photographs that are simply past their prime. Either they are showing their age or they are suffering the effects of careless or uninformed handling. Some of these photographs, like the Draper daguerreotype, may be quite old. Although it is unlikely that very many examples of the earliest paper prints and negatives, called calotypes, exist outside museums, occasionally one turns up—sometimes in good condition, but often with its naturally soft image faded to an almost imperceptible yellow. Far more frequently the family collection of photographs contains daguerreotypes, which were enormously popular for mid-19th Century portraits. Even more numerous are photographs based on a later development, the collodion process—ambrotypes, tintypes, collodion-coated glass-plate negatives—and on a contemporary of this process, the photograph printed on albumen-coated paper. Occasionally collections of old photographs even contain examples of the fleetingly used albumen-coated glass-plate negative. All can be penalized by time.

But in any average picture collection the majority of damaged photographs are likely to be those made in the early 20th Century, most by processes that are fundamentally the same as those in use today. Black-and-white prints and negatives tarnish and turn yellow, develop brown and purple splotches, fade or bleach, suffer scratches and finger marks, grow fungus, stick together or are eaten by insects. Color films and prints are even

more susceptible to damage: they share many of the problems of black-and-white materials, but they have their own special problems as well. Most often, their dyes fade, destroying the color balance.

Most of these troubles are caused by improper processing, handling and storage. The photograph, made of potentially unstable materials, is very sensitive to the chemicals used to process it, and to its physical surroundings. It can be damaged by excessive heat and cold, by intense light and humidity, by pollutants in the air or pollutants in the paper, and by adhesives that are used in mounting and storage. Most of all it can be damaged by the complications that arise when the-processing chemicals and their by-products are allowed to remain in the finished negative or print. In the case of new photographs, most of these troubles can be prevented. Processing techniques *(Chapter 2)* and methods of storage *(Chapter 3)* designed by archivists can make a photograph almost as permanent as any other human artifact; a life span of centuries seems quite probable.

But the problem facing most people is not so much preserving new pictures as rescuing old ones from decline. Sometimes the cures are very strange. In a recent experiment conducted for Washington's Smithsonian Institution, one of the world's great repositories of historical photographs, nuclear scientists at the Brookhaven National Laboratory on Long Island, New York, exposed a badly faded calotype to radiation in the laboratory's atomic reactor, making the almost invisible image radioactive. Then they put the "hot" picture in contact with a sheet of X-ray film. On development, the radioactivity generated a recognizable image of a breakfast table that had been virtually a blank on the original calotype.

Atomic reactors and X-ray film are hardly necessary in ordinary restoration. But chemicals or copying techniques unfamiliar to most photographers may be involved. The nature of the restoration process to be employed depends largely on the image itself—on the substances that form it and hold it together and on the chemicals used to develop and fix it. Also important is the kind of material behind the image—its support. Modern photographs are standardized. The image, whether negative or positive, is composed of silver metal suspended in a gelatin emulsion. Supporting this combination in a print is paper; in a negative or slide the support is usually a film of cellulose acetate or polyester synthetic plastic.

The materials in old photographs vary and it is not always easy for the restorer to tell at a glance what he is dealing with. Though both daguerreotypes and tintypes, for instance, have a metal backing, they are made by very different processes; fortunately, it is quite easy to identify them. But glass provides the support for a number of different kinds of old photographs: collodion negatives and ambrotypes, silver-albumen negatives and silver-

gelatin plates. Though the emulsions of many of these processes differ markedly, it is often quite difficult for anyone but an expert to tell them apart. In some cases there is no emulsion at all. In many of the earliest kinds of photographs, like the calotype negatives and positives, for instance, the paper itself was impregnated with light-sensitive silver compounds; only later were they incorporated into emulsions on the surface of the glass or metal or paper backings. Albumen, made from the whites of eggs, was the very first coating material, introduced in 1848. Collodion was the commonly used medium for glass-plate negatives between the early 1850s and the early 1880s, while the popular printing papers for the same period were coated with silver in either albumen or collodion emulsions. After about 1880 gelatin superseded collodion as an emulsion medium for glass plates and, after 1889, for roll film. Gelatin emulsions were also used to coat many printing papers after 1880, although some photographers continued to favor albumen papers right up into the early years of the 20th Century.

Combinations of processing chemicals and photographic materials can result in a number of problems—some shared by many processes, some unique to one process alone. But whatever the trouble, there is one corrective measure that works for all of them: copying. Indeed, copying is frequently the only practical remedy for a deteriorated picture. For instance, the faded image of an old calotype can sometimes be successfully restored chemically *(pages 26-33),* but the result is never foolproof. Even when the print appears to be in relatively good condition, the wetting that inevitably accompanies chemical treatment may very well cause the fragile paper fibers to tear or fall apart. Copying can also be the simplest way to rid a photograph of stains, restore a badly buckled print or remove the scratches from a negative. Ideally the copying procedure is done with a copying camera, but such specialized equipment is by no means essential. Many enlargers can be adapted to copying purposes, and accessories for use in copying are available for a number of cameras *(pages 112-115).*

Copying can do much more than merely provide a sturdy and accurate duplicate of an old and fragile picture, because a number of optical tricks can be used to minimize or eliminate damage. Some stains, for example, can be made invisible by copying through a color filter. If a light area in a print has a yellow blotch on it, a yellow filter on the lens of the copying camera will make the spot disappear—the copy film "sees" everything in yellow light, and the stain registers the same as other bright areas. If the stain is a faded yellow patch within a dark area, on the other hand, a filter in yellow's complementary color, blue, would be required; in this case, yellow light would be blocked and the yellow stain would register dark, like the dark area of the image around it.

In addition to wiping out stains, another technique can be used in conjunction with copying to make scratches on a negative nearly invisible. The trick in such a case requires sandwiching the original negative between two pieces of glass thinly coated with microscope immersion oil, a liquid normally used to bring together lens and specimen for examination under a high-power microscope. In this case the immersion oil fills in the scratches so that they seem to match the surrounding surface.

The copying process can introduce defects of its own, however, unless proper techniques are followed. The most common problem is reflections on the surface of some old pictures—either mirror images of the copying apparatus or bright spots and streaks caused by bouncing light. Light streaks can be very troublesome when copying photographs that are buckled or scratched and dented—as tintypes frequently are. These reflections can be eradicated by putting polarizing screens over the light sources and using a standard polarizing filter on the lens of the copying camera; simply adjust the angles of the lights and rotate the lens filter until the reflection disappears from the image on the viewing screen, as when shooting pictures through a display window that causes reflections. When copying extremely reflective pictures—particularly the silvery daguerreotypes—it may be necessary to mask the camera with a large piece of stiff black paper pierced by a hole just large enough for the lens to poke through; otherwise the copy print may also contain an image of the reflected camera.

Instead of simply copying, it is always preferable to restore the original photograph—if methods exist and if the condition of the photograph permits it. Originals, even when less than perfect, have qualities no copy can match. Their very antiquity is appealing; the character of the image may be quite different from that produced by modern photographic materials. Many experts, in fact, when making prints from old glass negatives, prefer to use proof, or printing-out, paper (the paper used by commercial photographers for preliminary proofs) because the image it produces has a tonal quality similar to papers that were popular around the turn of the century.

The restoration of old photographs by chemical means always involves some risk and should be done with the greatest care. Not only are such pictures unique and irreplaceable, but also the photographers who made them did not always go by the book—even when there was one. Often there were no standard rules at all. For insurance it is always wise to make a copy of the original before attempting a restoration. That way, if something does go wrong, there will at least be a record of the information on the picture. Care in touching and handling old photographs is even more important during restoration than it is at other times. Many are fragile from the effects of aging, and wetting them—as is usually necessary for restoration—weakens them

further. Some images were fragile even when new; the daguerreotype image is so delicate that even a fingerprint may permanently mar it; these plates must always be handled by their edges.

The daguerreotype is one of the oldest photographic processes, but it has proved to be a very durable one. Removing the plate from its case and frame can be a bit tricky *(page 35);* once this operation is accomplished, however, restoration is relatively simple. The daguerreotype's main problem is tarnish. Daguerreotypes were made by fuming iodine onto a sheet of mirror-bright silver-plated copper; on contact the silver and the iodine combined to form light-sensitive silver iodide. After exposure and the process of developing the latent image, fixer removed the undeveloped silver iodide from the plate, laying bare the nonimage portions of the metallic sheet. Like all silver, the sheet tarnishes—despite its protective case—and it is this picture-wide patina of tarnish that chemical restoration removes *(pages 34-39).*

In the processes that followed the daguerreotype the problem is generally not so much tarnishing as decomposition. Most of these processes used collodion (cellulose nitrate) as the medium for their light-sensitive silver compounds. Collodion may yellow with age and become brittle. The coating may even flake off its support—whether it is a glass plate or the thin metal backing of tintypes. Unfortunately there is no effective way to reverse the decomposition of collodion, but there are ways to slow it down. To halt blistering before flakes peel off, some restorers spray tintypes with the clear plastic fixative that artists use.

Two of the most popular collodion processes—ambrotypes and tintypes—also suffer from other ailments that can often be remedied simply. The ambrotype is actually a negative glass plate backed with black lacquer, paper or fabric. The image, viewed against this dark background, appears positive. What is thought to be damage to the image in an ambrotype usually is nothing more than damaged or faded backing material; replacing the backing restores the image *(pages 40-43).* The tintype is also a negative image meant to be viewed against a dark background; but in this case the emulsion is coated not on glass but directly on a thin, black-lacquered metal base. Made inexpensively to be carried around in breast pockets and purses or sent through the mail to loved ones, tintypes frequently got scratched, dirty and dented. The dirt can be removed, and the brightened picture can be copied photographically, so the scratches and dents do not show *(pages 44-47).*

For damaged photographs made with gelatin emulsions, introduced around 1880, salvage operations are essentially the same as those that apply to the black-and-white papers and films of today. Then, as now, the gelatin emulsion was laid down in extremely thin layers. When the support material was glass or film, the light-sensitive silver-bearing emulsion was often

topped with a protective layer of clear gelatin, and backed with a layer of dyed gelatin to reduce halation: internal reflections that may generate halos. Trouble comes to these gelatin-emulsion materials from chemical residues left after processing, as well as from environmental conditions that interact with all these substances. Most of the difficulties stem from inadequate processing. Any of the unexposed and undeveloped light-sensitive silver compounds that are not removed by the fixing bath, and any fixer that is not washed away, will cause the photograph to deteriorate in time. Undeveloped light-sensitive silver compounds, for instance, will gradually darken under the action of light. Fixer may react with the silver metal that makes up the image to produce yellowish-brown silver sulfide, causing the image to fade; under extremely severe conditions and over extended periods of time, the silver sulfide itself may decompose into white soluble silver sulfate, at which point the image actually begins to disappear. Other fixer residues may also decompose into silver sulfide and discolor large areas of the picture. Moisture or high humidity, high temperatures and air pollution all accelerate the unwanted sulfide formation.

Sometimes it is possible to spot trouble early. A sure sign of residual chemicals is bleaching in the light areas and along the edges of the negative or print. Old-time photographers used to detect residual fixer by touching the photograph with the tip of the tongue: the fixer chemical tastes sweet. But it is always wise to confirm such suspicions with chemical tests *(page 74)*, and often tests are essential.

After improper processing, the greatest enemies of gelatin-emulsion films and prints are improper storage and display. (For the right way to store and display photographs, see Chapters 3 and 4.) Many a photograph has been ruined by the presence of harmful ingredients in the envelope that was meant to protect it—by resins in the paper or sulfur in the adhesive that seals it. But the most pervasive damage caused by improper storage is probably due to dirt. It is surprising how many dulled images can be restored by nothing more than an application of the ordinary liquid film cleaner sold in photographic stores. Besides dulling the image, dirt may actually abrade the surface, leaving scratches in which more dirt becomes embedded. Film cleaner will lift out the dirt, but scratches require other measures. If the scratches are on film, which is often protected by a coat of lacquer, removing the lacquer will sometimes also dispose of the scratches. Two cleaning mixtures remove lacquer: one is a weak solution of baking soda and lukewarm water (1 tablespoon of soda to 1 pint of water); the other is a combination of ammonia and denatured alcohol *(page 60)*. When the scratches penetrate the emulsion of the film or the print, the photograph will probably have to be copied and retouched. Minor retouching can be done

with fine brushes and watercolor pigment available at art or camera supply stores *(pages 54-59),* but if the damage is extensive the retouching will probably have to be done with an airbrush—generally a professional job.

Another agent of destruction in collections of photographs is the presence of negatives made on nitrate sheet or roll film, the precursor of modern safety film. Nitrate film degenerates and in degenerating gives off gases that are likely to be extremely harmful to any other photographic materials in the vicinity. Therefore, if it must be kept at all, it should be stored away from other types of photographs. Nitrate film is also inflammable, and in large quantities can be dangerous. It is best to copy nitrate negatives on safety film, and if the originals develop a yellow tinge or a distinct odor, they should be destroyed.

Other storage-related problems, difficult to prevent in certain climates, are those caused by heat, cold and humidity. Gelatin emulsions tend to become brittle and to crack in temperatures below 32°F. (but the brittleness is not permanent, and will disappear if the film is gradually warmed to room temperature, 68°F.). In air with a relative humidity higher than 60 per cent, gelatin is a fertile culture medium for fungus. Cockroaches and silverfish also thrive on gelatin, and in eating it they naturally eat the image too. When fungus has simply coated the surface of a film or print, it often can be safely wiped off with a piece of absorbent cotton moistened in film cleaner. Do not use water-based cleaner, since fungus can make gelatin water-soluble—in which case the water may float the affected gelatin from its backing. If lacquer must be taken off, do not use water-based lacquer remover.

After the fungus is removed, a coating of film lacquer, for film, and a clear plastic spray, for prints, will retard damage if the fungus grows back. If the image itself has been affected by the fungus or insects, there is no remedy but copying and retouching.

Most problems that affect black-and-white photographs become double the trouble when color photographs are involved. Fungus, for instance, not only damages the emulsion of color film, as it does that of black-and-white film, but it also excretes substances that can alter the film's color. A much more serious problem is raised by the fundamental nature of a color picture. The image created by all commonly used color processes—for slides, prints and negatives—is not made up of durable silver metal, as nearly all black-and-white images are, but of layers of dye. Unfortunately, most such dyes are relatively unstable. They fade or bleach out in the presence of light, heat and humidity—and not at the same rate. Certain dyes, for instance, cannot survive prolonged exposure to direct sunlight or the light of an illuminated display case, or a slide projector. Others fade alarmingly in heat, even if they are kept in complete darkness. These varying rates of deterioration may produce color imbalances that are usually impossible to correct.

Careful attention to storage and viewing conditions can slow the deterioration of color pictures, but cannot be relied upon to prevent it—although some of the better films last very well (certain pictures made in the early years of modern color are still in good condition). For color photographs that have deteriorated there is no guaranteed method of restoration. The most that can be done to reclaim even mildly faded color photographs is to copy them, using color-correcting filters. This technique cannot bring back the quality of the original, but it can effect some improvement, as the demonstrations on pages 62-68 show.

While the prospects for rescuing a deteriorated color picture are gloomy, there is one almost foolproof method for saving the colors that exist—either to halt further loss in an old image or to preserve for the future the colors of a new image. The colors can be stored more or less permanently in the form of so-called separation negatives—black-and-white copies made by photographing the color original through three separate filters, in the three primary colors. To reconstitute the color picture, the separation negatives can be used to make inexpensive prints or slides, or to produce a very high-quality color print or transparency by a process known as dye transfer. The making of color separations and dye-transfer prints is a job for professionals, and the cost is high: for an 8 x 10 picture the initial cost is roughly $100. But the separations, once prepared, should last as long as any black-and-white negatives—probably a century or more—and can be used to reconstitute the original color pictures at any time. For some photographs, the price is obviously not too high. □

Walter Clark
Former Director of Applied Photographic Research, Kodak Research Laboratories

A Basic Procedure: Copying

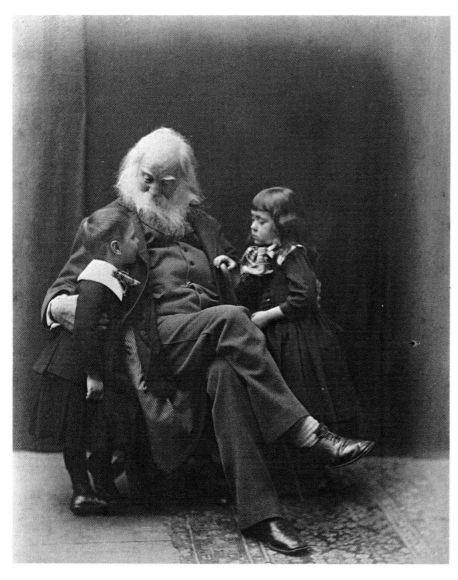

Taken just five years before Whitman's death, when he was 67 years old, this portrait—in its unrestored state—does scant justice to the poet's majestic snow-white hair, beard and eyebrows.

On April 15, 1887, at the age of 67, the poet Walt Whitman sat for this portrait by a fashionable New York photographer named George C. Cox. The picture was one of a set made for the sculptor Augustus Saint-Gaudens, who was preparing to do a bust of Whitman and frequently supplemented live sittings with photographs of his subjects.

The children in the picture are the niece and nephew of a friend who accompanied Whitman to Cox's studio. Cox made a number of prints of the picture; Whitman was by this time famous. This print remained in the photographer's own collection and was bought from his descendants by the Smithsonian Institution in 1962, along with some 1,500 other Cox prints.

Cox was a skillful professional who processed his work carefully, but for all his pains the print has lost contrast and has bleached on the edges. In restoring the photograph, Eugene Ostroff, the Smithsonian's Curator of Photography, elected to make a copy of the print rather than attempt to revive the original chemically. To attack the lack of contrast, Ostroff chose a high-contrast film and high-contrast developer, both of which tended to clarify the print's lights and darks. He used a 4 x 5 view camera mounted on a copying stand—photographic equipment sold at most camera supply stores—though he could have

gotten essentially the same results with a standard 35mm camera. The original print was lit by two standard 500-watt tungsten lamps. To correct the print's yellow fading, Ostroff masked the camera lens with a high-density yellow filter, which acted to brighten the light areas in the restored print and made the darks blacker. Though a blue filter is often useful in heightening contrast because it offsets deep areas of black in the print, in this case experimentation demonstrated that the yellow filter worked better.

The final step in the restoration was to burn-in the faded edges by giving them more exposure during the printing. A cardboard mask was held between the enlarger and the print so that the light struck only the edges.

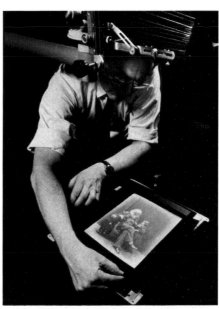

Preparing to make the copy, Ostroff places the print beneath the camera and anchors it flat with weights wrapped in nonreflecting tape.

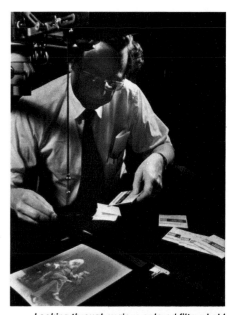

Looking through various colored filters held over the print, Ostroff searches for the one whose color does most to improve the image.

After experimenting with various filters, Ostroff selects a yellow one, which neutralizes the yellow color introduced by fading in the print.

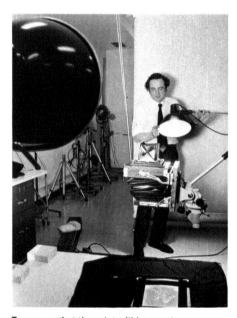

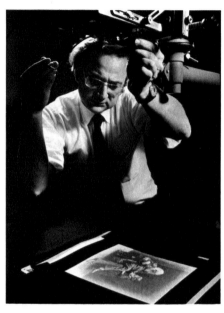

One of the common problems in copying is uneven illumination: if the original print is not lit uniformly over its entire surface, the camera will record the differing light levels as light and dark patches. To prevent this, Ostroff set up his lights so that their beams struck the print at precise angles measured from the positions of the lens and the print *(diagram below)*.

After exposure, the negative was developed and printed with the materials appropriate to the high-contrast copy film. The final print *(right)* revealed Whitman and his two young companions in tones as crisp and solid as they must have been at the time the original photograph was taken.

To ensure that the print will be evenly illuminated, Ostroff adjusts two 500-watt beams so that they intersect on the picture.

Holding the selected filter over the lens of the camera, Ostroff exposes the low-speed, high-contrast copy film for a total of eight seconds.

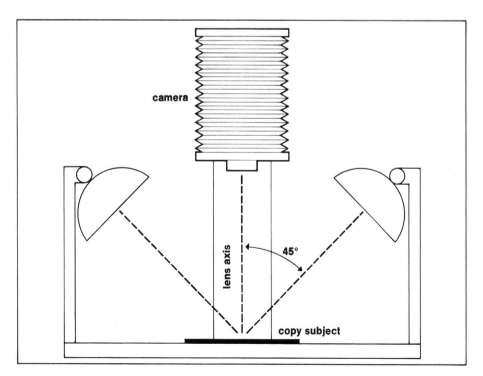

In setting up the lights, Ostroff placed two tungsten lamps on opposite sides of the print, their axes set at a 45° angle to the axis of the lens. In all copying, it is important that the camera-back be parallel to the picture plane.

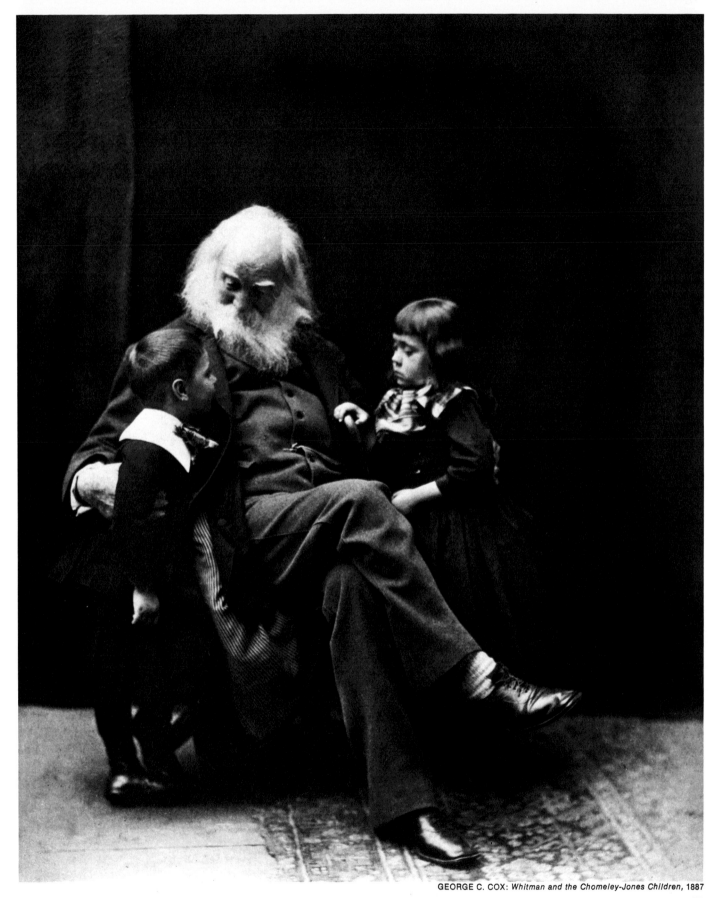

GEORGE C. COX: *Whitman and the Chomeley-Jones Children,* 1887

23

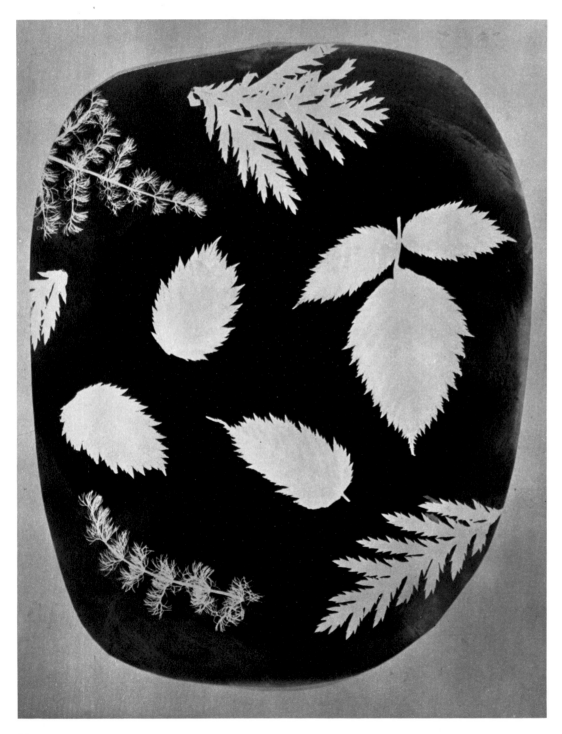

The picture at left—a shadow picture made on sensitized paper devised by William Henry Fox Talbot—has suffered loss of detail. To restore clarity to its images of botanical specimens, Eugene Ostroff used the same basic technique employed to revive the Whitman portrait on the previous page. Though there was no need to use filters—the print is merely faded, not discolored—Ostroff got the satisfying results shown at right by copying the original, using high-contrast film and printing paper to bring back the proper balance between darks and lights. For another way of restoring pictures made on Talbot's sensitized paper—pictures Talbot himself liked to refer to as calotypes—see page 26.

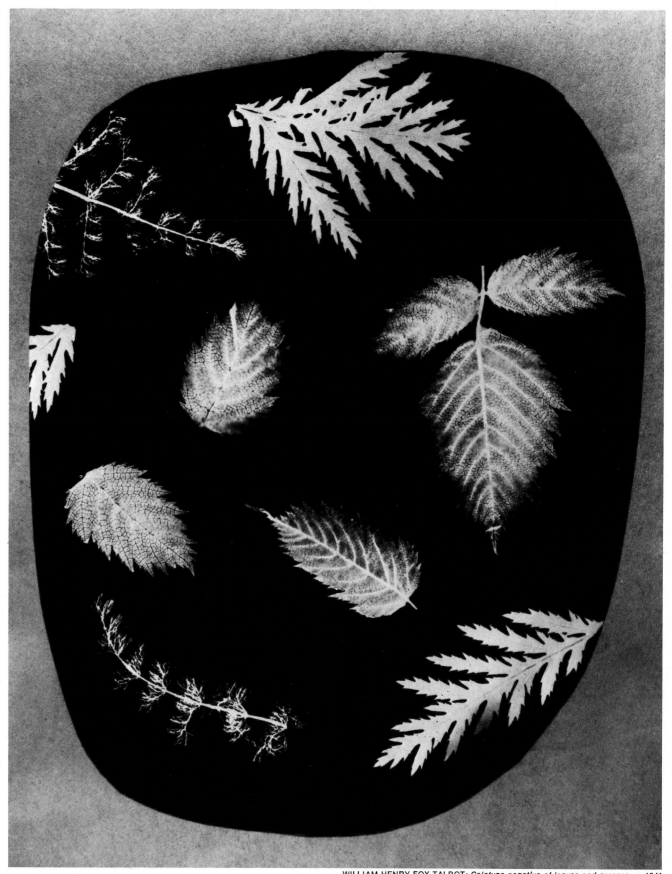

WILLIAM HENRY FOX TALBOT: *Calotype negative of leaves and grasses,* c. 1841

Chemical Aid for an Old Calotype

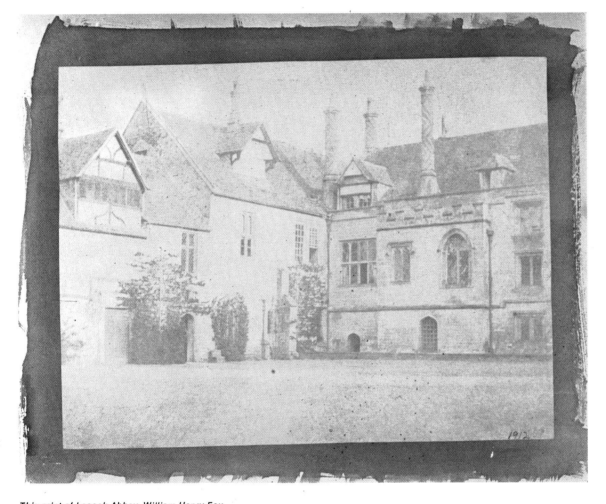

This print of Lacock Abbey, William Henry Fox Talbot's ancestral home and the subject of many of his photographic experiments, has lost much of its definition since it was made more than 125 years ago: the light areas have darkened and the dark areas have grown lighter, probably because the photograph was improperly fixed and washed (pages 72-73). The ragged-looking borders are areas that Talbot missed when brushing the light-sensitive compound onto his paper.

The calotype, the first photographic system that used the present negative-positive method, produced soft images that probably varied in tone from reddish brown to purplish black. The effect depended on the changing methods used by its inventor, an English gentleman named William Henry Fox Talbot, who was an inveterate experimenter.

Apparently Talbot did not fully realize the importance of washing his prints long enough to remove all the residual chemicals—or perhaps the fixing was inadequate. Either fault leads to the retention of processing chemicals that would, in time, decompose or react to light, darkening the background and fading the image—the defect that is now noticeable in many calotypes, some of which are today little more than pale yellow ghosts.

Calotypes were never widely popular, and most of those surviving are in museums. Given the difficulty of determining Talbot's methods in making any individual photograph, restoring calotypes is a chancy business. One expert, Eugene Ostroff of the Smithsonian Institution, uses a technique, demonstrated on the following pages, that was developed for strengthening weak images on modern film. Called silver intensification, the method supplements the silver already present in the image, after a series of baths has removed as many of the residual chemicals as possible—including undeveloped silver.

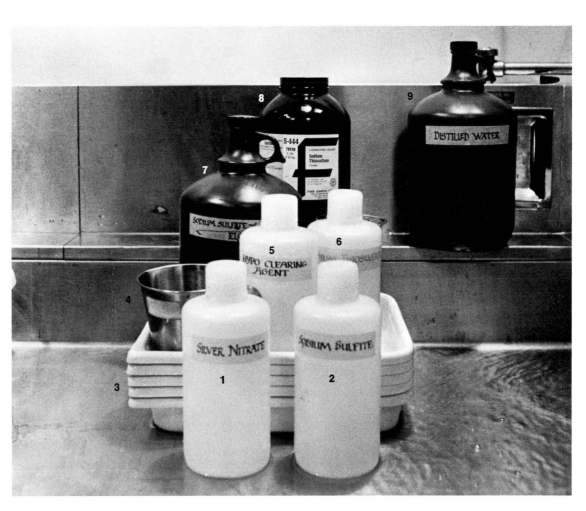

1 | silver nitrate stock solution
2 | sodium sulfite stock solution
3 | trays
4 | graduate
5 | hypo-clearing agent stock solution
6 | sodium thiosulfate (fixer) stock solution
7 | sodium sulfite and developer agent stock solution
8 | sodium thiosulfate
9 | distilled water

Four stock solutions go into the calotype restoration bath. The bath is a silver intensifier formula, such as Kodak IN-5 or Dupont 3-1, that is made up from standard photographic chemicals and is ordinarily used for adding contrast to pale images in modern negatives. In addition to other standard darkroom supplies, such as hypo-clearing agent and the five processing trays, the restoration also requires a washing tray, fitted with a siphon, to keep the water circulating.

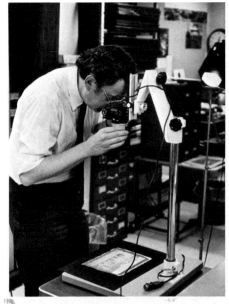

To make a record of the original, in case of trouble during the restoration, Eugene Ostroff uses a 35mm camera mounted on a vertical stand.

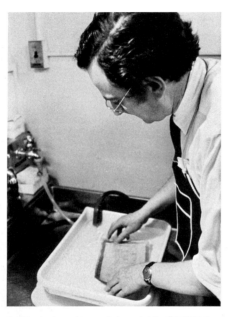

A 20-minute water wash in a siphon-fitted tray removes dirt; to protect the old and fragile paper, circulation has to be very gentle.

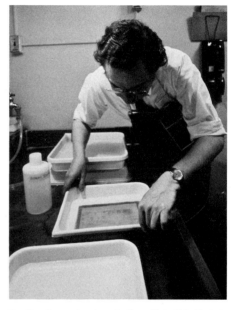

To dissolve undeveloped silver, Ostroff bathes the print in fixer for six to ten minutes, rocking the tray so that the fixer acts evenly.

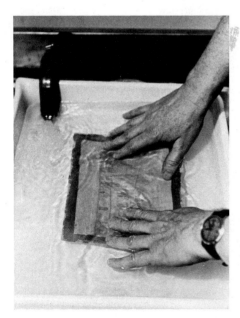

A washing in plain water for one or two minutes, using the siphon-fitted tray, removes much of the fixer and dissolved silver from the print.

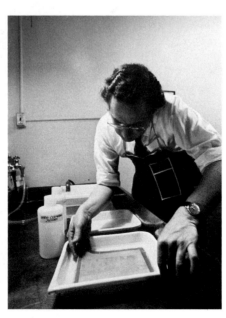

Before the final washing the print is bathed under constant agitation in a solution of hypo-clearing agent for about five minutes.

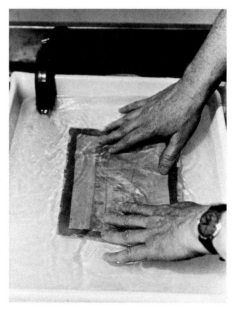

In water that is completely replaced through the siphon at least twice during the process, the print is washed for a total of 10 minutes.

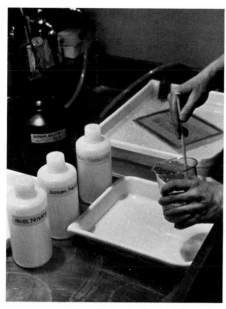

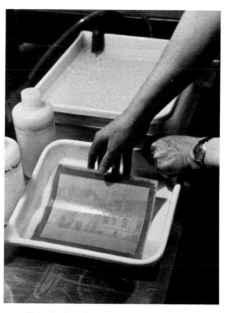

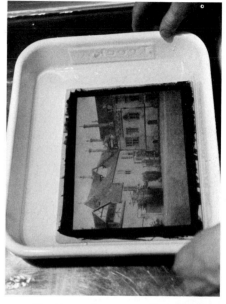

While the print is being washed, the four stock solutions are combined to make the IN-5 intensifier, which is then poured into a tray.

Ostroff slips the print into the intensifier and tips the tray back and forth so that the intensifier acts upon all parts of the image equally.

Checking on the progress, Ostroff removes the print when the image is strong enough, and washes it briefly in circulating water.

In preparation for intensification of a calotype image, the print is first copied (to provide a record in case restoration fails) and then put through several washing and fixing baths before the four stock solutions for its intensification bath are mixed and bottled. Washing and fixing, in addition to cleaning away surface dirt, also remove leftover light-sensitive compounds with which the silver intensifier might react and cause damage. The four stock solutions can be prepared in advance; but their final mixing to make the silver intensification bath must be done just before use, since the solution remains active only for about 30 minutes. The formulas that Eugene Ostroff used for the four solutions—their materials are available at photography or chemical supply houses—are as follows:

☐ Stock solution Number 1 is made by adding enough distilled water to 2 ounces of silver nitrate crystals to make 32 ounces of solution.

☐ Stock solution Number 2 is made by adding enough plain water to 2 ounces of desiccated sodium sulfite to make 32 ounces of solution.

☐ Stock solution Number 3 is made by adding enough plain water to 3½ ounces of sodium thiosulfate fixer to make 32 ounces of solution.

☐ Stock solution Number 4 is made by mixing ½ ounce of desiccated sodium sulfite and 365 grains (.8 ounce) of a developing agent, such as Elon, Metol or Rhodol, with plain water to make 96 ounces of solution.

In preparing enough silver intensifier bath to restore one print in an average-sized tray, these four stock solutions are mixed together in a beaker in the following order:

☐ One cup—eight ounces—of solution 2 is added to one cup of solution 1 and mixed until a white precipitate appears.

☐ The precipitate is dissolved by adding one cup of solution 3 and allowing the mixture to stand for several minutes until it is clear.

☐ Three cups of solution 4 are stirred in and the mixture is poured into a tray.

Because the silver intensifier formula is actually designed for modern film, its action on fragile paper calotypes must be carefully watched. The desired result, a deepening of image tones, should be reached in no more than 10 minutes. Left in the bath too long, the silver might begin to deposit onto lighter areas of the picture, fogging it and ruining the restoration.

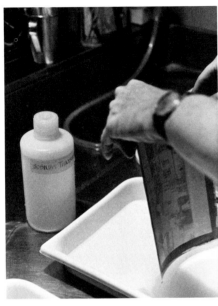

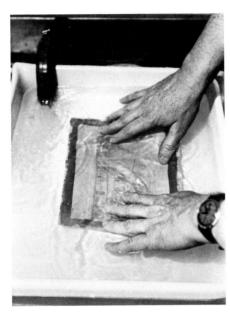

The intensified print is fixed in ordinary fixer for two minutes, followed by a two-minute wash in a regular hypo-clearing agent.

A final and thorough wash in gently circulating water for 30 minutes removes all remaining traces of the chemicals used in restoration.

To prevent the print from buckling, Ostroff sandwiches it between photographic blotters, and allows it to dry slowly for several hours.

In the restored calotype, washing and refixing have removed the muddy stains from the background and highlights, while the silver intensification treatment has reinforced the image tones. Much more detail is visible, especially in the grass in the foreground and in the texture of the rooftops and chimneys—all without loss of the calotype's original soft brown-black tones.

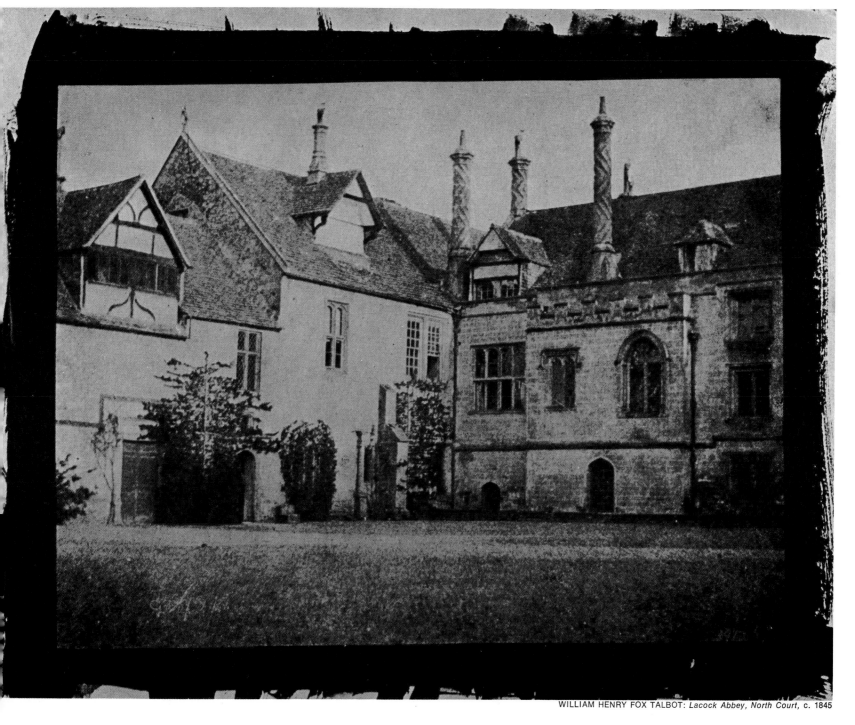

WILLIAM HENRY FOX TALBOT: *Lacock Abbey, North Court*, c. 1845

EIGHT FEET DRIVER LOCOMOTIVE
Built by Messrs. Norris Brother Philada.

The silver intensifier that brought La cock Abbey back to life *(pages 26-3* also helped revive this badly damage calotype of a steam locomotive. Th print, dated June 1850, had lost s much of its definition before restoratic that many of its details were no long visible. It was also dirty, and at som point in its long history it had bee damaged—perhaps by contact with a other print or an album page that left vertical streak down its right side.

The locomotive calotype was mac by William and Frederick Langenhein the only professional calotypists in th United States. The Langenheims wer best known as daguerreotypists; the clients included President John Tyl and Henry Clay. In 1849, the brothe bought the American patent rights t the calotype process from William He ry Fox Talbot, intending to sell license to other photographers for $30 to $5 But not a single photographer applie —probably because no license wa necessary to make daguerreotypes an because most people preferred the da guerreotype's sharper image.

In the unrestored picture of the "eight feet driver locomotive," above, the background trees are almost obliterated; the man standing in front of the engine and a second man between the engine and the tender are badly blurred; a third man, at the window of the cab, cannot be seen at all.

Besides revealing a previously invisible man the cab, cleaning and silver intensification in t restored calotype (right) have brought up su details as the trees, the grass between the trac and the wooden slats of the tender. The vertic streak at the right side could not be remove

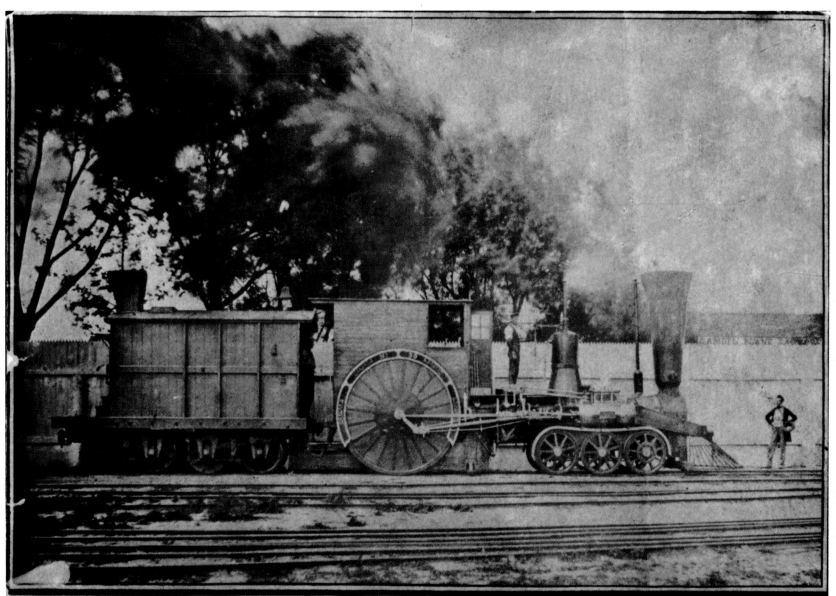

Patent Talbotype View, taken from nature June, 1850 by W. & F. Langenheim 216 Chestnut St Phila. & 247 Broadway N. York.

EIGHT FEET DRIVER LOCOMOTIVE
Built by Messrs. Norris Brother Philada.

WILLIAM AND FREDERICK LANGENHEIM: *Eight Feet Driver Locomotive*, 1850

Cleaning a Blackened Daguerreotype

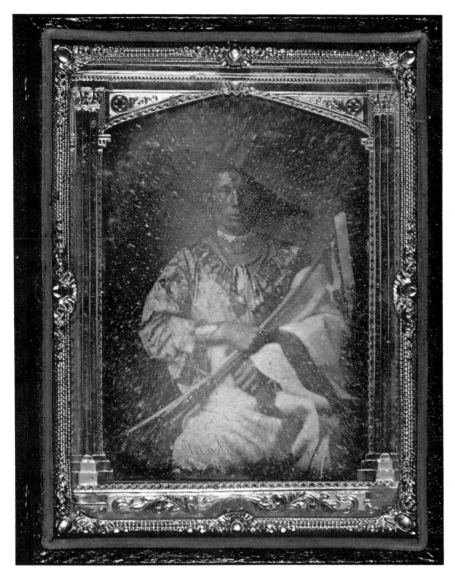

The daguerreotype, an instant success in its time—a period that ran roughly from 1840 to 1860—has also stood up remarkably well ever since. The daguerreotype image is an amalgam of mercury and silver on a silver-coated copper plate. Though the image can be permanently scratched by careless handling, the metallic silver surface of the plate itself is fairly tough. Like any silver, however, it tarnishes.

For many years the standard way of removing tarnish from daguerreotypes was to bathe them in a solution of potassium cyanide, a deadly poison that sometimes overdid the job, removing image along with tarnish. The modern method, shown in the demonstration at right by Eugene Ostroff of the Smithsonian Institution, is safer and easier. Ostroff uses thiourea, a chemical available at chemical supply houses and some photographic supply stores.

To clean a daguerreotype, the plate must first be removed from its frame. The frame almost always included an embossed brass mat and a piece of clear cover glass; mat, image and glass were taped together, and the taped edges were covered with a narrow metal "preserver" frame. The entire assembly fitted compactly into a hinged case included in the daguerreotype's price—often about two dollars.

The unknown photographer who made this daguerreotype etched the name of his subject into the plate: Mahe, a Brave. Over the years Mahe's image has dulled and the background has spotted.

1 | loosen the daguerreotype

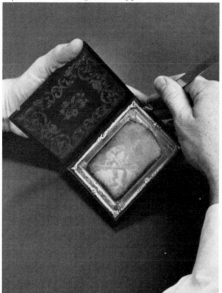

To pry the daguerreotype from its snug-fitting case, slip a slender knife blade between the case and the preserver frame, and gently lift.

2 | remove the daguerreotype assembly

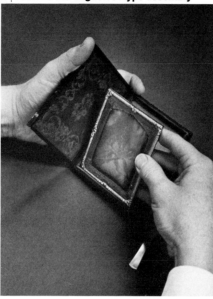

In lifting the daguerreotype from its case, grasp it firmly; its parts may be loose and slip across one another, scratching the daguerreotype plate.

3 | open the preserver frame

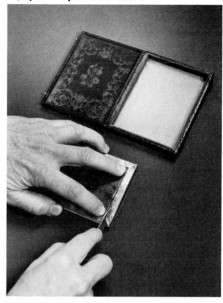

With the daguerreotype face down, gradually pry open the back edges of the preserver frame; the frame, of soft metal, will lift easily.

4 | remove the preserver frame

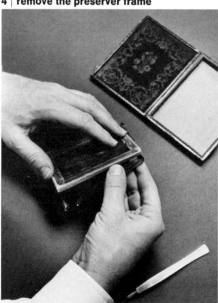

Tilt the daguerreotype upward, resting one long edge against a firm surface; ease off the preserver frame, exposing the taped edges.

5 | release the tape

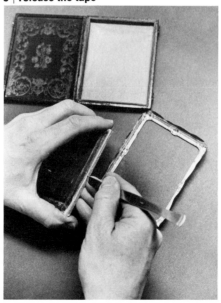

Slit the paper tape along the edges of the cover glass with a small sharp knife. Ostroff uses a scalpel but a razor blade will do just as well.

6 | remove the tape

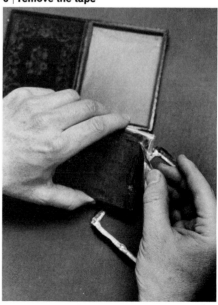

Peel away the tape from the front and back of the daguerreotype assembly. Any paper fragments that remain will slip off later in washing.

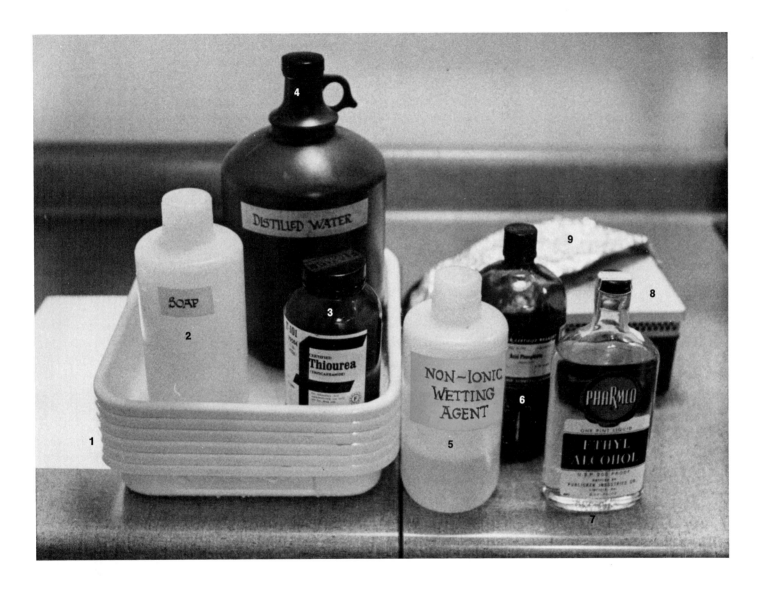

Cleaning a daguerreotype involves several washings and a bath in a thiourea solution that dissolves the silver tarnish. Thiourea is usually harmless to daguerreotypes, but since old materials are unknown quantities, it is best to make a record copy beforehand.

Only distilled water must be used throughout, to avoid contaminating the plate. To make the cleaning solution combine 16 ounces distilled water, 2⅓ ounces thiourea, ¼ ounce 85 per cent phosphoric acid, and one drop nonionic wetting agent—to prevent spotting. Then add enough distilled water for a total of 32 ounces of solution. (Ingredients can be bought at photographic and chemical supply houses.)

1	six trays
2	mild soap (not detergent)
3	thiourea stock solution
4	distilled water
5	nonionic wetting agent
6	85 per cent phosphoric acid
7	95 per cent ethyl (grain) alcohol
8	hot plate
9	aluminum foil

7 | copy the original

Before shooting the copy, mask the camera with black paper to avoid reflections from the daguerreotype's mirrorlike surface (page 45).

8 | clean the framing parts

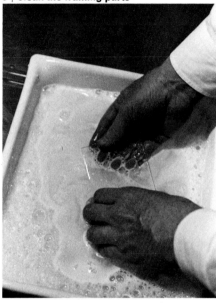

Wash the cover glass in mild soap and distilled water, then rinse it in distilled water. Dust the mat and preserver frame with a lint-free cloth.

9 | wash the daguerreotype plate

Holding the plate by its edges, agitate it in a bath of mild soap and distilled water; rub soapy water over the back; rinse in distilled water.

10 | bathe in thiourea solution

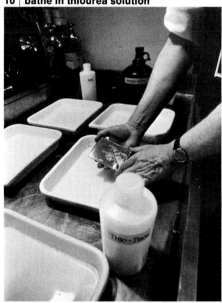

Place the plate face up in thiourea solution and agitate by gently rocking the tray; the tarnish will usually disappear in four or five minutes.

11 | rinse off the cleaning solution

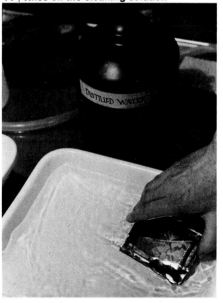

Wash off the thiourea solution by immersing the plate in distilled water; then pour additional distilled water on the front and back of the plate.

12 | prepare to dry

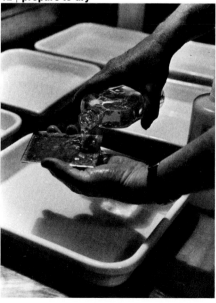

To prevent the formation of water spots and hasten drying, pour 95 per cent ethyl alcohol over the plate; the alcohol clears the water off.

13 | **begin the final drying**

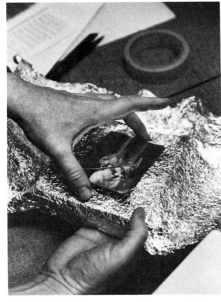

Continue the drying process over gentle heat.
Ostroff uses a hot plate topped with a piece
of crumpled aluminum foil to help diffuse heat.

14 | **complete the drying**

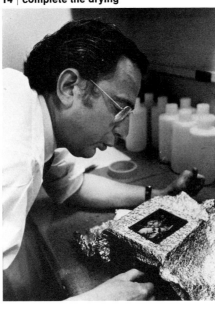

Blow gently across the daguerreotype's surface
to circulate the air heated from below by
the hot plate, and hasten the drying process.

15 | **reassemble the daguerreotype**

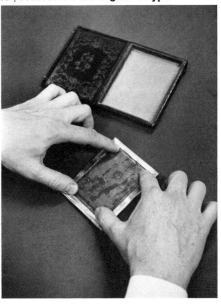

The clean daguerreotype and framing parts are
reassembled, the velvet case is brushed clean,
and the daguerreotype is reinserted in the case.

*Cleansed of its tarnish the daguerreotype shows
Mahe in all his pride: bow and arrows in hand,
ornaments in his hair and at his throat. The image,
brighter overall, is especially so in the highlights.
Mahe's rich brown coloring is the product of
gold toning (pages 80-83), a technique often used
by daguerreotype photographers to protect the
silvery image and make its naturally cool grays
seem warmer. If Mahe's portrait should again
tarnish, as it might in today's sulfur-polluted air,
the same thiourea bath will restore it once again.*

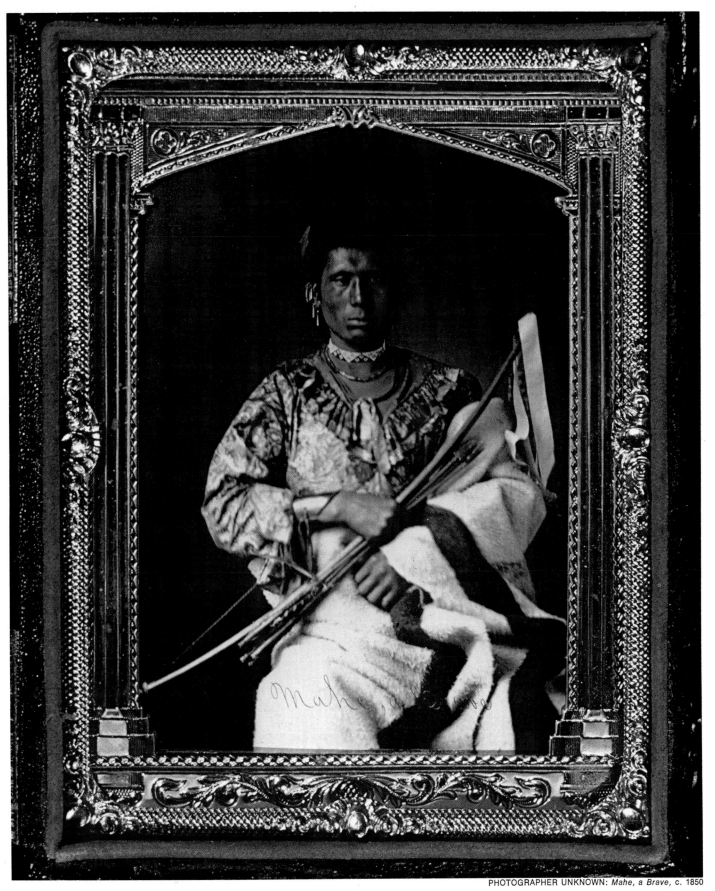

PHOTOGRAPHER UNKNOWN: *Mahe, a Brave*, c. 1850

Replacing an Ambrotype Backing

In old photographs, the scars of time frequently seem ineradicable: Great-Grandfather's nose obliterated by a blotch, Great-Grandmother's eyes put out. However, in the case of the ambrotype—a photograph made by a process that flourished in the mid-19th Century—such apparently serious damage is quite easy to repair.

The ambrotype was popular largely because it was inexpensive—the finished picture is actually a glass-plate negative—and no print had to be made. The problem with damaged ambrotypes generally involves not the photographic image itself but the backing. To make the negative image appear positive, the glass plate is backed with black paint, fabric, paper or lacquered metal. Any of them may deteriorate and, in doing so, interfere with the visibility of the image.

To restore the image, it is usually only necessary to replace the backing, a relatively easy operation that involves removing the ambrotype from its case and protective mounting: a combination of brass mat, cover glass and tape, all enclosed in a "preserver" frame.

Nothing is known about this family portrait except that it was probably made in the early 1860s. The blemishes across the woman's forehead and on the man's face and suit are actually bleached spots in the black fabric backing. The image itself, recorded in a collodion emulsion on the front surface of a glass plate, is almost as good as new.

1 | loosen the paper tape

After removing the ambrotype from its case, slit the tape that binds the parts together. Use the edge of the cover glass as a guide for the knife.

2 | remove the tape

Gently pull away the tape from the cover glass and the backing material. Usually the tape comes off easily because the old glue has deteriorated.

3 | separate the parts

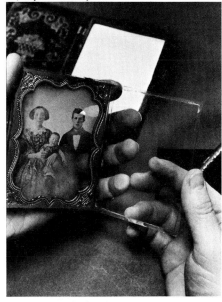

Lift off the cover glass, brass mat and backing. Wash the cover glass in mild soapy water; wipe the mat and the nonemulsion side of the plate.

4 | cut a new backing

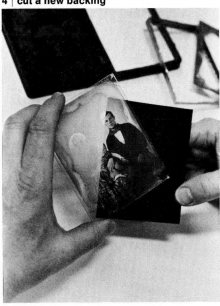

Using the cover glass as a pattern, cut a new backing from black paper. Slide the paper backing against the underside of the ambrotype.

5 | reassemble the parts

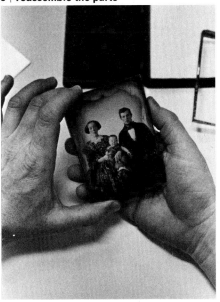

Align the brass mat and cover glass over the newly backed ambrotype, but do not tape the edges: most adhesives are harmful to images.

6 | replace the preserver frame

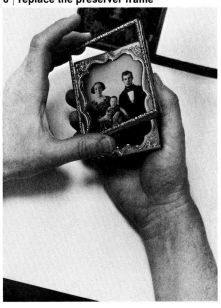

Slip all the parts into the preserver frame and press the frame edges down over the backing. Put the ambrotype back in its case (overleaf).

Given a new lease on life with nothing more than a fresh backing and judicious cleaning, an ambrotype portrait sparkles in its original case. Like many ambrotypes, this one was delicately tinted by hand: the cheeks are rosy and the woman's brooch and one of her rings are golden. The hinged case, with its red velvet lining, was made on a wooden frame covered with a pressed-paper material meant to look like tooled leather.

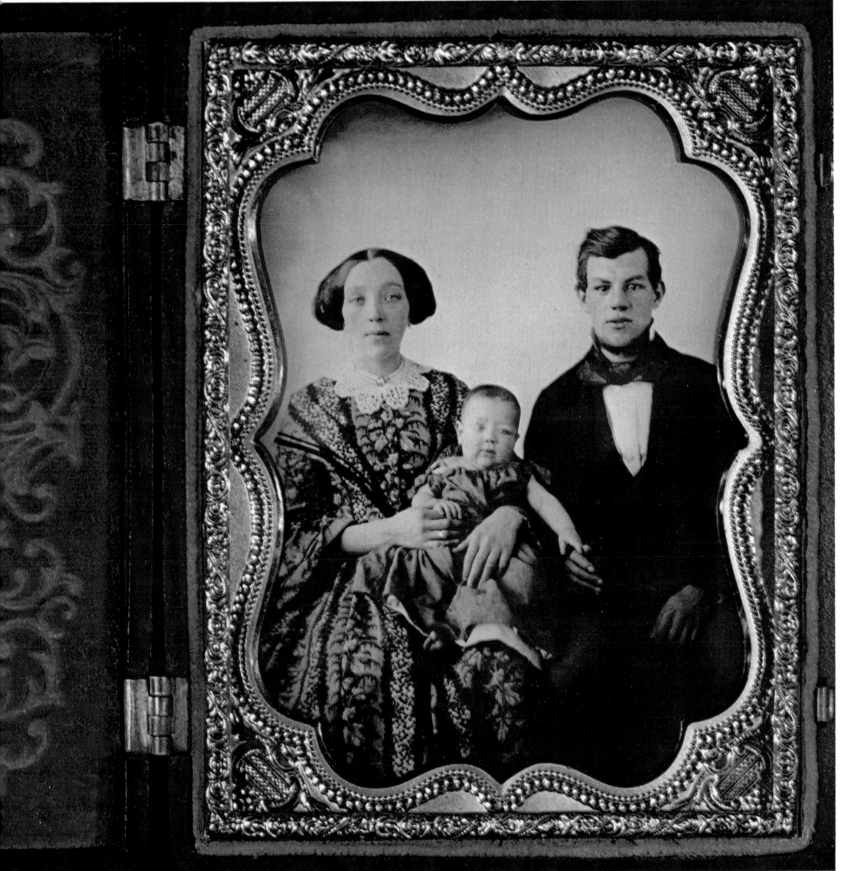

New Life for a Tintype

A copy of a tintype made without filters or mask to control light reflections emphasizes its imperfections. Lit by ordinary photoflood lamps, this copy looks even worse than the aged original. How this same picture appears when made with the right equipment is shown on page 47.

Widely used from the middle of the 19th Century until fairly recently, tintypes regularly turn up in attics—portraits of the past whose very age gives them an enduring charm. The popularity of the tintype stemmed from two advantages it was cheap to make and it was more durable than anything then available. The backing for the tintype image, unlike the fragile glass backing also used at the time, was a thin sheet of black-enameled iron. It could be shipped or carried about without danger of shattering. During the Civil War, soldiers took advantage of this characteristic to send home tintypes taken by itinerant camp photographers.

But the tintype's image deteriorates and the metal backing is easily dented. The only way to restore a tintype is to copy it photographically. In doing so, the tintype's shiny surface poses special problems. Scratches and dents are often more noticeable on the copy than on the original—because they are emphasized by the light used for copying. And on occasion the reflective surface may pick up the image of the camera with which the tintype is being photographed—and that, too, shows in the copy. There are two ways to counteract these effects. One is to mask the camera, except for its lens; the other is to use polarizing filters over the lens and the light sources. (Polarizing materials for both lights and lenses are available from large photographic supply houses.) Both techniques are demonstrated by Herbert Orth, deputy chief of the Time-Life Photo Lab, in the pictures at right and on the following page. Though a view camera was used for the demonstration, any camera equipped for close-up work will serve.

1 | mount the tintype

To lessen unwanted reflections, mount the tintype with double-sided tape on a wall covered with a sheet of matte-finished gray paper.

2 | align the camera

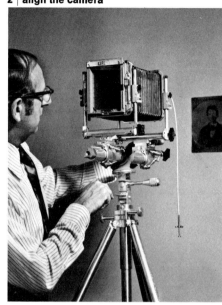

Level the camera so that the plane of the film and that of the tintype are exactly parallel; otherwise the image will be distorted.

3 | mask the camera

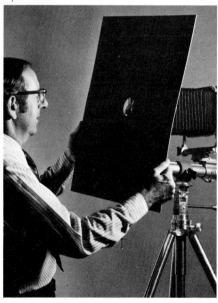

Cut a hole slightly larger than the lens in black cardboard and slip it over the lens to avoid a mirror image of the camera on the tintype.

4 | anchor the mask

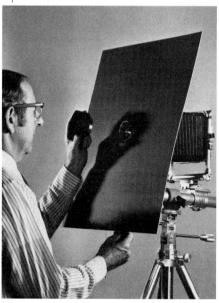

Screw on the lens hood to secure the mask. The mask will usually eliminate unwanted reflections if lights are set at 45° angles to the tintype.

45

5 | focus the camera

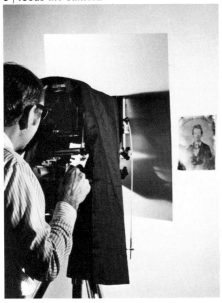

Make certain that the focus is sharp, using a magnifier, if possible, to examine every detail of the image as it appears on the viewing screen.

6 | double-check for reflections

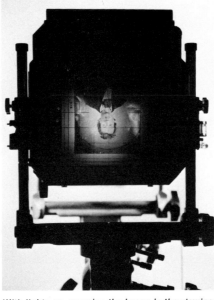

With lights on, examine the image in the viewing screen to be sure the reflections on the tintype have been eliminated; here, they are still visible.

7 | polarize the light sources

If re-angling the lights fails to remove reflections, place polarizing screens over each light. They can be clipped on or mounted on stands.

8 | adjust the lens polarizer

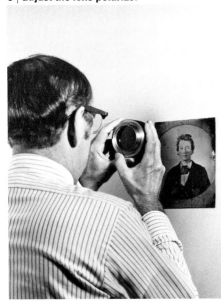

Put a polarizing filter in the lens hood; holding it to the eye, rotate it until reflections vanish; then put the lens hood on camera in this position.

9 | calculate exposure

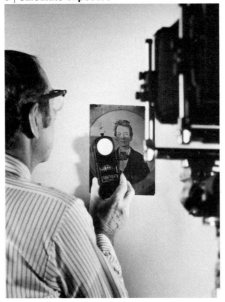

Using a light meter, gauge exposure. Because the polarizers block some light, increase the exposure about 2½ stops over the meter reading.

10 | make the exposure

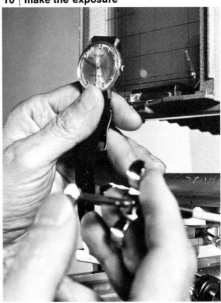

To time the exposure accurately, use a watch—a fairly long time exposure is generally needed. A medium-contrast film is recommended.

Photographed with polarizers and other light-controlling measures, the scratches and blemishes so apparent in the badly made tintype copy (page 44) have disappeared and the true nature of the portrait stands revealed. With its sharper definition and dent-free surface, this photographic copy, though it lacks the charm of the original, is in many ways a better image.

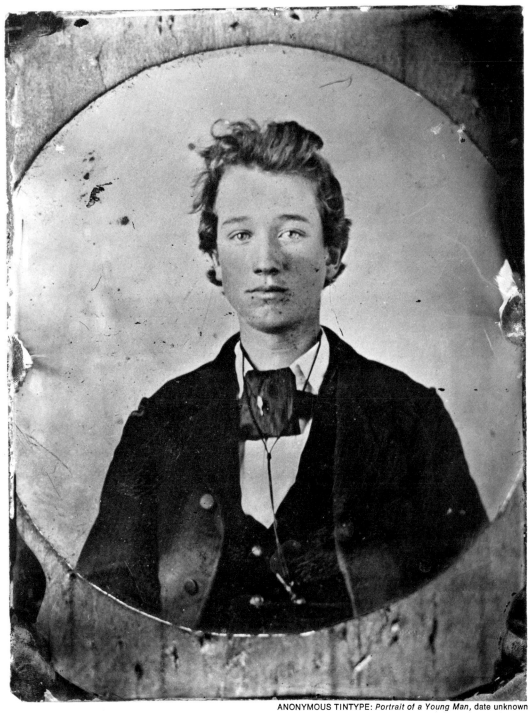

ANONYMOUS TINTYPE: *Portrait of a Young Man*, date unknown

The Value of Old-Time Printing-Out Paper

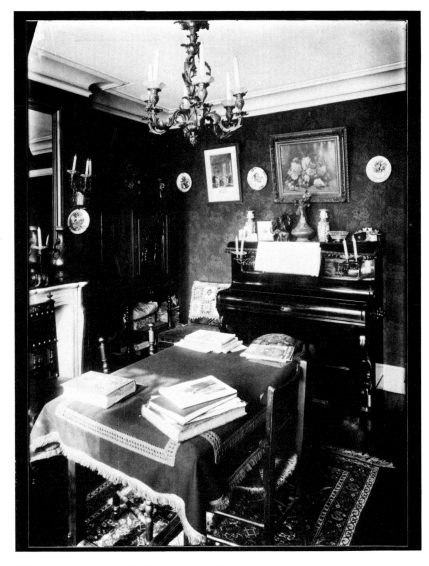

Printed on modern paper, the image from an old glass negative by Eugène Atget lacks some detail. The lettering on the books in the foreground is not clear, and in the room's far corner a cupboard and bric-a-brac are partially obscured.

Contemporary printmaking materials, for all their fine qualities, are often unworthy of negatives made long ago. The old glass negatives used by such 19th and early 20th Century photographers as Eugène Atget frequently contain rich detail and subtle tones that modern papers cannot reveal.

Only one type of paper made today approximates the papers used by Atget and his predecessors. It is the proof paper used by portrait photographers for preliminary prints. Like old-time materials, it is a printing-out paper, producing its image directly from the action of light and not requiring chemical development. Such paper gives a greater range of tones than chemically developed printing papers. But it has drawbacks: it is too slow to use for anything but contact prints; also, when it is fixed, the image turns an unpleasant color.

To eliminate the undesirable color of proof paper, printmaker George A. Tice uses gold toning—another old-fashioned process used with printing-out paper. At right Tice shows how to make gold-toned prints, and overleaf are the results of the process with an Atget photograph printed on printing-out paper. The gold-toning treatment employs a solution made in three steps. To prepare the solution, mix 200 grains of sodium thiocyanate in 20 ounces of water (be careful of the sodium thiocyanate; it is a poison if taken internally); then mix 15 grains of gold chloride in 20 ounces of distilled water; finally, to make the working solution, mix two ounces of the sodium thiocyanate solution in 20 ounces of water, to which are added two ounces of the gold solution. All these chemicals are sold at photographic or chemical supply houses.

1 | check the progress of the image

Open the frame in dim light to check progress after exposing the proof paper in bright sunlight for two minutes. Expose longer if necessary.

2 | preliminary washing

Working in subdued light, wash the exposed print in six changes of water to remove unexposed silver salts from the print's surface.

3 | tone with gold chloride

Immerse the washed print in a tray containing a freshly mixed batch of gold-toning solution, and agitate very gently for 20 minutes.

4 | wash the print

Remove the print from the gold-toning bath and wash it in a siphon-equipped tray of constantly flowing water for at least 15 minutes.

5 | fix with hypo

To remove the remaining unexposed silver salts, immerse the print in a tray containing ordinary fixer, and agitate it for 10 minutes.

6 | clear away the fixer

Rinse the print in water, then bathe it for two minutes in hypo-clearing agent, followed by a full hour of washing in running water; air-dry.

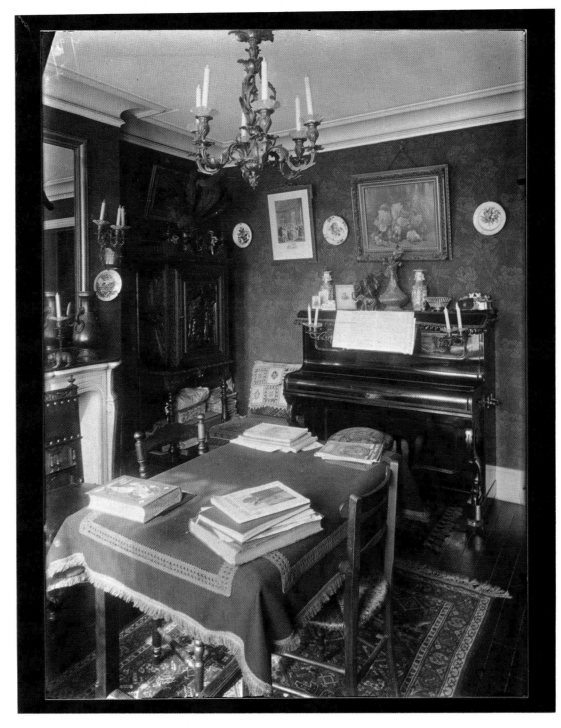

When Eugène Atget died in 1927, he left behind a treasure of 2,000 glass negatives, the record of his passion for the city of Paris and for his chosen craft, photography. During Atget's 71-year lifetime, photographic technology advanced rapidly, making photographic processes simple and fast operations. Yet despite the fact that photography was Atget's livelihood (a not especially lucrative one), he preferred to use the clumsy equipment and the complicated processes he had become familiar with early in his career.

Atget carried around an outmoded view camera and heavy glass plates. He printed his pictures on old-fashioned albumen and gelatin papers by painstaking techniques similar to the one described on the preceding page. His reasons for these preferences were simple: the older materials produced the effects he wanted—pin-sharp details and a tonal range that captured every nuance of shading from somber black to radiant white.

Lacking the intermediate gold-toning treatment, this version of the Atget photograph, printed on printing-out paper, has an unattractive reddish hue. Nevertheless, the subtle tonal gradations that were obscured in the modern print on page 48 are all present: the books have titles, the musical score on the piano is plainer, and the cupboard in the corner is clear.

When the Atget photograph is reproduced on printing-out paper that is treated with gold chloride before fixing, it not only gains in detail but also acquires a pleasing purplish-brown cast (right). In Atget's day this rich color was much admired, and Atget's own prints resembled this modern reconstruction. Atget sometimes gold-toned his prints by techniques like the one described on page 49—and sometimes he used self-toning papers into which the gold-toning chemicals had already been incorporated.

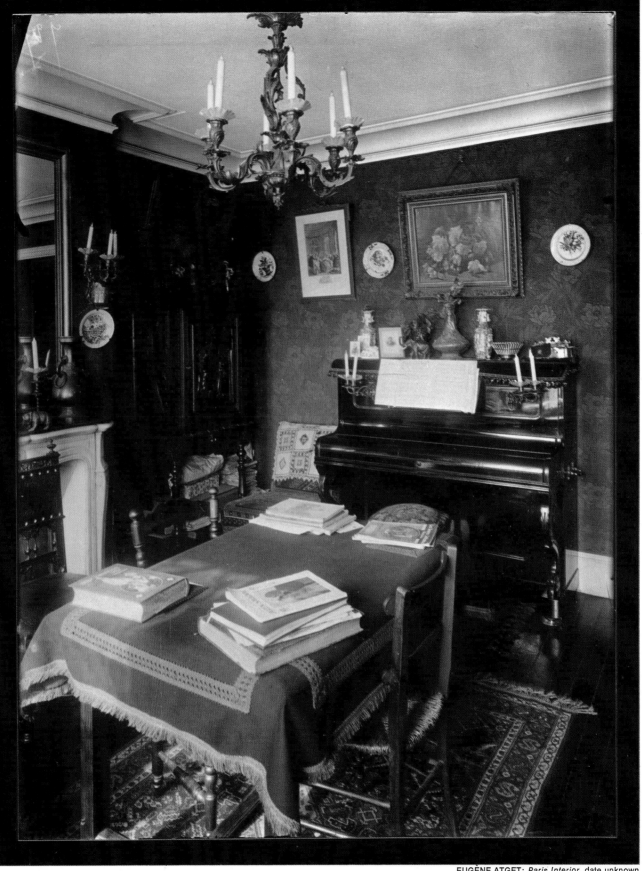

EUGÈNE ATGET: *Paris Interior*, date unknown

The difference that proof paper and gold toning can make in reproducing the details of an old glass negative was revealed to photographer Lee Friedlander right in his own darkroom when he printed a treasure of forgotten plates he had found in New Orleans.

Friedlander's plates, dating from before World War I, were pictures of the girls in a house in Storyville, the city's red-light district. They had been made by E. J. Bellocq, a little-known commercial photographer who was born in France and had a studio in New Orleans from 1895 to the 1940s.

Nothing is known about the circumstances under which the Storyville pictures were taken, but apparently the girls were simply Bellocq's friends. A homely man with an irascible temperament, he may have turned to prostitutes simply for companionship.

With no clue to the appearance of Bellocq's original prints, Friedlander made his first test prints on modern developing paper, and found that he lost much of the negatives' detail. Only when he turned to proof paper and gold toning did he get the results shown here, which reproduce all the richness of tone present in Bellocq's plates.

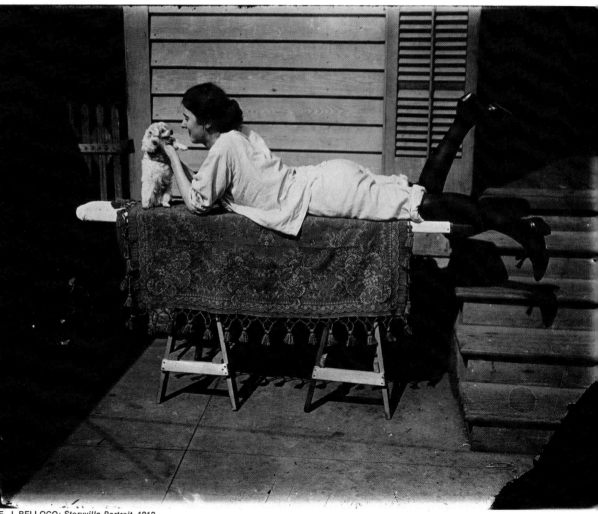

E. J. BELLOCQ: *Storyville Portrait,* 1912

Artfully stretched out on an ironing board, a New Orleans prostitute swaps smiles with a friendly dog. The gold-toned print brings out a wide rang of textural detail—wood-grain steps, tapestry pattern, sunlight glinting off the girl's hair.

Despite the dimly lit interior, Bellocq's picture of strangely winsome Storyville girl is so sharp i this toned print that it is easy to trace the tufte surface of the design in the Oriental carpet, and t count the tiny beads in the girl's necklace

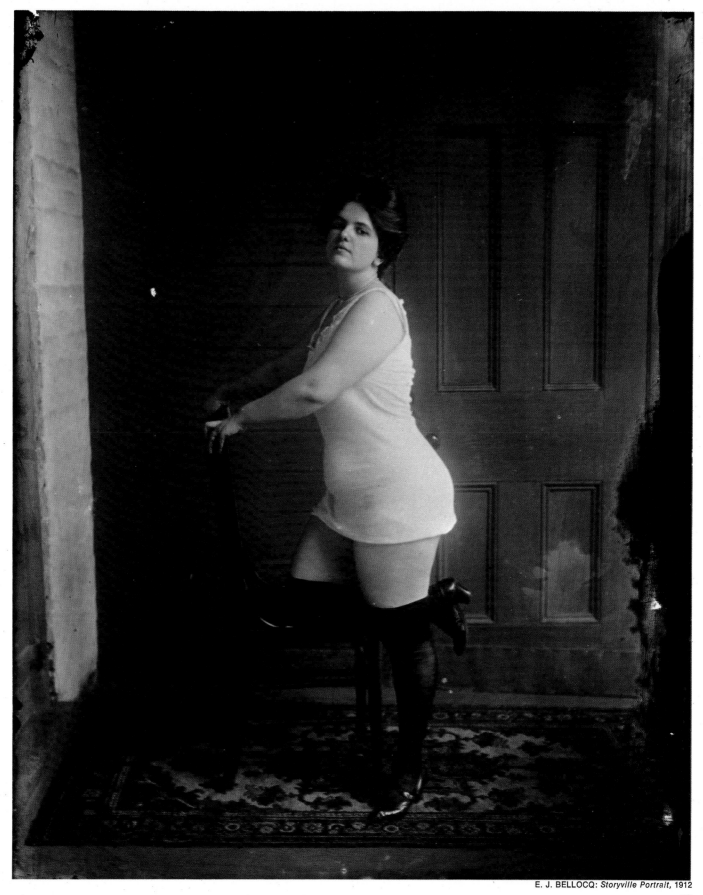

E. J. BELLOCQ: *Storyville Portrait*, 1912

Retouching Damaged Pictures

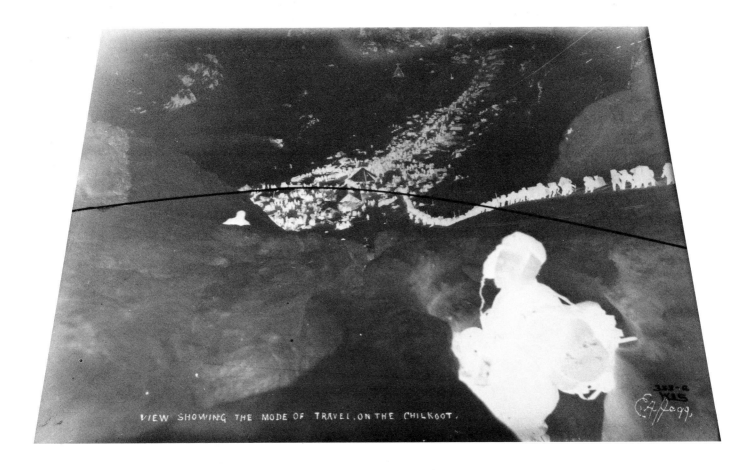

VIEW SHOWING THE MODE OF TRAVEL ON THE CHILKOOT.

The glass negative reproduced above —documenting the stampede of gold-seeking sourdoughs across Chilkoot Pass into the Klondike—has suffered damage that cannot be repaired, yet the image is not lost, for a print can be made to look unscarred by the retouching methods demonstrated on the following pages. The picture was taken in 1897 by Eric A. Hegg, and is one of 1,500 Hegg plates now in the University of Washington Library. But for years before it found this refuge it was subjected to casual mistreatment.

Hegg's plates survived immersion in floodwaters, arctic backpacking, storage between the walls of a below-zero Alaskan cabin, and a covetous lady who wanted to turn the glass into windows for a greenhouse.

These and countless other abuses have cracked the glass of the negative shown on this page, bubbled, chipped and scratched the emulsion, and also engraved the image indelibly with fingerprints. The damage is permanent, yet with skillful retouching a print made from the bruised glass negative was doctored so that the blemishes scarcely show in the result *(page 57)*.

A nearly 80-year-old glass negative shows the signs of its age and maltreatment. For this illustration, it was photographed at a slight angle to emphasize its worst injury: the deep horizontal crack that runs across it.

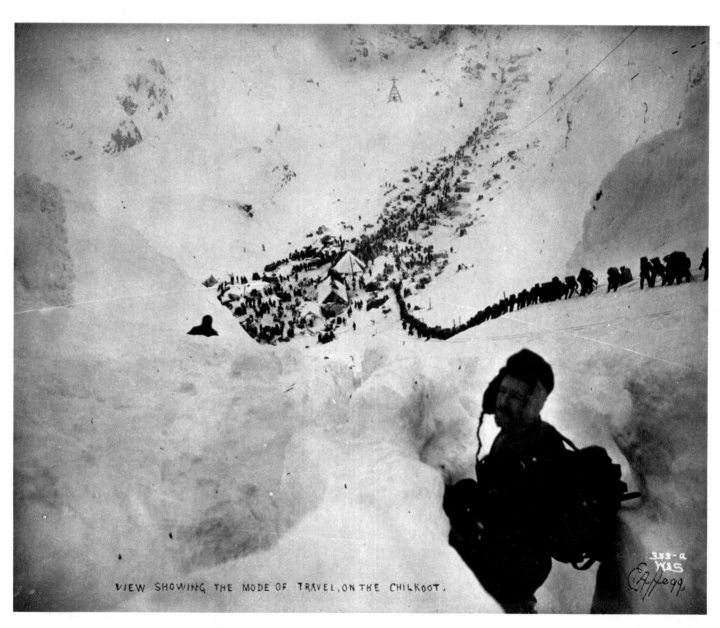

VIEW SHOWING THE MODE OF TRAVEL ON THE CHILKOOT.

A print from the damaged negative exposes fingerprints in the top right corner, bubbled and cracked emulsion in the lower left, a long scratch across the bottom, and the center crack.

1 | magnifying glass on a stand
2 | water can with holder for brushes
3 | retouchers water-soluble paints
4 | brushes
5 | airbrush
6 | steel ruler

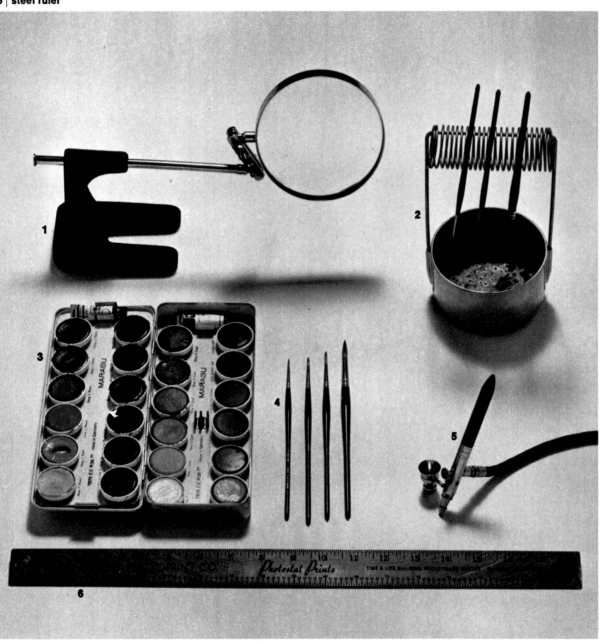

Retouching is painting and requires a degree of manual dexterity. But when areas to be retouched are small, as they are in the Hegg photograph reproduced on the preceding pages, the task is generally not beyond the talents of the average amateur.

The equipment and materials needed *(left)* are available in most camera and art supply stores. The paints are standard watercolors in black, white and a range of grays; often they are sold in retouching kits. The brushes, of sable or camel's hair, must hold a fine point when wet for making hairline strokes and for stippling, that is, covering a damaged area with minuscule dots with the tip of the brush. For very fine work a magnifying glass is helpful, and a steel-edged ruler helps for filling in fine lines. Professionals often use an airbrush, which sprays a thin layer of paint and allows color to be applied much more quickly and evenly than a brush does. It requires compressed air to run it, however, and is not essential.

The most difficult part of retouching is blending a gray shade to match the tone of the surrounding area, mixing small quantities of black or gray pigment with white until the desired shade is obtained. This matching becomes easier with practice—and besides, watercolors can be wiped off, so repeated trials can be made.

In addition to the basic equipment shown above, a simple retouching job requires a palette for mixing the paint (a pane of glass or a china plate is ideal) and, in order to operate the airbrush, a reliable supply of compressed air.

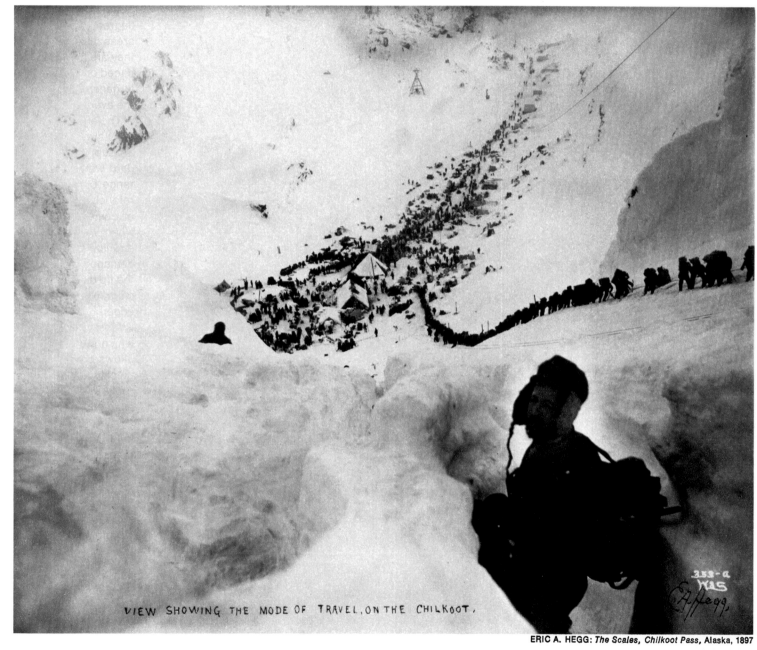

VIEW SHOWING THE MODE OF TRAVEL, ON THE CHILKOOT.

ERIC A. HEGG: *The Scales, Chilkoot Pass, Alaska,* 1897

*Invisible strokes and dots of paint have made this
photograph practically blemish-free. For
retouching, the print was made on dull-finish
paper because watercolors have a dull finish, and
because such paper takes paint better.*

Despite a cautionary "Do Not Bend" legend on the envelope, the print at top left was cracked in mailing. Luckily the crack ran through a shadowed part of the picture, and the damage was easily concealed by retouching (bottom) with warm blacks matching the shadow tones.

A carelessly placed coffee cup marred the face in the print at left. Swabbing removed some of the coffee before it impregnated the picture; the remaining stain was deftly stippled (above) with grays matching those around the damaged area.

Checking the Spread of Fungus

Fungus spores—often called mold and mildew—exist in the air everywhere, but they thrive and multiply with a vengeance in high relative humidity (60 per cent or more) whether the air is hot or cool. Fungus needs a culture medium to grow in, and gelatin photographic emulsions, with their high-protein content, provide it. Fungus that has eaten into the emulsion of a photograph may harm it so much that only copying and retouching can repair it *(pages 54-59).*

But there are ways to prevent fungus growth. Proper storage is vital *(Chapter 3).* The storage container should include a drying agent, such as silica gel. Cleanliness is also important: fungus prefers greasy, finger-marked surfaces.

Damage can also be prevented by applying a protective coating directly to the photograph before fungus has a chance to grow. Film lacquer, brushed onto color and black-and-white film, will help to keep the fungus away from the image itself. If fungus growth occurs, it can be removed with film cleaner, available at camera stores. Should the growth mar the lacquer coating on film, it can be removed and replaced, and if the image has not yet been affected, the film will suffer no permanent damage. Film lacquer can be stripped off with a homemade mixture of one tablespoon of household ammonia and one cup of denatured alcohol. If the plastic print coating appears damaged after fungus has been wiped off, it is usually not necessary to remove the entire coating; a touch-up respraying is generally sufficient. In any case, never use a water-based solution to combat fungus, for if the fungus has softened the emulsion, water will remove it from its backing.

1 | spray for protection

Sprayed lightly and evenly over the surface of the print, a clear coating of plastic provides a tough barrier, difficult for fungus to penetrate.

2 | assess the damage

Although the fungus growth on this print looks extensive, it is only the surface coating that is affected by it; the image itself is undamaged.

3 | remove the fungus

Using absorbent cotton dipped in film cleaner, wipe off the fungus. Replace the swab as it gets dirty, to keep from spreading the spores.

4 | the print restored

Cleansed of fungus, the print is as good as new; any dull patches in the protective coating can be easily remedied by light respraying.

Uncurling a Print

Curling is so frequently a problem with photographs that it might almost be called endemic. It is a direct result of the way photographic print materials are constructed. Most printing papers consist of a paper base coated with a gelatin emulsion. The two often shrink unevenly in drying, the emulsion contracting more than the paper base, causing the print to roll up with the emulsion side inward. Stored prints can also curl when changes in temperature and humidity occur, causing the paper base and emulsion to swell or shrink unevenly. If the curled print is a very old one, it may be too brittle for an amateur to attempt to flatten and should be turned over to an expert for treatment.

For a normal amount of curling in a print that is not brittle, however, various corrective measures are possible. The simplest treatment is mechanical: draw the print, image side up, gently over the edge of a table. There is some risk, however, that the emulsion may crack, particularly if the print has a glossy finish. A second method employs the commercial flattening agents that some photographers introduce into the final wash to stop curling before it starts. These solutions will also uncurl prints, but their ingredients—chemicals that attract and hold moisture—remain in the print and may hasten deterioration.

A third method, probably the safest, is illustrated at right. It involves moistening the back of the print, sandwiching it between blotters, and pressing it until it is dry. The only precaution lies in the choice of sponge and blotters, which should be free of chemicals damaging to the image; sponges and blotters possessing this quality are sold in photographic supply stores.

1 | evaluate the damage

If the extent of the curl is not appreciably greater than that shown above, the print can usually be flattened by the steps shown.

2 | moisten the paper backing

Place the print face down on a clean surface, flatten it out gently, and moisten the back of the print by wiping it with a damp sponge.

3 | weight the print

After sandwiching the moistened print between clean blotters, press it with heavy objects whose dimensions are larger than those of the print.

4 | check the results

When the print is dry, place it on a flat surface to see if the curl has been completely removed; if necessary, the treatment can be repeated.

A Copying Machine to Re-create Lost Colors

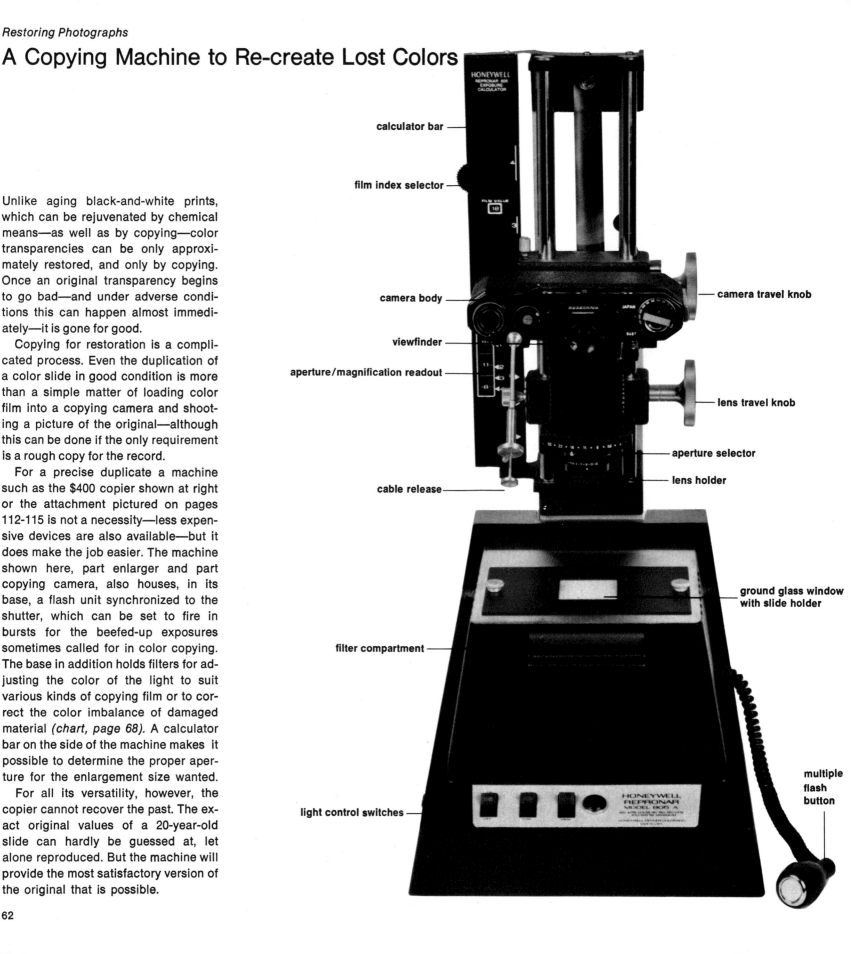

calculator bar

film index selector

camera body

viewfinder

aperture/magnification readout

cable release

light control switches

filter compartment

camera travel knob

lens travel knob

aperture selector

lens holder

ground glass window with slide holder

multiple flash button

HONEYWELL
REPRONAR
MODEL 805 A

Unlike aging black-and-white prints, which can be rejuvenated by chemical means—as well as by copying—color transparencies can be only approximately restored, and only by copying. Once an original transparency begins to go bad—and under adverse conditions this can happen almost immediately—it is gone for good.

Copying for restoration is a complicated process. Even the duplication of a color slide in good condition is more than a simple matter of loading color film into a copying camera and shooting a picture of the original—although this can be done if the only requirement is a rough copy for the record.

For a precise duplicate a machine such as the $400 copier shown at right or the attachment pictured on pages 112-115 is not a necessity—less expensive devices are also available—but it does make the job easier. The machine shown here, part enlarger and part copying camera, also houses, in its base, a flash unit synchronized to the shutter, which can be set to fire in bursts for the beefed-up exposures sometimes called for in color copying. The base in addition holds filters for adjusting the color of the light to suit various kinds of copying film or to correct the color imbalance of damaged material *(chart, page 68).* A calculator bar on the side of the machine makes it possible to determine the proper aperture for the enlargement size wanted.

For all its versatility, however, the copier cannot recover the past. The exact original values of a 20-year-old slide can hardly be guessed at, let alone reproduced. But the machine will provide the most satisfactory version of the original that is possible.

1 | insert the original

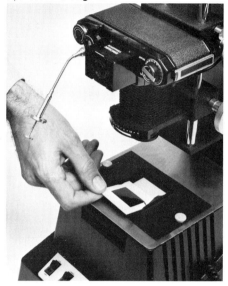

Slipping the transparency into the holder provided on the base top, position it for copying. Preparatory to focusing (step 3) set the lens aperture selector to open as wide as possible.

2 | adjust magnification

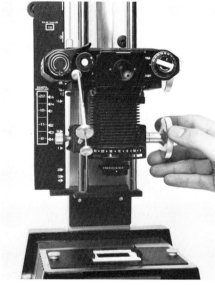

To copy the transparency in the same size, turn the lens and camera travel knobs until the pointers on the camera and lens holder line up with the "1"s marked on the calculator bar.

3 | focus the camera

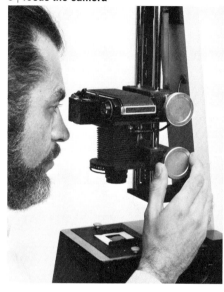

Looking through the viewfinder with the flash switch in the view position, the operator of the copying machine adjusts the lens travel knob to bring the transparency into sharp focus.

4 | set the aperture

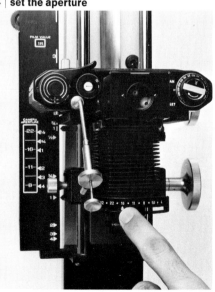

For a same-size copy, the aperture is set at the f-stop indicated on the calculator bar by the small metal arrow mounted on the lens holder. In this case the setting is f/16.

5 | load the filter compartment

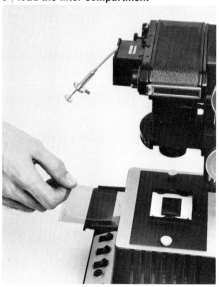

Place a filter or filters—their choice is dictated by the type of copying film (page 68) and by the colors needed to correct the damaged original —in the shallow filter drawer provided for them.

6 | expose the film

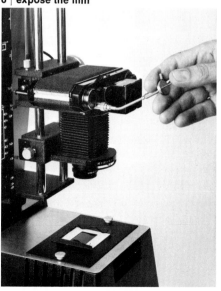

With the light-control switch set on flash, the copying film is exposed by opening the shutter with the cable release. Both shutter and flash can be set for single or multiple exposures.

Thanks to the Germanic thoroughness of the photographer who took it, this 1939 color picture of a delighted Adolf Hitler accepting a fiftieth-birthday present—a Volksflug convertible presented by Ferdinand Porsche—is still in fairly good shape. The picture is one of a collection of 2,000 color transparencies made by Hitler's personal photographer, Hugo Jaeger. In the aftermath of Germany's surrender, Jaeger sealed his pictures in canning jars and buried them in various spots around the town where he lived. From time to time the collection was disinterred, checked, repacked and reburied.

When LIFE acquired Jaeger's transparencies in 1965, their color was superior to that of many World War II photographs *(for examples, see pages 66, 67).* The original Hitler picture at right, for example, merely appeared to be washed out; copying alone did much to improve the contrast. For the particular copying film chosen, Ektachrome reversal print film, the combination of filters that normally gives an exact duplication of existing colors consists of yellow and cyan *(chart, page 68).* In this instance exact duplication was not desired because the slide had yellowed slightly; the filter combination used was a slightly less intense version of the basic pack that allowed more magenta and cyan to come through and restored the colors to an acceptable facsimile of those in the original photograph.

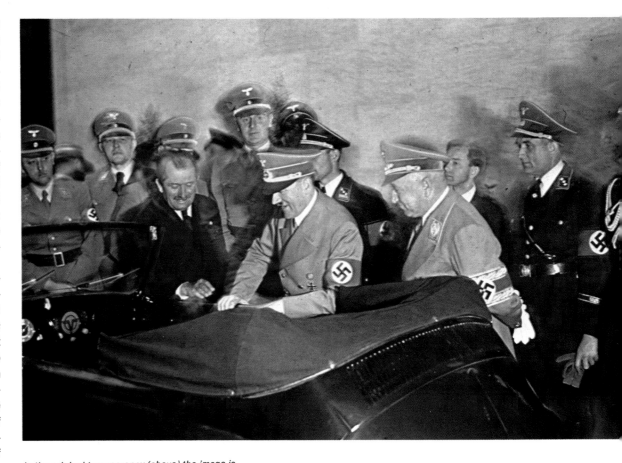

In the original transparency (above) the image is faded throughout, most noticeably in the flesh tones—which are generally among the first things to look unnatural when color begins to go. Though it is impossible to reconstruct color exactly, the golden hue of the transparency suggests that the picture originally contained less yellow than this, and more cyan and magenta.

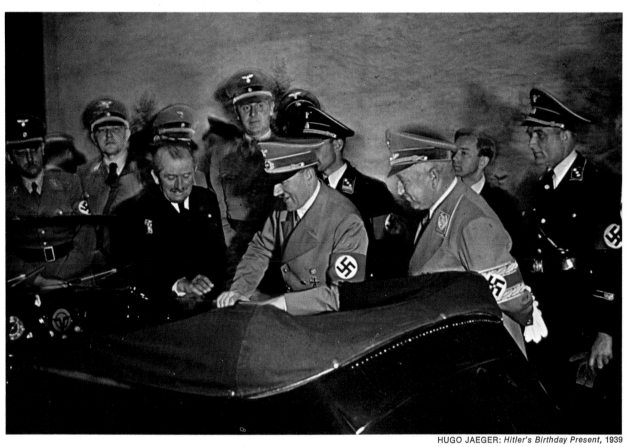

HUGO JAEGER: *Hitler's Birthday Present*, 1939

The restored version of the Hitler transparency (above) was made by copying the original in much the same way exact color duplicates are made (chart, page 68), but using a less intense yellow in the filter pack. Instead of the basic combination of filters—called 20C, 40Y and Wratten 85—that is used for identical copies, the restoration was shot through a combination of 20C, 35Y and Wratten 85.

During the blitz of 1940-1941, when Hitler nightly rained bombs on Britain, London was a city full of sights like the one in the photograph at right, taken by LIFE photographer William Vandivert. In common with many transparencies from the World War II period, the colors in Vandivert's original have badly deteriorated. They were restored *(far right)* by copying the original through filters.

In Vandivert's picture the yellow dye in the topmost of the three layers of emulsion has faded badly, causing the color balance to shift to the magenta and cyan hues of the two layers beneath. To correct this imbalance the Time-Life Photo Lab followed the same procedure outlined on the preceding pages. The starting point for trial color correction was the filter combination that experience has shown gives an exact duplicate of a normal transparency when the copying film is Ektachrome reversal print film. This pack consists of filter types known by code designation *(chart, page 68)* as 20C, 40Y and Wratten 85. Inspection of the faded transparency indicated that the restoration needed more yellow and cyan than the basic filter pack provided.

In the first trial *(right center),* the cyan filter was 45C and the yellow 65Y. Since stronger filters cut the amount of light reaching the film, the exposure was increased by two f-stops over the meter reading (instead of the 1⅓ f-stop increase used with the basic pack). These changes were not enough, however: the distinctive red of the London bus, which provided a clue to the original color, was still somewhat too magenta. In the final correction, shown in the last picture, the intensity of the yellow filter was again increased to 85Y.

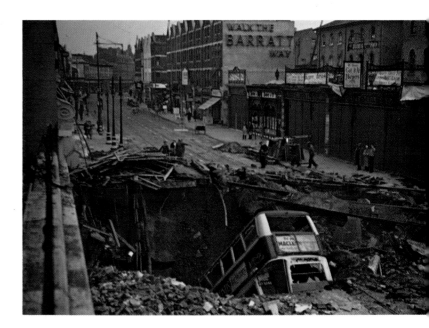

In the original transparency, the fading of the yellow dye layer has turned everything a funereal purple, most noticeably in the shadows and in the bus—which should be scarlet. To bring the colors back into balance, it was necessary to copy the original through filters that added the missing tints of yellow and cyan (chart, page 68).

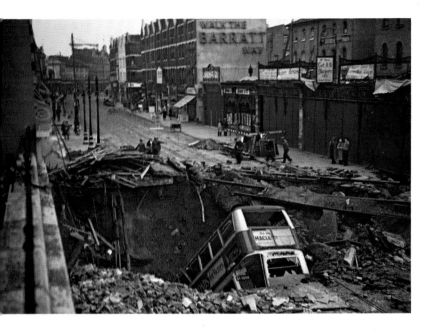

WILLIAM VANDIVERT: *London Blitz*, 1940

For the first attempt at restoration, the filter combination was a slightly intensified version of the same hues—yellow and cyan—employed in making normal transparencies. The result is an improvement on the original, but the color in this version still seems to contain, for most tastes, an unnatural amount of purple.

The final version of the restoration was made with a deeper yellow filter than the one used in the first trial; the cyan and Wratten filters remained unchanged. The deep filters require considerably more exposure, in this case 2⅓ f-stops above the setting that a meter would indicate for copying a normal transparency.

Filters for Color Correction

The charts on this page serve as a guide in the use of filters in copying any color transparency to restore its original colors, as described on pages 62-67. The filters are sold as code-labeled gelatin sheets, the code letters indicating basic hue—Y for yellow, M for magenta, C for cyan—and the numbers indicating shade. Shades range from 05 (very pale) to 50 (very deep), and two or even three filters can also be combined —a 10C with a 20C is equivalent to a 30C. There are two filter grades; the less expensive CP filters are satisfactory, provided they are placed between the light source and the picture being copied, but the distortion-free CC type must be used if the filters are between the picture and the lens.

The starting point for a corrected-color copy is always the filter combination, or "pack," that would be used to make an exact duplicate of a normal picture without any color change. The top chart at right, created especially for this book by the Time-Life Photo Lab, lists such "normal" packs for five kinds of film in making copies, and also gives the exposure correction each pack requires if a separate meter is used or if flash exposure is calculated.

How the normal pack is modified to provide color correction is indicated in the middle chart, which lists filter hues needed to accomplish specified color changes. Exact shades are established by trial. For example, to supply additional blue to a picture being copied on Agfa CT 18 film, the normal pack, 25C-25M, might first be modified to 35C-35M. Suggested exposure corrections for each filter are given in the bottom chart; exact values depend upon the copying equipment being used.

filters for normal copying without color change (daylight or electronic flash)

film	filter pack	exposure increase
Agfa CT 18	25C + 25M	⅔ stop
Ektachrome Reversal Print Film	20C + 40Y + Wratten 85[1]	1⅓ stops
Ektachrome X	05C + 05M	⅔ stop
GAF 64	50C + 50M	1⅔ stops
Kodachrome II	10C + 20M	⅔ stop

[1]*The Wratten 85 filter converts this indoor-type film to daylight or flash.*

filters for correcting color

to add	use	to remove	use
red	yellow and magenta	red	cyan
green	cyan and yellow	green	magenta
blue	cyan and magenta	blue	yellow
cyan	cyan	cyan	yellow and magenta
magenta	magenta	magenta	cyan and yellow
yellow	yellow	yellow	cyan and magenta

exposure correction required by filters in color-correction copying

cyan filters	magenta filters	yellow filters
exposure increase	exposure increase	exposure increase
05C ⅓ f-stop	05M ⅓ f-stop	05Y none
10C ⅓	10M ⅓	10Y ⅓ f-stop
20C ⅓	20M ⅓	20Y ⅓
30C ⅔	30M ⅔	30Y ⅓
40C ⅔	40M ⅔	40Y ⅓
50C 1	50M ⅔	50Y ⅔

Processing for Permanence

Picture-saving Secrets of the Archivists 72

This print of Westminster Abbey, made in 1911 by ▶
the English photographer Frederick H. Evans,
shows the exquisite detail attainable when
platinum is used instead of silver in printing
—detail that will never fade because the metal is
impervious to chemical harm that a silver image
can suffer. The picture also has historic interest: It
shows the usually busy sanctuary devoid of
chairs or people after it was cleared during
preparations for the coronation of King George V.

FREDERICK H. EVANS: *Westminster Abbey: The Sanctuary*, 1911

Picture-saving Secrets of the Archivists

How long does a photograph last? Some of the first ever made have held up perfectly, their images as durable as if they had been carved in stone. Yet other photographs not nearly so old have faded to a brownish yellow, their scenes lost perhaps forever. The crucial difference between the long-lasting photograph and the faded one is the care that went into its processing. The photographer who wants to ensure extended life for his pictures should do his own processing to be certain it is handled correctly. And for those photographs he wants to endure indefinitely, he should use the special techniques that are known as archival processing and are described on the following pages. If he takes these recommended steps, he can expect his photographs to last longer than he will.

For black-and-white pictures, archival processing is not radically different from the customary method of developing, fixing and washing. It is basically an extension of the ordinary procedures, involving a few extra steps, some additional expense—and careful attention to the fine details of the work. Its principal aim is the total removal of chemicals that, although essential to the picture-making operation, can ruin the image if allowed to remain in a finished negative or print.

Among the potentially harmful substances that archival processing seeks to remove are the very ones that create the normal black-and-white image: salts of silver, such as silver bromide or silver chloride. During development, those grains of silver salts that have been exposed to light are reduced to black metallic silver, which forms the image; but unexposed grains are not reduced and remain in the form of a silver compound. If this is not removed, it will darken when struck by light and blot out the image. The chemical used to remove these unexposed grains is fixer, or hypo as it is sometimes called, which converts them into soluble compounds that can be washed away. The fixer, however, must also be removed. It contains sulfur and, if allowed to remain in a picture, it will tarnish the metallic silver of the image just as sulfur in the air tarnishes a silver fork. Also, fixer can become attached to silver salts to form complex compounds that are themselves insoluble and cannot be easily removed. When these silver-fixer complexes decompose they produce a brown-yellow sulfide compound that may discolor the entire picture. Archival processing includes procedures that eliminate the last traces of these residual chemicals—unreduced silver salts, fixer and silver-fixer compounds. Washing alone, for example, cannot make a print entirely free of fixer; even after 20 hours in running water a slight but potentially harmful amount of fixer would remain—and such prolonged washing would itself endanger the print by weakening the paper fibers. Once the picture is clear of residual chemicals, the final step in the archival procedure is to protect the image with a special treatment using a gold or selenium compound *(pages*

80-83). Either of them unites with the silver in the image to act as a shield against damage from external contaminants, such as the sulfur that is part of the pollution in the air.

Archival processing calls for special care in several respects. The chemicals used, like those employed in ordinary processing, can be dangerous; most will stain clothing and are poisonous if taken internally. Never keep them within the reach of children. Never attempt to process in a kitchen near food, and never use drinking glasses or eating utensils for mixing the solutions. Never let any of the chemicals get near the mouth, never taste them and always make sure that hands are washed thoroughly after processing, particularly before eating or drinking. Some photographic chemicals may also cause skin irritation, so use tongs to handle film or prints in the working solutions. Meticulous cleanliness is necessary for personal safety, but it is also essential to the success of archival processing. Sloppiness defeats the techniques' purposes by introducing materials that can cause image deterioration. Any chemicals left to linger in trays or bottles may contaminate the solutions next used in them. Similarly, chemical residues in sponges or blotters could be passed on to the picture. The processes also depend heavily on careful preparation of the several working solutions. The formulas must be followed exactly (although they may be reduced proportionately to make small batches). While excess quantities of most solutions can be stored (in amber bottles to prevent light-caused deterioration), it is wise to discard any leftovers and make up fresh batches each time. That way there is no risk of employing chemicals that have spoiled or have been exhausted through use.

Most of the techniques of archival processing are meant to neutralize the dangers that threaten images formed of silver, but photographic images need not necessarily be composed of silver. Platinum printing, for example *(pages 86-93),* uses paper coated with light-sensitive compounds that produce an image of metallic platinum, an element almost totally impervious to chemical attack; such prints are exceptionally durable. Even color pictures, whose images are composed of perishable dyes, can be preserved in a roundabout fashion—by translating their colors into black-and-white records that can be processed for permanence in the same way as other black-and-white pictures *(pages 94-96).* Thus any kind of photograph can, if appropriately handled, be guaranteed an almost unlimited life. ☐

Special Treatments for Negatives

The steps that assure long life to negatives begin after the film is developed in the ordinary way. It is fixing, washing and later treatments that determine how permanent the image will be.

In fixing negatives, extra protection is gained by using two separate baths in order to make certain that fresh solution reaches every part of the emulsion. Either of the two standard types of fixer, ammonium thiosulfate ("rapid" fixer) or sodium thiosulfate, may be used, provided the temperature of the solution does not exceed 75°F. After a normal stop bath has been used and poured from the tank, add the first fixer bath and agitate for half the recommended time; then discard the solution. Next fill the tank with the second fixing bath and agitate again for half the recommended time. The exact fixing times must be observed. If the film is underfixed, silver halides will linger in the negative. If it is overfixed, insoluble silver-fixer compounds may form.

Once fixing is finished, the fixer and its by-products must be totally removed from the film. Empty the tank and fill with rinse water. Agitate the reels of film several times by lifting them up and down by the central rod, discard the rinse water and fill the tank with a standard hypo-clearing agent. Agitate the film in this solution for three minutes.

Only after rinsing and clearing is the film ready for washing, preferably in an archival washer, a device designed to provide great water exchange and circulation without excessive turbulence. If the developing tank is to be used as a washer, insert the connecting hose deep into the tank to make sure that the water circulates completely. To make sure such a setup provides sufficient water flow, test it by placing several drops of ordinary food coloring inside the tank. The flow should clear the water of all the dye in five minutes or less. Wash for 10 minutes, and for optimum results keep the water temperature between 68° and 75°F.

After the washing, a simple test for residual hypo in the film should be made. One such test is made by using Kodak Formula HT-2, which is prepared by adding 4 ounces of 28 per cent acetic acid to 24 ounces of distilled water. Add ¼ ounce of silver nitrate, then pour in enough distilled water to make 32 ounces. Since only a drop or so is used at a time, this solution lasts a long time. Both compounds are available from most chemical supply houses, but acetic acid is generally sold in special concentrated "glacial" form and must be diluted, three parts to eight parts distilled water, to get the 28 per cent strength needed.

To use the hypo test solution, first cut off a strip from the wet film's clear margin and blot the water remaining on the surface. Using a dropper, place one drop of test solution on the clear area and allow to remain for two minutes. Blot off the excess and compare the stain that appears with one on a Kodak Hypo Estimator sheet, which may be purchased at many camera stores. The stain on the test area should be appreciably lighter than the lightest stain on the estimator sheet. In fact, the test area should show very little stain at all. If the test stain is too dark, continue the washing for a while and test again.

Once washing is completed—that is, after all traces of fixer have been eliminated—the silver image can be protected against chemical attack by treating it with a gold solution. The solution used for negatives is the same as the one employed for prints and should be mixed as explained in the discussion of print protection on pages 80-81. For treating film, fill the developing tank with the gold solution and agitate the film in it for 10 minutes. Then rinse and wash for 20 minutes. This process will give film an impervious surface without altering image tones.

The final steps in processing film for durability are those that will guarantee even, safe drying. Fill the developing tank with any standard photographic nonionic wetting agent that has been diluted in distilled water (not tap water), and agitate the film in it for a minute. The agent decreases the surface tension of water, allowing it to flow off the film evenly without collecting in drops or leaving streaks; sponging to remove droplets should not be necessary. Now hang the film on clips to dry at room temperature; do not use heat, which may cause film to become brittle.

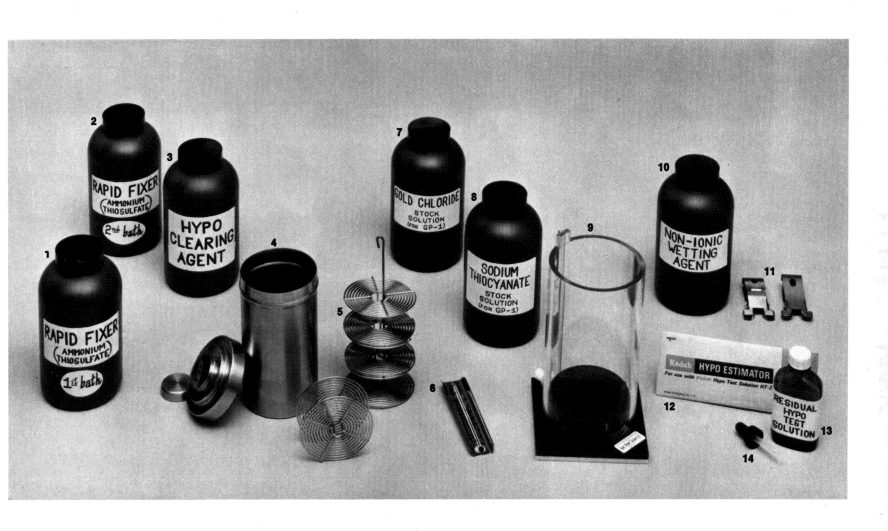

1	fixer for first bath	8	sodium thiocyanate for gold treatment
2	fixer for second bath	9	film washer
3	hypo-clearing agent	10	nonionic wetting agent
4	stainless steel developing tank	11	film clips
5	film reels and rod	12	hypo estimator stain sheet
6	thermometer	13	residual hypo test solution
7	gold chloride for gold treatment	14	dropper

SISKIYOU COUNTY MUSEUM
YREKA, CALIFORNIA

Special Treatments for Prints

Prints, like negatives, gain durability from steps taken after normal development. Two fixer baths are required but they must be made with a slow sodium thiosulfate "hardening" fixer, not the rapid ammonium type often used for film. Agitate the print—process one at a time—in the first tray of fixer for a minimum of three but no more than five minutes. Then rinse in a tray of water, slip the print into the second fixer bath and agitate for three to five minutes.

Immediately after fixing, a protective treatment of selenium can be applied simultaneously with the hypo-clearing bath. (If gold is to be used instead, as the protective coating, follow the procedure shown on pages 80-83.) Mix about 1½ ounces of selenium toner concentrate in a gallon of a prepared solution of hypo-clearing agent, and pour some into a tray; agitate the print in it for three to five minutes, then rinse for a minute. The print now is washed, either in special washer *(far right)* or in a siphon-equipped tray that provides a complete change of water every five minutes. Continue washing for about an hour; stop when the standard test *(preceding pages)* detects no residual fixer.

Even though the test indicates all fixer is gone, a trace remains and must be eliminated with a bath that is mixed just before use. Mix 16 ounces of water with 4 ounces of 3 per cent drugstore hydrogen peroxide and 3¼ ounces of dilute ammonia solution (one part 28 per cent drugstore ammonia mixed with 9 parts water). Be careful with this working solution. It must be kept in an open container—if closed, gases created could crack the bottle. Agitate the print in a tray of this solution for six minutes, rinse, and wash for 20 minutes.

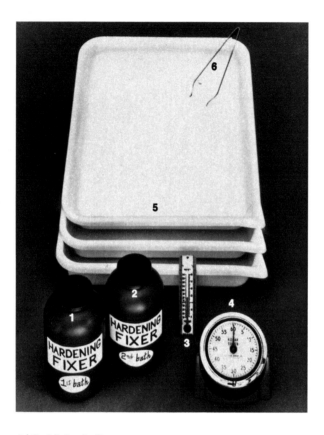

1	first fixing bath
2	second fixing bath
3	thermometer
4	timer
5	three trays
6	tongs

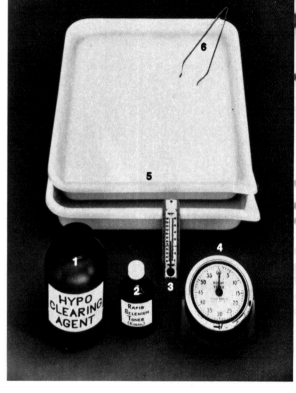

1	hypo-clearing agent
2	selenium toner concentrate
3	thermometer
4	timer
5	two trays
6	tongs

To clear away the residual chemicals that may harm images, this special washer bathes each print in its own vertical compartment with water circulating on both sides. The washer is made by the East Street Gallery, Grinnell, Iowa, a firm that also makes a special film washer (preceding page) and dryer (overleaf). The compartments reduce the chance of damage—the prints remain stationary during washing. They also keep the prints from touching and allow new ones to be added without their chemicals contaminating those already being washed.

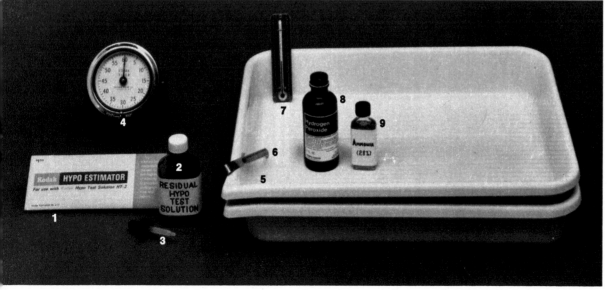

1	hypo estimator stain sheet
2	residual hypo test solution
3	dropper
4	timer
5	two trays
6	tongs
7	thermometer
8	3 per cent hydrogen peroxide
9	28 per cent ammonia

The Importance of Drying

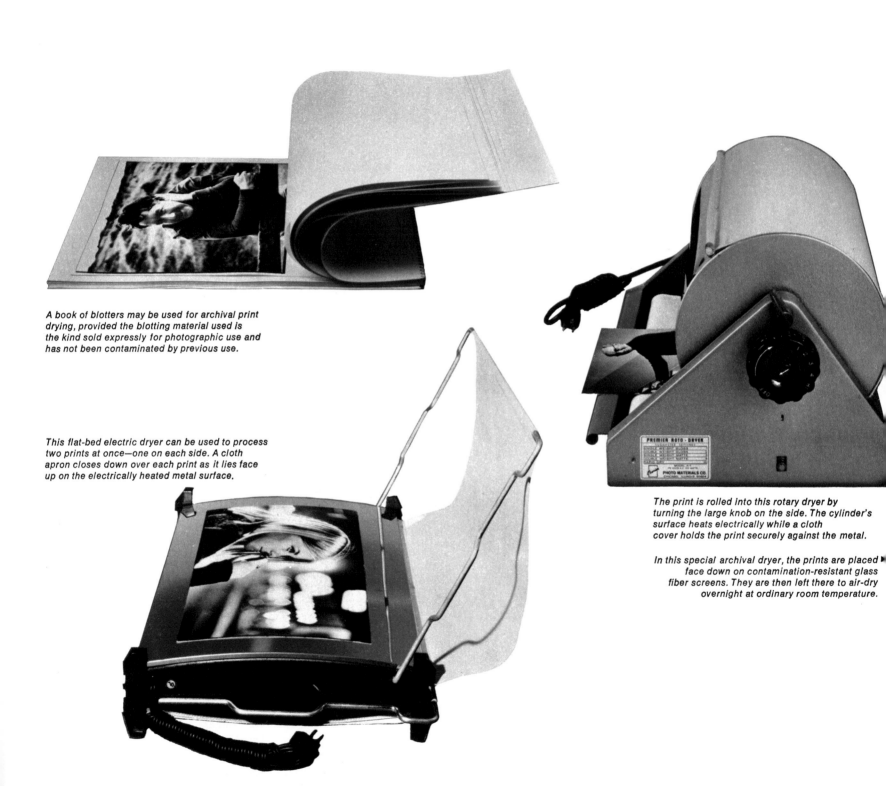

A book of blotters may be used for archival print drying, provided the blotting material used is the kind sold expressly for photographic use and has not been contaminated by previous use.

This flat-bed electric dryer can be used to process two prints at once—one on each side. A cloth apron closes down over each print as it lies face up on the electrically heated metal surface.

The print is rolled into this rotary dryer by turning the large knob on the side. The cylinder's surface heats electrically while a cloth cover holds the print securely against the metal.

In this special archival dryer, the prints are placed ▶ face down on contamination-resistant glass fiber screens. They are then left there to air-dry overnight at ordinary room temperature.

Even drying requires special care if a print is to be safeguarded against deterioration. The special dryer above can avoid many problems. But any standard equipment can be satisfactory if it is properly used.

The cloth aprons and belts of electri-cally heated dryers *(left)* should be thoroughly washed to prevent harm from chemicals that may have accumulated in the fabric. Also, these electric dryers must be adjusted to the lowest possible temperature setting, since excessive heat will dehydrate prints, mak-ing them brittle and altering tones. If blotters are employed, they should be of high-quality acid-free material without inherent impurities; most blotters made for photography are of this quality, and some bear labels indicating they are acid-free.

An Impervious Plating of Gold

1 | distilled water
2 | sodium thiocyanate
3 | tray
4 | gold chloride 1 per cent stock solution
5 | gold chloride crystals
6 | balance scales
7 | graduate and glass stirring rod

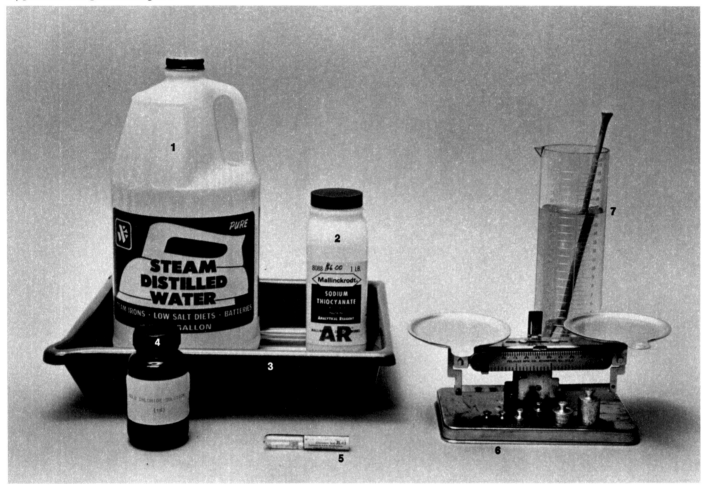

Even photographs that are processed with great care can be attacked by chemicals in their surroundings—such as pollutants in the air and also image-damaging ingredients in the materials used for storage. But for a few cents a print, there is a way to ward off these external assaults. It is a modified version of the gold-toning process once commonly used to give prints a rich tint of brown or blue-black. (When used as a protective measure, the gold-toning treatment need not alter color.)

The gold-protection treatment is applied after processing *(pages 74-77)* but before drying, while the pictures are still wet from washing. In effect, it plates the silver image with gold, a metal that resists virtually all chemical change. While most often used to protect prints, it can also be used to preserve negatives. The gold solution used here is Kodak's GP-1, but similar formulas, such as GAF231 and Ilford IT-4, are also suitable for this process. GP-1 is a mixture of water and two com-

pounds obtainable from chemical supply houses: gold chloride and sodium thiocyanate. These materials require caution, for sodium thiocyanate is a poison if taken internally.

The solution is prepared in four steps described on the opposite page, the last three of which should be done just before using. But the first step, the making of the gold stock solution, can be completed in advance—if the solution is then stored in an amber bottle to prevent light-caused deterioration.

1 | make the stock solution

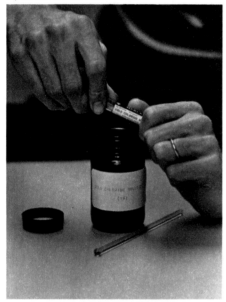

Add the contents of a 15-grain vial of gold chloride to three ounces of distilled water in an amber bottle and stir until dissolved.

2 | mix stock solution and water

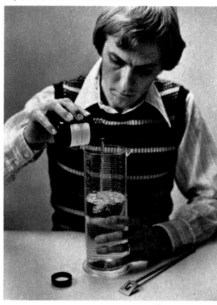

To 24 ounces of tap water measured in the large graduate, add 2½ drams of the gold chloride stock solution and stir well.

3 | prepare sodium thiocyanate solution

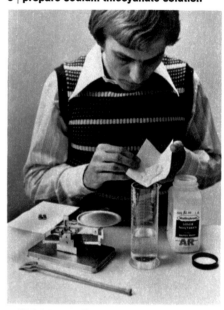

Weigh 145 grains of sodium thiocyanate on the balance scales and add it to four ounces of tap water measured in a second graduate. Stir well.

4 | make the working solution

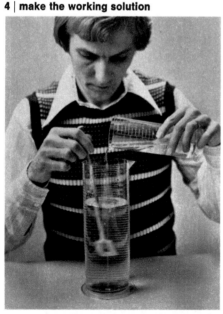

Stir the four ounces of sodium thiocyanate solution into the diluted stock solution prepared in step 2. Add enough water to make 32 ounces.

5 | treat the print

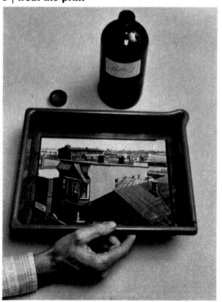

Immerse the washed print—while it is still wet—in working solution. Agitate it for about 10 minutes, or until the image is barely bluish black.

6 | wash the toned print

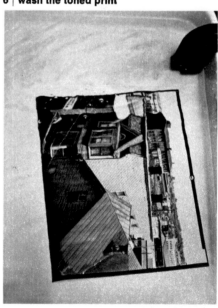

After rinsing the treated print in running water for 10 seconds, wash it in a siphon-equipped tray for 20 minutes; air-dry it thoroughly.

To give this print maximum protection for long life, it was treated with a gold solution, following a procedure (pages 80-81) that was designed to emphasize preservation. The resulting print is not visibly different from an untreated one.

Gold compounds shield a photographic image against deterioration, but they can also. give the picture an attractive tint. The process is then called toning. Examples of both uses are shown here, applied to prints from the same negative. The print above was treated with a solution called GP-1; its tonal values remain unchanged, but it has gained maximum protection against future deterioration. The print to its right was given an overall deep neutral brown tone by immersing it in Kodak Gold Toner T-21. Like other gold solutions,

GEORGE A. TICE: *Rooftops*, Paterson, New Jersey, 1969

this formula provides protection for the image, but it does not give as much protection as solutions such as GP-1.

Other gold toners can produce tones ranging from deep blue to fiery red, the color depending partly on the toners, partly on the printing paper and partly on the duration of treatment. Gold protective and toning compounds are not readily available in packaged form, but the necessary chemicals are widely sold and formulas can be found in publications such as the Photo-Lab-Index and Kodak Pamphlet G-23.

The brown tone of this print was produced with a gold solution used principally for the tinting effect, although protection is also given. Both this print and the one on the opposite page were made on neutral semi-matte printing paper.

Chemical Toning for Appearance

Although the gold treatment described on pages 80-81 gives prints the greatest degree of protection, gold is not the only substance that can be useful for this purpose. Compounds of other elements, while primarily intended to impart pleasing tints, also guard photographs against the effects of time and the destructive chemicals they may come in contact with.

Some of the most common of these compounds contain sulfur or selenium. These compounds convert the silver into more stable and permanent chemical complexes (a selenium protective treatment is described on pages 76-77). Many of these toning compounds can be purchased in packaged concentrate form in photography stores, and are inexpensive and easy to use.

A wide variety of tonal changes is possible, depending not only on the toner selected but also on the degree of dilution of the concentrate, the type of printing paper used, the length of time the print is in the toner, and even the conditions of earlier stages of processing. A sampling of the effects attainable is indicated by the pictures reproduced here, all made by George A. Tice and printed on the same paper.

GEORGE A. TICE: *Tombstone, Catherine Holland,* Bodie, California, 1965

For the warm reddish-brown tone of this quiet Western scene, Tice used Kodak Poly-Toner, which contains both sulfur and selenium. The bottled concentrate was diluted to a weak 1:100 ratio; a stronger solution gives browner tints.

Picnic on Garret Mountain, Paterson, New Jersey, 1968

The soft brownish tinge of the family portrait above gives skin tones a pleasingly natural look. They were achieved with Kodak Brown Toner, a sulfur compound, diluted in a 1:32 ratio. A stronger concentration gives a browner tint.

Roaring Fork River, Aspen, Colorado, 1969

A mountain stream was toned a deep purplish brown in Kodak Rapid Selenium Toner, which was diluted in a 1:12 ratio; a variety of other tones can be achieved by using different printing papers.

85

Durable Beauty in Images of Platinum

Around the turn of the century, some of the most beautiful photographic prints ever made were produced on platinum paper, which has a light-sensitive coating that contains no silver and produces an image of platinum metal. Its subtle gradations of tone and delicately smooth, glare-free surface give unsurpassable clarity and depth. And since platinum is immune to almost all chemical action, the images are virtually indestructible. The process was little used for decades because of the scarcity (and cost) of platinum, but now it is being revived, partly for its beauty, partly for its durability.

The revival of platinum printing is being stimulated by a reawakened interest in the work of a Victorian master of the technique, Frederick H. Evans, who was a London bookseller-turned-photographer. Evans is best remembered for his photographs of architecture, which he made into platinum prints and also into lantern slides for use in illustrated lectures that he gave.

New prints from Evans' original negatives can no longer be made—after his death his widow, for reasons of her own, had all his glass-plate negatives destroyed. Recently, however, an American photographer, George A. Tice, happened upon a collection of Evans' lantern slides that somehow had survived. To reproduce these pictures in the way Evans would have, Tice has worked out a platinum printing method that can be used for any photographs.

The paper must be homemade by coating some commercial chemicals onto high-grade writing paper, but the process is easy to carry out and the materials for it are relatively inexpensive —about two dollars pays for one print.

The lantern slide of the tomb of King Edward II at right is one in a wooden box of glass slides (above) made around the turn of the century by Frederick H. Evans and now owned by photographer George A. Tice; from them Tice produces stunning prints by a platinum printing process similar to Evans' own. Evans' handwriting on the box lid gives his name and address.

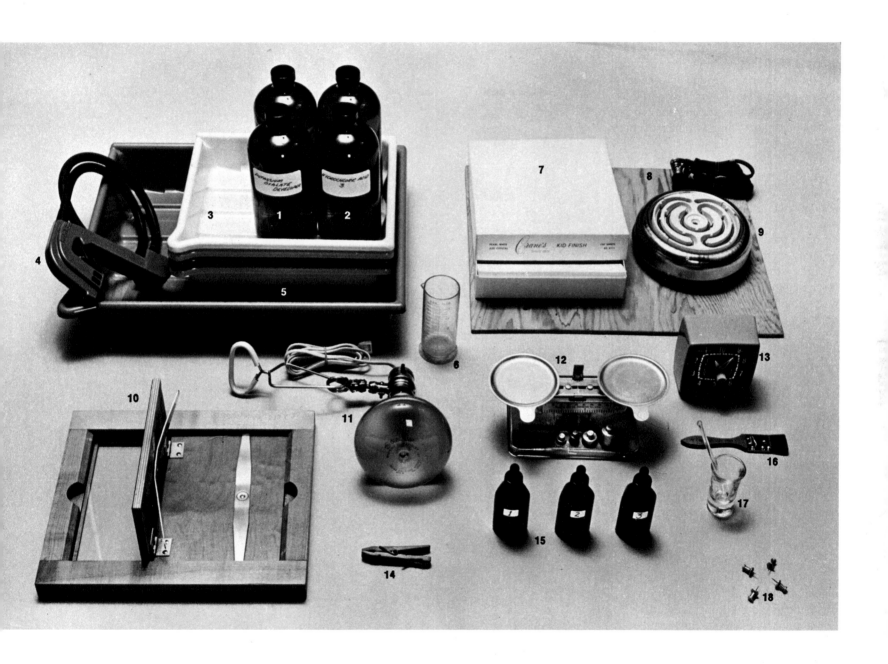

1	potassium oxalate solution	**7**	100 per cent rag paper	**13**	timer
2	hydrochloric acid solution	**8**	board	**14**	clip
3	four trays	**9**	hot plate	**15**	three sensitizer stock solutions
4	siphon	**10**	contact printing frame	**16**	camel's-hair brush
5	washing tray	**11**	sun lamp	**17**	glass and stirring rod
6	graduate	**12**	balance scales	**18**	pushpins

The first step in the platinum printing process is to duplicate the original picture in an enlarger, producing a negative of the size desired for the print; the platinum emulsion is so slow that contact rather than enlarged prints must be made. The compounds that will be used to sensitize the printing paper are available from chemical supply houses, but all are poisonous if taken internally; handle them with care. Because they are not very sensitive to light, however, all operations can be carried out with ordinary room illumination.

Three stock solutions are required for the method George A. Tice uses. To make solution 1, stir 8 grains of oxalic acid and 120 grains of ferric oxalate into 1 ounce of distilled water heated to 125°F. To make solution 2, mix 8 grains of oxalic acid, 120 grains of ferric oxalate and 2 grains of potassium chlorate into 1 ounce of 125°F. distilled water. To make solution 3, mix ¼ ounce of potassium chloroplatinite into 1¼ ounces of 125°F. distilled water. These stock solutions may be stored in amber dropper-capped bottles.

The light-sensitive coating for the paper is made by adding 24 drops of solution 3 to variable amounts of solutions 1 and 2, the proportions depending on the contrast desired in the print. Experiment to arrive at an appropriate mix. For an average print, use 14 drops of solution 1 and 8 drops of solution 2. For a print with greater contrast, decrease the amount of solution 1 and increase the amount of solution 2 to a proportion of 10 to 12 or even zero to 22. For less contrast, increase the amount of solution 1 used and decrease solution 2 to a proportion of 18 to 4 or even 22 to zero.

1 | make the negative

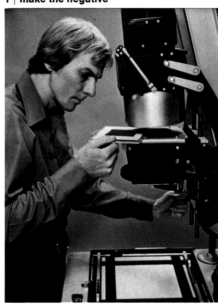

Since the final print will be the exact size of the negative, an enlarged negative must be made —in this case by blowing up a lantern slide.

2 | process the negative

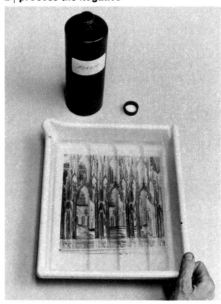

Develop the negative in the normal way, but to ensure its longevity, use the methods shown on pages 74-75 for other steps in processing.

3 | mix the stock solutions

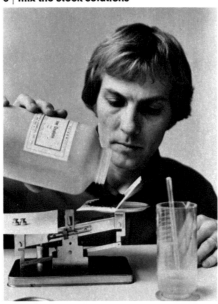

To prepare the three stock solutions for the sensitizer, weigh the ingredients on a balance scale and mix as explained in the text at left.

4 | make the sensitizer

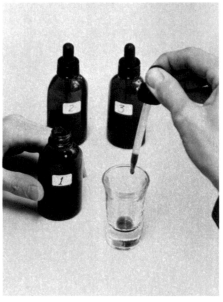

Using droppers, measure the appropriate number of drops of the three stock solutions (text) into a glass, stirring after each is added.

5 | sensitize the paper

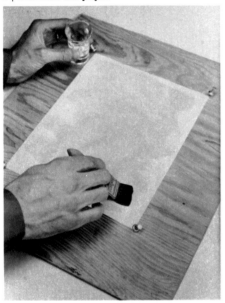

Tack the paper to a board; pour the sensitizer over it and spread the liquid evenly over the surface with a damp camel's-hair brush.

6 | air-dry the paper

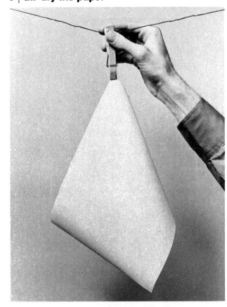

Hang the sensitized paper by a corner from a suspended clip. It takes about 10 minutes to be sufficiently dry for the next step.

7 | heat-dry the paper

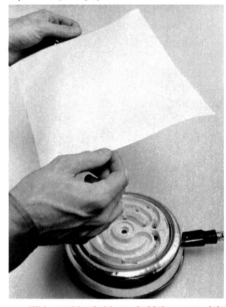

With sensitized side up, hold the paper eight inches above a hot plate for 1½ minutes. When fully dry, it will be a yellow-orange color.

The paper to be sensitized should be a very high-quality 100 per cent rag. After coating it with the sensitizing mixture, cut unneeded sections from the margins to use as test strips for trial exposures, which are made in the customary way. Exposure can also be judged while the print is being made, since a faint yellowish image begins to appear before development.

Platinum paper is developed in a solution of potassium oxalate: one pound dissolved in 48 ounces of 68°F. water. After development is complete, the image is no longer sensitive to light and fixing is not required. Residual chemicals are removed in baths of dilute hydrochloric acid; prepare three separate baths of it from a solution of 1 ounce commercial hydrochloric acid in 60 ounces of water.

8 | prepare to expose

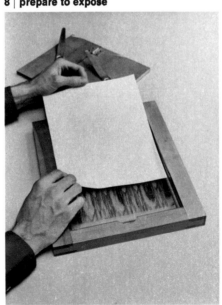

With the paper trimmed to size, place the sensitized surface against the negative; then close both inside the contact printing frame.

9 | make the exposure

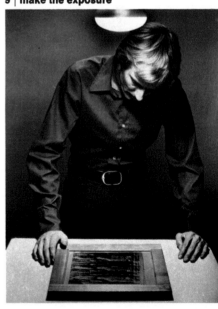

To expose, the frame is put negative side up under a sun lamp that has been heated for two minutes. Direct sunlight can also be used.

10 | check the exposure

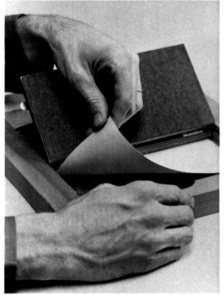

Open the frame and lift a corner of the print to judge the forming image. An average print requires an exposure of about 25 minutes.

11 | develop the print

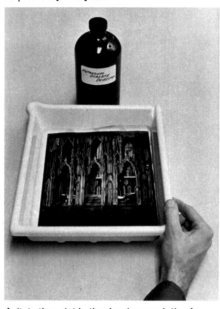

Agitate the print in the developer solution for two minutes at about 68°F. The resulting image will be permanent—and needs no fixing.

12 | clear the residual chemicals

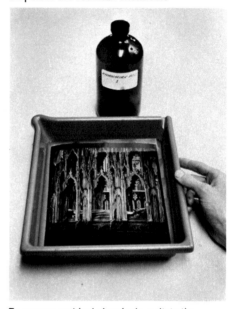

To remove residual chemicals, agitate the print for five minutes in each of the three dilute hydrochloric acid clearing solutions.

13 | wash the print

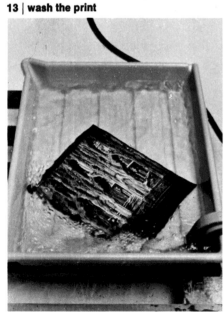

Wash the print for 30 minutes in a tray with a siphon. Adjust water flow for a complete change of water in the tray every five minutes.

14 | dry the print

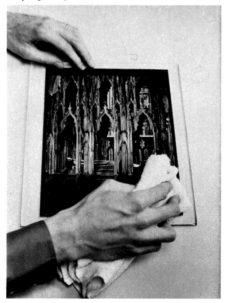

With the print on a clean, hard surface—such as a countertop—blot excess water from face and back with a soft cloth towel. Allow to air-dry.

15 | flatten the print

When the print is dry, it can be flattened by placing it between two sheets of mounting board in a dry-mounting press; use low heat.

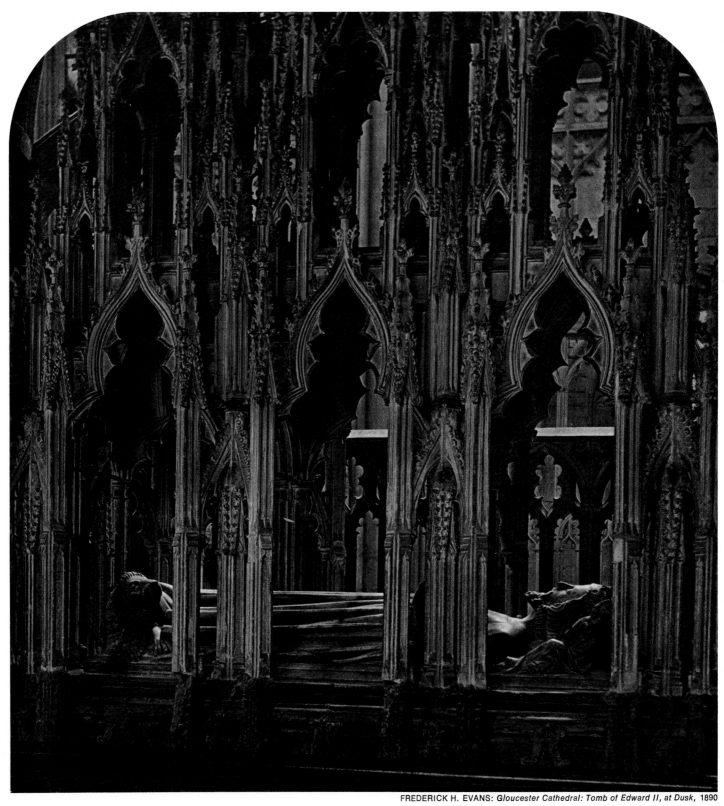

FREDERICK H. EVANS: *Gloucester Cathedral: Tomb of Edward II, at Dusk,* 1890

FREDERICK H. EVANS: *Kelmscott Manor: in the Attics, 1897*

The wood-beamed attic of an Elizabethan manor house shows how the photographer was able to create an artistic study from the simplest of subjects. The subtle play of light and shadow, the austere lines of the construction and the almost palpable textures revealed in this platinum print, which was made by George A. Tice from one of Evans' lantern slides, indicate the delicacy that can be attained with the process.

The fine detail possible in a platinum print can be ▶ seen in this view of the famous medieval Cathedral in Lincoln, England, printed by Tice from an Evans glass slide. In the platinum print itself, the sharply delineated bricks of the houses and the Cathedral stonework, muted by wisps of smoke rising from the chimneys, create an astonishing three-dimensional effect that is only partially conveyed when reproduced on a book page.

FREDERICK H. EVANS: *Lincoln Cathedral: From the Castle*, 1898

Preserving Color in a Black-and-White Record

the original transparency

A 35mm color transparency provided the starting point for the dye-transfer print shown on page 96. The colors of the original—made in 1967 in Ecuador by Douglas Faulkner—will surely fade in time, but their primary hues can be recorded and stored in black and white on separation negatives, and from these negatives an accurate, full-color print can be produced whenever necessary.

Because color photographs are formed from dyes, and even the best dyes fade, the life expectancy of color pictures is limited. There is, however, a method of preserving a permanent record of the colors of an image, and from this re-creating the original in a print made by the "dye-transfer" process.

The permanent record is in black and white—a negative for each of three primary colors that constitute the many shades in the picture. From these "separation" negatives a color print can be reconstructed at any time, since black-and-white negatives—if properly processed by the methods explained on pages 72-75—last indefinitely.

The making of the separation negatives and their use in reconstructing the original image is a job generally left to professionals, for it requires special film and camera equipment. The technique itself, however, can be easily explained. The first step is to make the separation negatives: this is done by copying the color original on sheets of 8 x 10 black-and-white film. Each negative is made through a filter in one of the three primary colors—red, green and blue. The red filter screens out all but the red tones in the original, resulting in a black-and-white record of the original's reds; the blue and green fil-

ters similarly provide black-and-white records of blues and greens.

To re-create the original colors in a dye-transfer print, these negatives are used to make positive enlargements on special gelatin-emulsion film known as matrix film. When the film is developed, the portions of the emulsion struck by light become hard and insoluble, while those unaffected remain soft and can be washed away in hot water. The result is a photographic relief, a kind of flexible printing plate, in which the raised areas form the image. Actually, they do not represent the color transcribed onto the separation negative, but the areas from which that color is absent. In other words, the matrix made from the "red" separation negative now represents the complement of red, cyan; the matrix from the "green" separation represents green's complement, magenta; that from the "blue" represents blue's complement, yellow.

For printing, each matrix is immersed in a dye of the appropriate color: the cyan matrix in cyan dye, and so on. The matrices are pressed, one at a time, onto a special printing paper that absorbs the dyes from the raised surfaces, and the superimposition of the three dye images produces a replica of the original color picture.

The dye-transfer process for making color prints ▶ requires six ghostly versions of the original: three black-and-white negatives, one for each primary color (top row), and three matrices enlarged from the separation negatives to the size of the final print. Each matrix prints the complement of its negative's primary color (bottom row) to re-create the original color image (overleaf).

red separation negative green separation negative blue separation negative

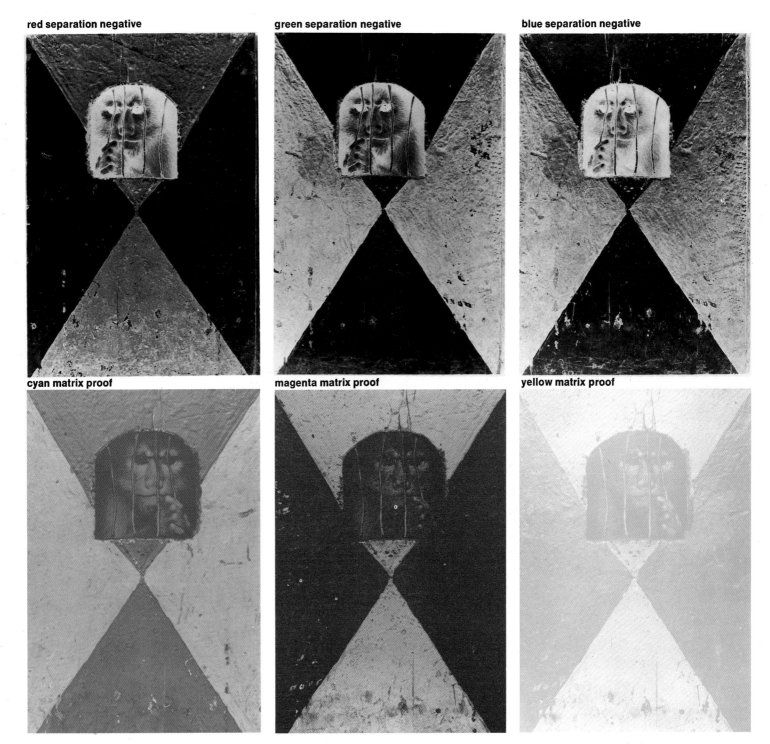

cyan matrix proof magenta matrix proof yellow matrix proof

the dye-transfer print

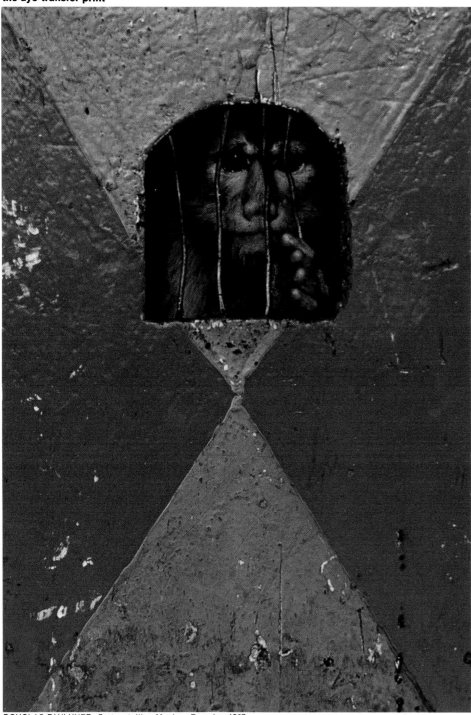

In a dye-transfer print made from separation negatives of the transparency on page 94, the bold hues of a painted cage frame the face of a monkey that tells fortunes with cards. The print will eventually fade, just as the original will—but a new, true-color print can be made at any time, since the black-and-white records of the original colors in the separation negatives can be as permanent as any black-and-white picture.

DOUGLAS FAULKNER: *Fortunetelling Monkey,* Ecuador, 1967

96

Indexed photographs can be stored in a variety of ▶ ways. The best method of keeping related transparencies together is to leave them in the slide holders, either straight tray or carousel. For other transparencies or prints, use plastic sheets that are perforated for insertion into binders.

An Easy-to-Use Filing System

Indexing photographs is a chore to most photographers, even the professionals. Mark Kauffman, when he was a LIFE photographer, was approached by an enterprising former colleague who was starting her own picture agency. Kauffman agreed to let her represent him, but when she asked for his collection of photographs, Kauffman descended to the basement of his home and emerged with two shopping bags haphazardly packed with loose transparencies. In order to find out exactly what pictures Kauffman had, his new agent had to sort them all out and index them. Once she had accomplished this drudgery, she began to make extra money from pictures Kauffman had forgotten he even possessed. Not only had the disorganization cost Kauffman income, but also by putting his photographs in paper bags he had run the risk of damaging them. Over the years, paper, cardboard and untreated wood give off chemicals that can interact with the silver in a photograph and hasten the fading process.

This is not an isolated incident. A great many photographers, professional and amateur, regard filing and storage as a baffling and disheartening experience, one to be delayed or avoided indefinitely. Yet the ability to locate pictures increases the pleasure—and often the profit—a photographer gets from his work. And correct storage preserves them. When done systematically, indexing and storing photographs can become as automatic a process as keeping track of the exposures on a roll of film.

One thorough and reliable indexing system has been perfected by the Time Inc. Picture Collection. It is a more ambitious operation than most photographers would attempt by themselves, but the basic idea is applicable to any private collection. Some 3,500 pictures pour into the Time Inc. collection every week from photographers on assignment all over the world for the company's many publications. It also receives from the major wire services thousands of news photos a week and picks up hundreds of other photographs from the important picture agencies. In all, it has access to 18 million pictures, making it the largest indexed picture collection in the world.

Under the Time Inc. system a special number is given to each assignment undertaken by a photographer. This "set number" is stamped on every picture and on any research or caption material relative to the assignment. The set numbers run chronologically. Number one was stamped on the pictures taken in 1936 for a photographic essay on Texas by Carl Mydans—the first assignment made by the editors of the newly founded magazine LIFE. Thirty-five years later the set numbers were in the high 80,000s and were headed rapidly toward 90,000.

When the set is numbered and ready for storage, its parts are segregated according to type of image: negatives, contact sheets, prints and color transparencies each have their own metal cabinets. In these cabinets everything

The front and back of the cardboard mount are used to identify and describe this transparency filed by the Time Inc. Picture Collection. On the back (top) is the set number, used for all photographs taken on the same assignment, and the division of the company that assigned the work—BKS, an abbreviation for TIME-LIFE Books. The typed label notes in which book and on which page the picture appeared, while the grease pencil mark at lower left indicates that the slide is to be kept and the "F" at upper right shows that it has been filed. On the front side (below), the handwritten phrase describes what the picture is about and where it was shot.

is filed in succession according to set number. For ease in handling and storage, negatives are cut into strips of five exposures each and slipped into protective sleeves.

But a filing system is only as good as its retrieval system. To pull the pictures from the files, a comprehensive cross-reference method is used. There are about 4,000 main headings—such as ACCIDENTS, ANATOMY, ART, and geographic location headings. Each of these is usually augmented by subheadings, and sometimes sub-subheadings. These in turn are supplemented by cross references. For example, under "ANATOMY, Bones" is the listing "see also MEDICINE, Bones."

The notations on the transparency on page 101 illustrate how this filing system operates. The transparency came into the collection as part of a 1970 assignment in Bulgaria for a volume in the TIME-LIFE Foods of the World series. On the cardboard mounting of the transparency is the set number, and a phrase that explains what the picture shows, in what publication it was used and on what page it appeared.

The transparency, with 81 others taken on the same assignment, is filed in the picture collection under its set number. The picture is also indexed under five different subject headings: MARKETS-BULGARIA; AGRICULTURAL PRODUCE-VEGETABLES-PEPPERS; BULGARIA-PEOPLE & CUSTOMS; RELIGIONS-ORTHODOX EASTERN-CLERGY-BULGARIA; and VENDORS. Each card includes brief references to those pictures that are related to its subject heading—for example, "An orthodox Eastern priest selects red hot peppers for his basket at open market, Gabrova." All the cards also carry the set number, the photographer's name, the date the picture was taken and that of the publication in which it was used.

Simply by looking through the card index, a researcher can get a good idea of what pictures are on file. And one of these photographs made for a cookbook may serve a totally different purpose in a magazine story about Bulgaria or Eastern Orthodoxy. The researcher looking for pictures in one of the latter categories will be led to it by the cross references in the file.

Most photographers will not need as comprehensive an index system as the one used by Time Inc. Professionals who specialize will require appropriately specialized headings. Amateurs will want to use generalized, personalized headings. It is wise to employ as few separate headings as possible—perhaps only FAMILY; PEOPLE-FRIENDS AND ACQUAINTANCES; EVENTS; PLACES; SPECIAL INTERESTS and MISCELLANEOUS. Under FAMILY would be filed not only pictures of close relatives but also all photographs of the home and household. PEOPLE might include pictures of friends, neighbors and visitors as well as interesting strangers who caught the photographer's eye. EVENTS are birthday parties, graduations, confir-

The room containing the Time Inc. Picture Collection is shown in slight distortion, caused by joining two wide-angle photographs. The deep-drawer cabinets (center and right) hold the photographs on file, while the card index is located in the small-drawer cabinets behind them. The circular staircase in the center background leads to the editorial offices of LIFE.

mations, Fourth of July celebrations, etc. PLACES would include pictures made while visiting—from a national park to the grandparents' house. What fits under the SPECIAL INTERESTS heading would depend on the individual photographer's pet subject—nature, cityscapes, abstract patterns, sports events. MISCELLANEOUS, of course, includes all those pictures that defy categorization under the other headings.

With all the photographs separated by general subject, they might now be divided according to, say, the relation of the FAMILY member, the name of the person under the PEOPLE heading, the time of the EVENT, the location of the PLACE, the subject of SPECIAL INTEREST or the MISCELLANEOUS item; further breakdowns might be dictated to some extent by the journalist's yardstick of "who, what, when, where and why." With the photographs thus differentiated, a set number can be assigned to each separate group of pictures. The set number should then be keyed to a file card containing a brief description of the photograph, the time it was taken and any other important information. But before arranging the cards in their file, the photographs should be studied once more for purposes of cross referencing so that the photographer can always find the picture he wants.

Here, for example, is how the pictures taken at Suzie's fifth birthday party at the summer cabin would be filed, with cross references. First, all the pictures of the event would be given the same set number, say, 421. Then four cards would be made out for cross referencing. Under the heading FAMILY would be a card titled "Suzie, fifth birthday party at summer cabin, June 21, 1972. Set number 421." A second card would go under the heading PEOPLE-FRIENDS AND ACQUAINTANCES; the entry would read, "Smith, Joey. At Suzie's fifth birthday party at the summer cabin, June 21, 1972. Set number 421." The card in the section EVENTS would read, "Birthday parties, Suzie's fifth at the summer cabin, June 21, 1972. Set number 421." Finally, under the PLACES section would be this card, "Summer cabin. Suzie's fifth birthday party, June 21, 1972. Set number 421."

Once this type of system is established, the photographs can be filed in cabinets according to their set number, and the cards can be filed in separate index boxes labeled with the general headings. By consulting the cards in the index files the photographer will easily be able to find the pictures of Suzie—or the summer cabin or even little Joey Smith. He simply gets the set number from the index card and pulls the pictures with that number from the files. The photographer may have to check through the 20 or 30 pictures in each set, but that is far easier than rummaging through an unindexed pile of photographs that have been tossed at random over the years into old boxes or shopping bags.

There are several tricks a photographer can use to make his filing work

An illustrated card, such as the one made of a LIFE photograph for the picture collection (above, right), gives an example of the pictures in a black-and-white set. Anyone can make a similar card by gluing a picture cut from a contact sheet to a card bearing the set's number and an appropriate heading. For transparencies, use an index system such as the one described on pages 104-105.

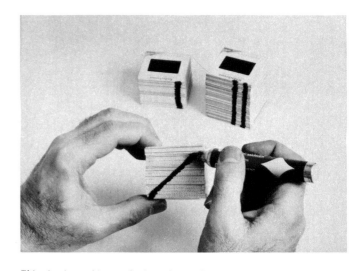

This simple marking method can be used to rate the transparencies in a collection. The top-quality pictures are stacked together and marked with a single line; the stack of second-quality transparencies receives a double line. Pictures that go in sequence as part of a slide show, for example, get a diagonal line, which serves as a guide when they must be reassembled in order.

easier. The Time Inc. Picture Collection occasionally attaches pictures to the file cards to give an idea of the type of photographs contained in a set—a device the home photographer can also employ. And there are special marking methods that make transparencies easy to categorize *(page 104)*.

Perhaps the best way to simplify the indexing chore is to weed out incorrectly exposed and low-quality pictures ruthlessly at the time the set is filed. If there are many shots of the same subject, each bracketed with slightly different exposures, only the best should be kept. The photographer must be stern with himself here, editing his own collection to reduce its size. If he does not stick with his finest pictures, the others will merely clutter up the file and require excessive storage space.

After the photographs are weeded out and properly indexed, they must be stored in a safe place. Some professionals, fearing loss of their originals through fire or theft, actually keep them in safe-deposit boxes in bank vaults. But even in that secure haven, a photograph can be damaged if it is stored in the wrong kind of box or envelope.

The list of materials that can harm photographs is a long one and it includes many things that photographers regularly use for storage. Cardboard boxes will give off, through the years, discernible amounts of gases and peroxides that tarnish the silver in the film, causing fading and loss of picture detail. Brown kraft paper envelopes, often used to hold prints, negatives and even transparencies, and the glassine sleeves regularly employed to protect negative strips, are both made of a low-grade fiber that can gradually affect the film's silver. The brown paper contains lignin and such additives as aluminum sulfate, which accelerate the fading of the image. Similarly, additives in the glue in the seams of some envelopes can cause discoloration and bleaching if they get too close to the emulsion of a picture. Most adhesives can damage pictures. Rubber bands wrapped around transparencies or rolls of film contain sulfur compounds that can turn the silver image brown or yellow even when the photographs are in envelopes. And some plastics intended to protect negatives or transparencies may in fact mar the emulsion.

Photographs are also susceptible to the peroxides in most bleached and uncoated woods, such as the boards used for shelving. The solution is to paint the shelves—but since photographs are also sensitive to new paint, the shelves should not be used for storing pictures until about a month after they are painted. High humidity and temperatures are also detrimental to photographs; both conditions hasten corrosive chemical activity. Air pollutants can be even more damaging. The pages that follow contain advice on how to avoid these dangers, to assure safe as well as efficient storage of the photographer's most prized possessions: his pictures. □

How to Keep Negatives

Care in storing and preserving any collection of black-and-white pictures must begin with the negatives. Since the emulsion is particularly susceptible to the gases given off by cardboard boxes, low-grade paper envelopes and adhesives, the negatives must be carefully protected. This can most easily be done by slipping them into polyethylene transparent holders which can be secured in vinyl binders. There are some acid-free paper envelopes, but they are difficult to find.

It is also wise to store negatives in a filing cabinet, if only for easier retrieval. But the cabinet should be made of steel, and its finish should be of baked enamel—the pernicious effects of the paint's resins and peroxide are eliminated by the baking process. A deep drawer file *(near right)* can accommodate contact sheets, along with any size of negative. The more compact cabinet next to it is made for strips of 35mm negatives. The drawers in both cabinets are labeled with subject headings.

The polyethylene holder *(far right)* is also exclusively for 35mm negatives. The plastic resists moisture and will not decay or grow misty with age. Furthermore, contact sheets can be made of the negatives without removing them from the holder. For storage, the contact sheets can be perforated along one side and attached in the vinyl binder.

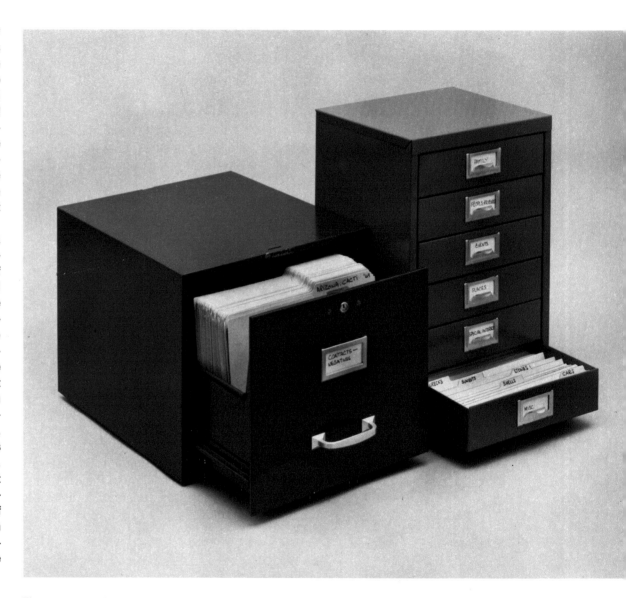

These are two of the many baked-enamel steel cabinets that can be used for storing negatives. The desk-top file (left) is a regular office model, its 10-by-12¼-inch capacity large enough to hold contact sheets and negatives of any size. The narrow file, made expressly for 35mm negatives (right), can hold up to 2,100 frames per drawer.

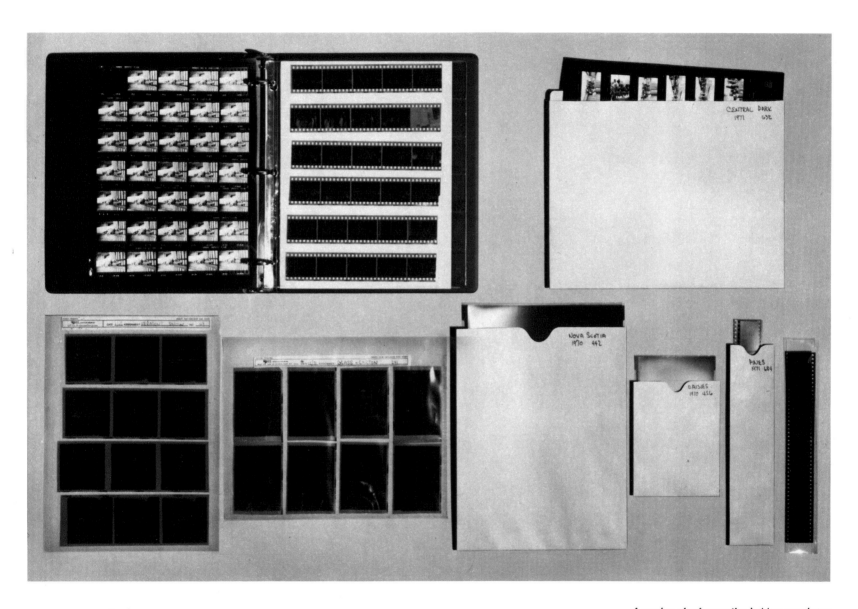

A number of safe negative holders are shown here. Polyethylene transparent sleeves for strips of 35mm negatives fit into a vinyl binder (top, left). Contact sheets with holes punched in them will also attach in the binder. At bottom left are polyethylene holders with negatives inserted. At top and bottom right are acid-free envelopes —except in the bottom right-hand corner; this is a cellulose acetate sleeve for 35mm negatives that comes in long strips that can be cut to any length.

How to Keep Prints

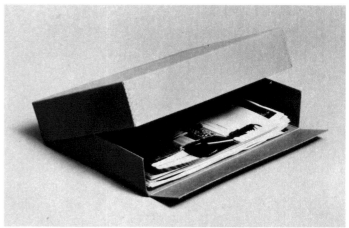

This print-storage box is made of heavy-duty acid-free paper. It is bound by metal clips, without adhesives that can cause trouble. The boxes come in different sizes, but should be packed full when stored vertically, so the prints will not curl.

Three materials that are safe for holding prints are shown here. A cellulose acetate holder, with an edge punched to fit a binder, is at top left. Beside it is a side-seam, acid-free paper folder. Below them is an acetate sleeve for prints or negatives.

Steel cabinets are as important for storing prints as for keeping transparencies and negatives. Sunlight fades and bleaches color prints, and the gases in some papers and cardboards can alter the images in black-and-white photographs. Yet even when enclosed in metal, the prints are not immune from harm. They should be protected with plastics or acid-free interleaving papers. Some of the best are shown here.

Cellulose acetate is regularly employed as an interleaving material. Light and stable, it is a low-cost thermoplastic that is also used as the flexible backing of most commercial films. Another convenient interleaving sheet is the black paper that is used by commercial film concerns to wrap enlarging papers. Cut into the proper sizes, and placed between color prints, black paper helps keep out light.

Several harmless materials for interleaving and filing prints are arrayed here. The interleaving materials are cellulose acetate (any size can be cut from the roll), acid-free tissue paper (left) and trimmed black enlargement-paper wrapping. The acid-free paper folder is for vertical filing.

How to Keep Slides

An enemy to all photographic materials —and especially to color transparencies—is moisture. In an atmosphere that has more than 60 per cent relative humidity, fungus can form on transparencies. Storage equipment for slides should provide, if possible, for fully circulating air, one of the best preventives of fungus formation. Most standard open plastic and carousel trays and metal slide-storage boxes are specifically manufactured to permit air to circulate. And some of the best compartmentalized vinyl sheets, for holding color transparencies in binders, are designed with grooves that keep the vinyl sheet from pressing against the transparency and locking moisture in.

Another way to lower humidity is to place a container of silica gel, a special drying agent that draws moisture from the air, in the cabinet drawers. But under excessively humid conditions silica gel has to be dried out often because it becomes saturated. It works best for treating moisture-impaired slides. If such slides are placed in an airtight container with a can of silica gel, they will dry out in a few days.

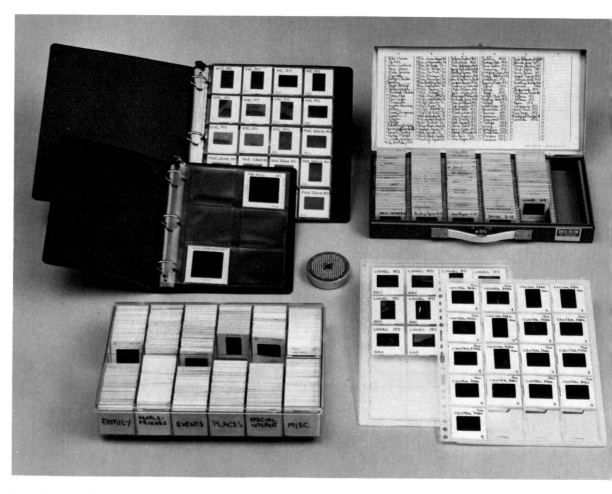

Several types of slide holders, grouped around a container of silica gel, include two sizes of vinyl slide protectors perforated to fit vinyl binders (top left); and, clockwise, a steel portable slide file and two kinds of slide holders—one made of styrene and the other (lying on top of it) made of vinyl. At bottom left is an indexed polystyrene tray.

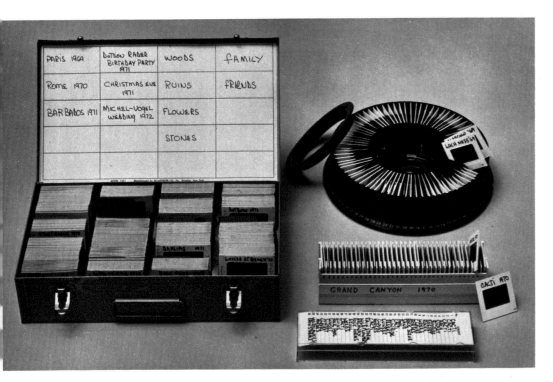

PARIS 1969	DOTSON RADER BIRTHDAY PARTY 1971	WOODS	FAMILY
ROME 1970	CHRISTMAS EVE 1971	RUINS	FRIENDS
BARBADOS 1971	MICHEL-VOGEL WEDDING 1972	FLOWERS	
		STONES	

Slides can be stored safely in metal files; the baked-enamel storage box at top left, which has an index on its lid, is for 2¼-x-2¼-inch slides. Carousels and trays provide for air circulation but must be covered or protected. The carousel at top right holds 80 slides and is numbered on the base for easy identification. The straight tray, with a dust-cover index, holds 36 slides.

Color transparencies can be mounted and protected in many ways. At top left is a snap-together plastic frame with glass slide cover; at right, a polystyrene slide mount. In the next row are a metal and glass binder and a common grayboard mount. Below them are a traditional cardboard slide mount from a commercial film processor (left) and a large grayboard mount. At bottom are two sizes of cellulose acetate protecting sleeves, made without adhesives.

Duplicating Slides for Safety's Sake

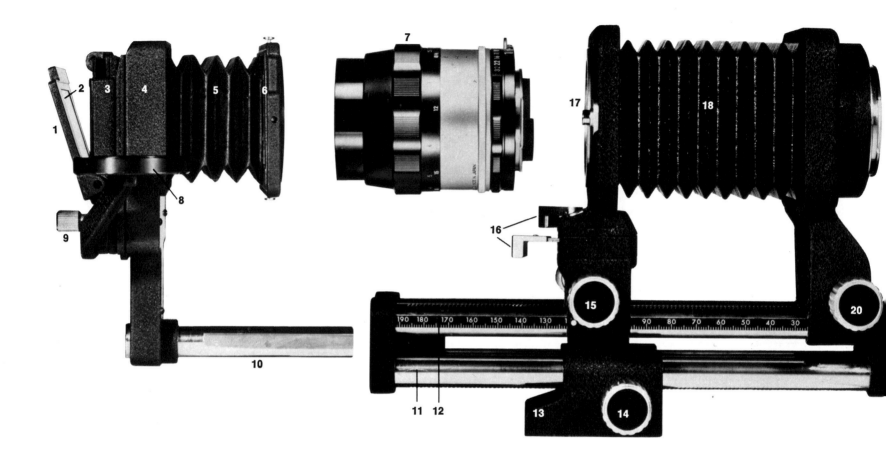

1	hinged opening
2	frosted plate
3	slit for mounted transparency
4	copying adapter
5	bellows of copying adapter
6	lens mount to adapter
7	lens
8	holder for rolled film
9	lock knob for frosted plate
10	rod for attaching adapter
11	base for focusing bellows
12	distance-measuring scale
13	attachment for tripod
14	knob for moving device on tripod
15	left knob for moving bellows
16	bellows locks
17	lens mount to bellows
18	focusing bellows
19	camera mount to bellows
20	right knob for moving bellows
21	camera

Nothing can be so frustrating to the photographer who has carefully stored and protected his transparencies as lending them to someone who damages or loses them. One solution is to make duplicates. And the generally accepted premise that copies are inferior is no longer wholly true. There are methods for making duplicates with almost perfect color fidelity.

There are several types of duplicating equipment. An elaborate machine for copying and color correcting is shown on pages 62-63. At the other end of the scale are devices that cost as little as $20 but are limited in their application. An all-purpose copying de-

vice is shown on these and the following pages. Since it costs over $400 (not including the camera), it is perhaps a better investment for the commercial photographer than for the amateur. Nevertheless, it produces faithful duplicates for about 20 cents a picture; commercial copies, which are often of poor quality, cost about 35 cents—and an expert commercial duplicate can cost up to $40.

This device can be used only with an SLR camera, whose viewfinder shows what the lens sees. The whole assembly, including camera, is so compact that it can be mounted on a tripod. It is extremely flexible as well. It can dupli-

21

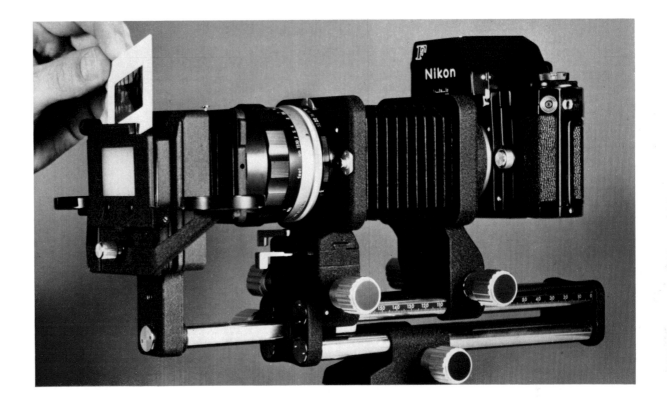

cate transparencies in color when used with appropriate filters *(page 68)* or in black and white, and it can also be manipulated to isolate a detail from an original picture and even enlarge it.

The essential pieces of the device shown here are a bellows focusing attachment, a 55mm f/3.5 lens and a copying adapter. The camera *(above at left on this page)* fits onto the mount on the copying device's bellows focusing attachment *(opposite page, right)*. The lens *(opposite page, center)* fits between the focusing attachment and the copying adapter *(opposite page, left)*, which itself has a small bellows; its chief purpose, however, is to hold the

picture that is to be copied. Mounted transparencies fit into a slot to the left of the adapter's bellows. The adapter also has holders on each side for rolled uncut film strips, and a hinged opening to facilitate threading the film past the frosted window through which the film is lighted for copying.

A transparency larger than 35mm can be copied by framing it in black cardboard, taping it onto a light box, focusing a tripod-mounted camera at it and rephotographing it. For such use, the copying adapter must be removed from the device. The bellows focusing attachment, with its lens, will then bring the original into proper focus.

With the slide-duplicating device assembled, a color transparency ready to be reproduced is dropped into the slide holder of the copying adapter (left). When the slide is in place, the camera is aimed at a light source. Thus the copy is simply a picture of the original transparency.

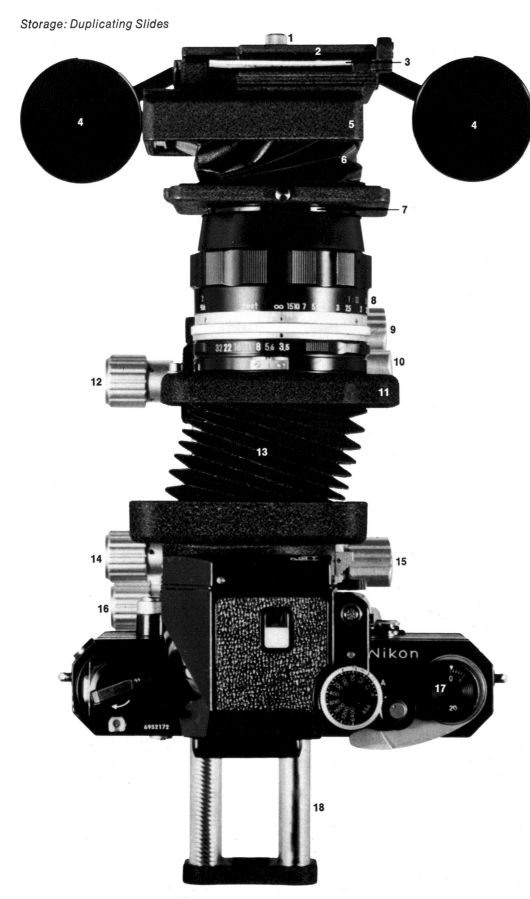

This top view of the slide-duplicating system shows how both sets of bellows can be twisted, allowing the lens to zero in on a given section of the transparency. Without this flexibility in the bellows, the lens would be locked into a straight-on view and detailed blow-ups of a side portion of a transparency (opposite) would be impossible.

1	lock knob for hinged opening
2	hinged opening
3	slit for mounted transparency
4	holders for roll film
5	copying adapter
6	bellows of copying adapter
7	lens mount to copying adapter
8	lens
9	lock knob for copying adapter rod
10	lock for left bellows moving knob
11	lens mount to bellows
12	left knob for moving bellows
13	focusing bellows
14	right knob for moving bellows
15	lock for above knob
16	knob for moving copying device on tripod
17	camera
18	base for focusing bellows

The original picture (left) was a simple color transparency of a young woman and girl enjoying flowers on a lawn. To highlight the focus of the picture—the faces and the flowers—the transparency was cropped in the slide duplicator. First the image of the transparency was put in full view in the camera, then the bellows was adjusted until only the desired portion of the picture showed (dotted line). The picture was then enlarged by extending the bellows, placing the lens closer to the transparency.

A major advantage of this versatile slide-duplicating device is its ability to crop out part of the original. The bellows can be twisted so that the lens is set off-center in a way that segregates one section of the picture. And by using the bellows to bring the lens in closer, this section can be enlarged (above).

In using this equipment, lighting is important. A good black-and-white facsimile of a color slide can be made with nearly any light source that is bright enough; pointing the camera toward a lighted window or a bright lighting fixture will serve the purpose. But for a color copy, in which color must be accurate, filters must be used and correct lighting also becomes critical. Aiming the camera at the sky will produce a good color copy in midday but not in early morning or late afternoon. Even the slight fading of the sun caused by the passing of a distant cloud can sufficiently alter the light level to change the color in the copy. And shooting toward a window can add a green or blue tinge to the duplicate as a result of the coloring that, although not visible to the eye, is in every pane of glass.

A more trustworthy light source is electronic flash; aim it squarely at the frosted glass of the copying adapter. To make exact color copies, the filters shown in the chart on page 68 must be used along with the corresponding aperture adjustment.

A test roll or two should be shot to gauge the correct exposure. But once the variations in the light source are compensated for, the photographer has a quick copying system that is a welcome insurance against lost or damaged originals, and can even create pictures through cropping.

One Photographer's Setup

One of the best examples of well-planned storage for pictures is the system designed by photographer Douglas Faulkner. His storage room, 10 by 12 feet, has walls lined with asbestos fire-resistant wallboard. It is centrally heated in winter and air conditioned in summer, so that the temperature remains around 70°F. (a bit higher than is usually recommended for storage, since he also uses it as a workroom). Because Faulkner lives in a geographic area of only moderate humidity, the room needs no special dehumidifiers.

Faulkner uses two traditional types of baked-enamel metal cabinets for filing. One is a map file, adapted for oversize prints (stored flat) and some 35mm slides that he stores vertically in containers. The other is a cabinet that he uses for filing magazines and books in which his work has appeared.

In his work Faulkner frequently uses a twin-lens reflex camera, which produces 2¾ x 2¾ transparencies when mounted. To accommodate them he uses standard metal boxes designed for this size transparency, and has constructed special shelves for the boxes.

Douglas Faulkner's commodious room was designed for the most efficient storage. The special shelves constructed for the boxes of his transparencies are at the center; on top of them is a combination thermometer and humidity indicator. Oversize prints and boxes of 35mm transparencies are stored in the map file at left, on top of which is a light box. The cabinet at right is for his office files. Drawn curtains keep out the bright sunlight; beneath them is the air conditioner. The picture on the wall, a Faulkner favorite, is of Astronaut Edwin Aldrin on the moon.

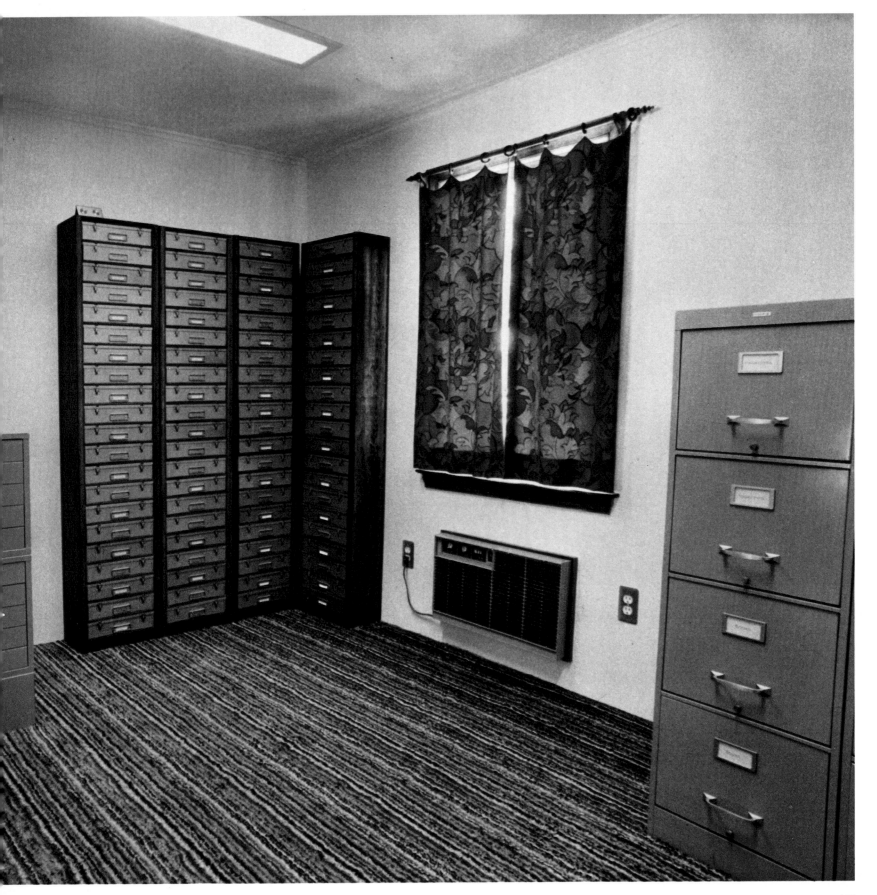

Ingeniously adapting a simple design to satisfy his individual needs, Douglas Faulkner built these wooden shelves for the steel boxes that hold his 2¼ x 2¼ color transparencies. The shelves are made of stained pine; since the transparencies are protected by the boxes, the peroxides given off by lignin in the wood do not harm them. The columns of shelves, each of which can hold 21 of the metal boxes, are constructed individually so that new columns can be added as required.

Any photographer can adapt Faulkner's design for his own boxes of transparencies by varying the size of the shelves and the height of the columns. To duplicate Faulkner's design exactly, two 9-inch-wide pine boards 6 feet long are required for the sides, and a 15½-inch pine board the same length for the back. A 9-by-15½-inch piece is also needed for the top. Masonite slabs will serve as shelves; they slip into grooves in the sides cut 3½ inches apart. The sides are screwed into the back, and the top screwed onto the finished column. The facing strips are attached with finishing nails.

Displaying Pictures 4

Arranged in geometric display are samples of ►
decorative frames that are marketed in ready-
to-assemble kits. Available in various colors and
finishes, they provide a simple and inexpensive
way to produce attractive displays of photographs.

ROBERT COLTON: *Color Frames,* 1972

The Many Ways of Enjoying Photographs

Although much of the pleasure of photography is in the taking of pictures, the real reward lies in displaying and viewing the results. Mounting and framing prints for family and visitors to enjoy should be as much a part of photography as composing a picture; yet too many photographers, daunted by the challenge of preparing their pictures for viewing, never carry the art to this logical stage.

The challenge is both esthetic and technical. Having enjoyed complete artistic control over all the earlier stages of picturemaking—shooting, developing, editing and printing—many photographers naturally choose to do the work of preparing their photographs for display as well, if only because they can make all their own decisions about the size, color and texture of a mat or the style of a frame. The alternative to do-it-yourself work, of course, is to take pictures to a professional craftsman for custom mounting, matting and framing. The cost of a professional framing job can easily reach $60; for less than $15, a photographer who is willing to do some practicing can accomplish the same work himself and get equally good results.

The technical aspects begin with preserving the condition of the prints. Photographs, like all other kinds of graphic art, are perishable, and they need protection from careless handling and from injury by humidity and polluted air. Once a picture has been selected for display, the first step in preserving it is to make a good permanent print of it *(Chapter 2).*

To save a print from tearing, curling or punctures, it should be mounted on a stiff backing. A picture that is to be on exhibit for a long time also needs the protection of glass or clear plastic over its front. More formal displays often involve placing a picture mat as a border around the print and then framing the matted picture. On the following pages, four mounting methods are shown, step by step, along with methods for cutting a picture mat and constructing a frame.

Most of the tools shown are available in photographic, art supply and hardware stores. And the mounting materials, such as mat board and dry-mounting tissue, are stock items in most art supply stores. They should be selected with care. Mat board, whether used as a backing *(pages 124-125, 130-133)* or cut as a border *(pages 134-137),* must have a high-grade, 100 per cent rag content. If it is not labeled as rag board, question the dealer or his buyer; if they cannot be certain that a piece of board has a 100 per cent rag content, go to another dealer who can guarantee it. Cheaper pulpboard, made from pulverized wood instead of cloth, contains acids; as these chemicals age, they invade the paper of the print itself. Acid-caused damage appears first as a brownish discoloration in the print, but it can eventually destroy a photograph's image. Rag board does not contain these acids and is chemically more stable.

The wrong kind of glue can also cause trouble. Old-fashioned glues, made from animal or vegetable matter, tend to disintegrate with age; some of them simply allow a print to curl off its backing, others release destructive acids. Glue made of synthetic, organic substances is therefore essential. Look for glues whose labels specify that they are meant for mounting photographs.

Apart from such basic principles of art and technique, there are procedural questions to be answered—both before and after pictures are ready for showing. The first concern: What photographs are suitable for display? Most photographic prints are no larger than 8 x 10—smaller than most other art works displayed in homes. So the most appropriate images are those with distinct, highly visible elements, bold enough to be seen clearly at eye level from a comfortable viewing distance. Pictures with extremely subtle details and gradations of tone, though easy to view in a book or portfolio, may get lost hanging on a wall.

Where should mounted or framed pictures be placed? The primary consideration is proper lighting. Intense, glaring light can bounce harsh hot spots off a print's surface; lighting should be strong but evenly diffused. Sometimes a single lamp or chandelier, too close to a picture, may give poor, uneven illumination, although a lamp with a strong bulb and a pale shade, which diffuses light, can work well. One good way to light photographs is to set a row of several small bulbs suspended in reflectors on an overhead bar a few feet in front of the pictures.

What places are suitable for displays? No large pieces of furniture should obstruct viewers who want to walk up and examine a picture closely. To display a number of photographs, the walls of a hall or empty corner can be converted into a kind of minigallery with a floor-to-ceiling lining of cork or soft wallboard—the type used for bulletin boards. Pushpins, nails or thumbtacks can be freely used in these materials for arranging—and rearranging—exhibits of mounted or framed prints. With a little help from professional craftsmen, more venturesome displays are possible, such as the expansive murals shown on pages 156-158.

Not every household allows for such extensive installations, however, and not everyone has the time or patience for do-it-yourself mounting and framing. For these situations, several ways of arranging photographs on ordinary walls and shelves—and some of the numerous commercially available picture frames—are shown on pages 142-147. □

Wet Mounting on Mat Board

1	sheet of glass	6	cheesecloth
2	sponge	7	organic glue
3	squeegee	8	photographic pan
4	mat board for mount	9	mat knife
5	brush for glue	10	prints

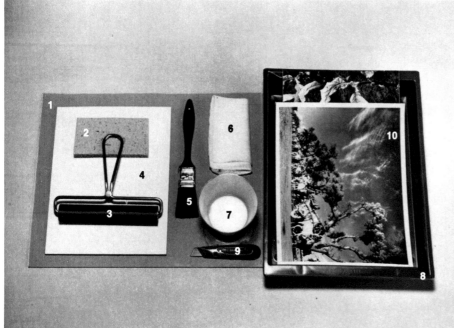

1 | soak the prints

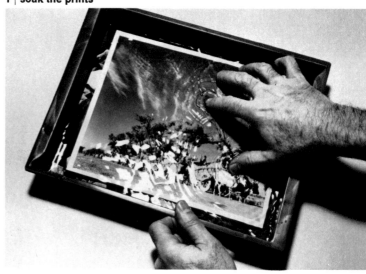

Wet the prints that are to be mounted by immersing them in a tray of lukewarm water. In addition to the print intended for display, another print must be soaked so that it can be mounted on the back of the board to prevent buckling.

2 | remove excess water

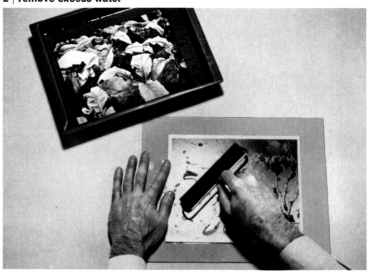

When the display print is thoroughly soaked, press out excess water with a squeegee. To avoid tearing the fragile wet print with the pressure of the squeegee, use many light strokes across the surface rather than a few heavy ones.

The basic materials of wet mounting —paper, glue and water—seem like the ingredients for a messy disaster, but handled with care they give pristinely elegant results. The main reason for mastering the delicate wet-mounting technique is economy: the materials and tools shown above cost less than $12 in photographic and art supply stores. Buy mat board with the highest available rag content and organic, water-soluble glue (low-grade materials contain chemicals that can damage prints). The mat knife—a metal holder for replaceable blades—ought to be bought with extra blades.

Before mounting a photograph for display, decide whether the picture should be cropped, and whether the print should cover the entire board as in the example on these pages, or whether the board should be larger than the print to provide a frame of white around it. Then cut the board to the desired size with the mat knife.

One troublesome problem with wet mounting is buckling: a damp print shrinks as it dries and pulls the board into a curve. Buckling can be minimized by mounting a reject print on the back of the board so that the shrinkage in one counterbalances shrinkage in the other. When mounting the backup print, be sure that its grain—the direction in which the paper's fibers run—is parallel to that of the display print; the grain is visible under a magnifying glass. When the two prints are mounted back to back—like a sandwich with the board for filling—they will pull in opposite directions while they are shrinking and prevent the board from bending.

3 | apply glue to the mount board

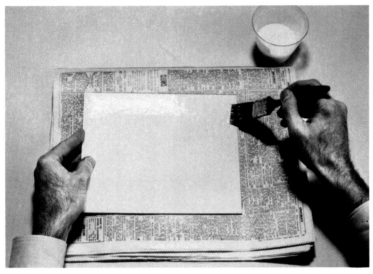

Lay the mounting board on clean, dry newspaper and brush glue evenly over the entire front surface. The glue, which can be thinned with water, should be the consistency of heavy cream. Wash the brush with water immediately after use.

4 | apply the display print

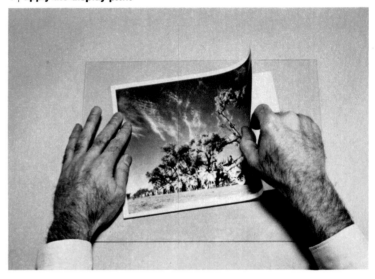

Align one edge of the damp print with one edge of the board and press the print edge down firmly with one hand. With the other hand, roll the rest of the print down slowly into the glue that has been applied to the front of the board.

5 | trim the display print

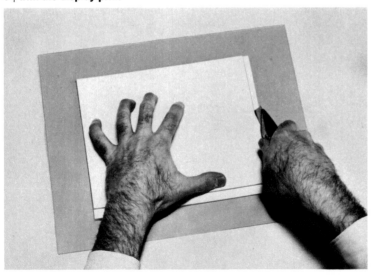

Turn the mounted print face down on the sheet of glass and, using the board as a guide, trim off the edges of the print with a fresh, razor-sharp blade in the mat knife. Take care to make a single, absolutely straight cut without nicking the board.

6 | mount the backup print

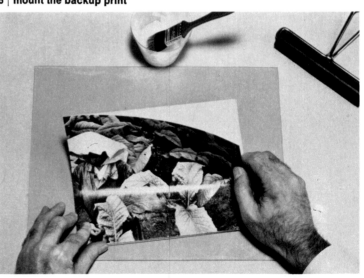

Transfer the print to fresh newspaper, brush glue over the back of the board, then mount the backup print by the same method previously used. Make sure the grains, or paper-fiber directions, of the two prints are parallel with each other.

7 | prepare the print for drying

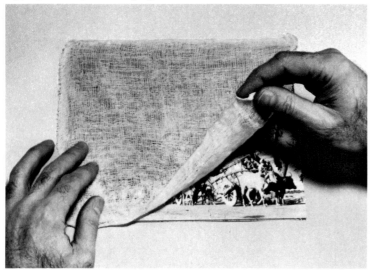

Before setting the print aside to dry, sponge away any glue that has seeped from under the print's edges. Then spread a single layer of cheesecloth over it; this causes the moisture to evaporate from the print and board slowly and uniformly.

8 | the mounted print

Even when it is dry, the mounted print should be handled only with the fingertips at the edges. This picture by Margaret Bourke-White, showing a peasant caravan in India, is now ready to be displayed—pinned to a wall with tacks or framed.

Wrap-around Mounting

An easy way to prevent buckling in wet-mounted prints—without the necessity for providing a backup print *(page 125)*—is to use a piece of stiff fiberboard, such as Masonite, for the backing. A print mounted on fiberboard can be trimmed so that its edges are flush with the board's, like the example at left; but some photographers prefer to wrap the print around the board, as shown at right, to hide the board's edges and help bind the print to the board.

To avoid cropping the image when wrapping the print's edges around the edges of the board, make a print with a generous border of blank paper—at least two inches all around. To crop the print, as in the example at right, the dimensions of the image to be displayed should be lightly drawn on the back of the print—and checked by holding it up to a strong light so the image is visible through the back. Cut the fiberboard precisely to the dimensions of the image. Fiberboard is so tough it is difficult to cut with home tools, but most lumberyards will sell it cut to size for little or no extra charge.

1 | outline the board on the print

Using the precut fiberboard as a template, draw its outline on the back of the print. Then, following the steps displayed on the preceding pages, wet mount the print on the shiny front side of the board, using the pencil outlines as a guide.

2 | cut out the print's corners

With a mat knife, cut out the print's corners from the exact tips of the mounting board's corners. The cuts should make an angle of approximately 110° so that the edges of the print will not show from the front when they are turned under.

3 | apply the glue

Lay the mounted print, face down, on clean newspaper and apply glue in a one-inch strip around the edge of the board. Since the back of a piece of fiberboard has a porous surface of coarse fibers, it may absorb quite a lot of the glue.

4 | wrap the edges of the print

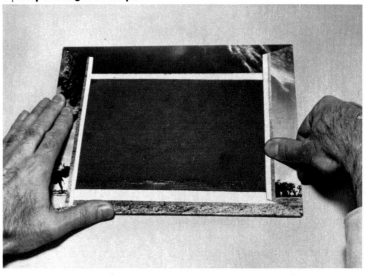

Fold the edges of the print up and over the board and press them down firmly into the glue. Wrap the longer sides first, then the shorter sides. When folding, press tight against the edges of the board to keep the print corners straight.

A Simple Metal Backing

1 | Egaplate
2 | sheet of glass
3 | cheesecloth
4 | photographic pan
5 | mat knife
6 | squeegee

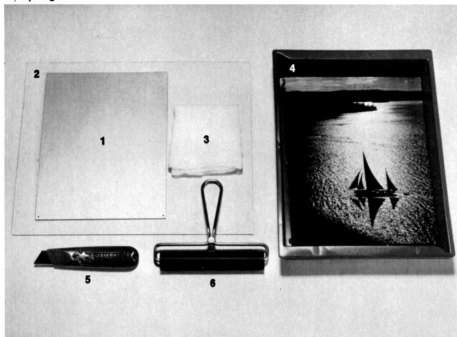

1 | soak the print

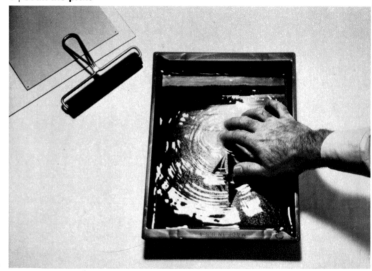

Following standard wet-mounting procedure (pages 124-127), soak the print in a photographic pan filled with lukewarm water. Remove it from the water after several minutes; when it becomes completely saturated it will be quite limp.

2 | squeegee out excess water

Lay the wet print on a sheet of glass and squeegee out excess water. Work on the back of the print first, then gently pick it up by the corners, taking care not to crease or wrinkle them, wipe the glass dry and squeegee the front.

Not so much necessity as frustration may well be the mother of a Swiss invention called Egaplate, which eliminates many of the troublesome steps of the traditional wet-mounting processes shown on the preceding pages. It is an adhesive-coated sheet of aluminum, 1/25 inch thick, that makes a sturdy, shrinkproof and buckleproof mounting when a wet print is simply pressed onto its surface. The simplicity of using Egaplate makes it an ideal method for beginners and for photographers too rushed to fuss with damageable materials. There are even holes drilled at the corners to hang the finished display.

The cost of these aluminum plates ranges from around two dollars for an 8-by-10-inch plate, to about $40 for a plate five feet by four feet—little more on the average than the total cost of the

board, glue and brush needed for conventional wet mounting. Their aluminum is impervious to most kinds of abuse—though the print itself must be handled as carefully as one mounted on any other material.

What Egaplates offer in convenience they lack in flexibility, however: they cannot be trimmed to fractions of an inch as other backing materials can. But the plates are especially practical for mounting fresh prints straight out of the final wash bath. Simply remove the print from the rinse, squeegee the excess water from it, and apply it to the plate; the moisture still in the print is sufficient to activate the adhesive. Dry prints such as the one shown in the demonstration on these pages can be mounted as easily as wet new prints after a brief immersion in water.

3 | moisten the plate

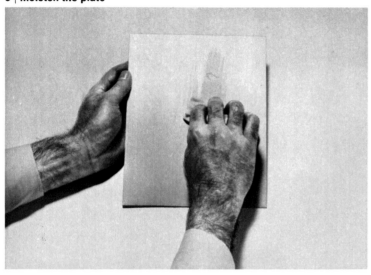

Using a piece of fresh wet cheesecloth, dampen the entire front surface of the Egaplate. Take care not to miss any spots. Within a few seconds the moisture will activate the adhesive and it will become tacky to the touch of a fingertip.

4 | squeegee the print onto the plate

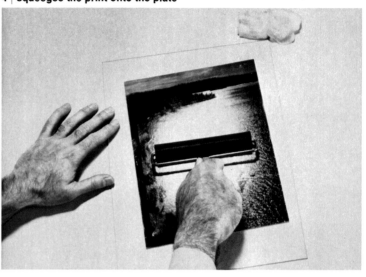

Lay the print down on the sticky plate, using the technique described on page 125. Then squeegee the print down, working from the center outward, to remove all air bubbles and to press all parts of it firmly into contact with the Egaplate.

5 | trim the print's edges

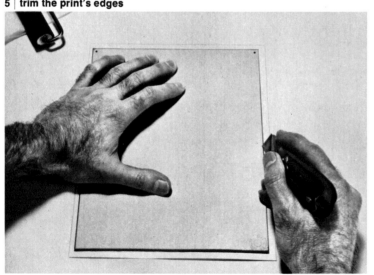

While the print is still wet turn it face down on the glass and trim it, using the edges of the plate to guide the knife blade. Make single, swift cuts to avoid giving the print a ragged edge. Because the plate is metal there is little risk of nicking it.

6 | the mounted print

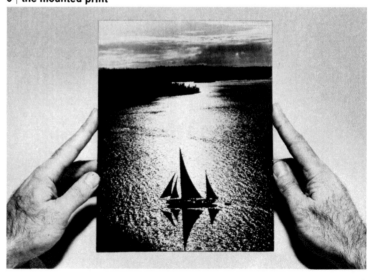

Lay the photograph on a flat surface until it is completely dry; after about 30 minutes, it will be ready for display. This photograph, by LIFE photographer Loomis Dean, shows a yawl in full sail in a calm sea off the San Juan Islands.

The Advantages of Dry Mounting

1 | ruler
2 | mat knife
3 | tacking iron
4 | dry-mount tissue
5 | print
6 | mat board
7 | press
8 | tracing paper

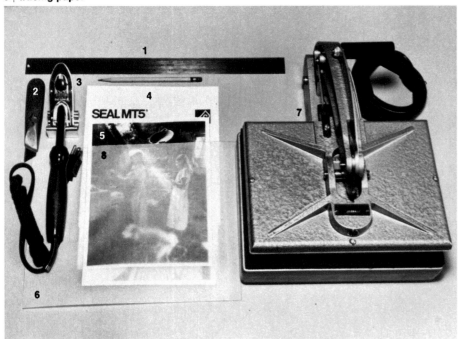

1 | dry the materials

To bake out all moisture, place the mount board and the print in the press, with a sheet of tracing paper over them. If the press has a thermostat, set it at 250°; leave the materials in the press for a minute or two or slightly longer in a humid climate.

2 | wipe the materials clean

After the materials have been baked dry, let them cool for a few minutes, and then wipe away any loose dirt with cheesecloth; examine them for cleanliness under a strong light. Always use clean cloth, and take care not to grind dirt into the board.

The fastest and neatest of mounting methods is a technique that avoids the use of liquid glue—the messiest ingredient of wet mounting—and uses dry adhesive instead. Sold in photographic and art supply stores as dry-mount tissue, the special adhesive is made in thin sheets coated with a compound that becomes sticky when heated. The molten adhesive penetrates the fibers of both mounting board and print, and as it cools forms a tight, perfect bond.

Dry mounting works best if two items of special equipment are used; a small tacking iron *(above)* to position the tissue on board and print, and a press to dry the materials and fix the print to the board. The press is a simple mechanism with a heating plate hinged to a bed plate; in it, the adhesive melts uniformly and is pressed into the board and print. A small press, like the one shown above, which can accommodate prints up to 8 x 10, costs under $100—a worthwhile investment for the photographer who has many prints to mount. (For occasional mounting jobs, an ordinary household iron can be used as shown on pages 132-133.)

One prerequisite in employing this technique is that the dry materials must be bone dry: the first step of a dry-mounting project is to put mat board and print in the press to bake every droplet of moisture out of them. Another requirement is that the materials be absolutely free of dirt; even the tiniest dust particle trapped between print and board causes an unsightly—and permanent—lump in the print. So clean the print, tissue and board carefully before putting them in the press.

3 | tack the mounting tissue to the print

With the print face down and mounting tissue on top of it, tack the tissue to the center of the print. The tacking iron has to be heated in advance; it takes about 10 minutes to get to the temperature that is hot enough to melt mounting tissue.

4 | trim the mounting tissue

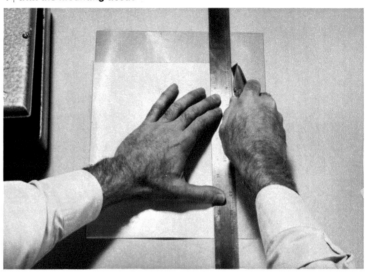

Using the ruler to guide the blade of the mat knife, trim the mounting tissue to the same size as the print. Since the tissue is thin, little pressure is needed, but be careful not to cut through the tissue into the edges of the print.

5 | attach mounting tissue and print to the board

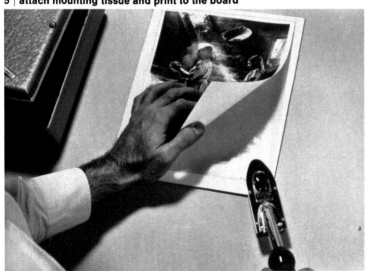

Place the print and tissue, face up, on top of the mount board and tack two corners of the tissue to the board with the tacking iron. The tissue must lie absolutely flat on the board to prevent distorting ripples from forming under the print.

6 | mount the print

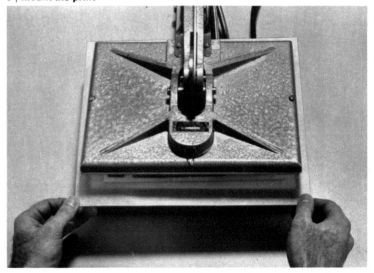

Put the board, tissue and print, protected by a sheet of tracing paper, into the press. Instructions that come with the mounting tissue specify press temperature and how long to heat the assemblage before removing it for trimming (overleaf).

7 | trim the mounted print

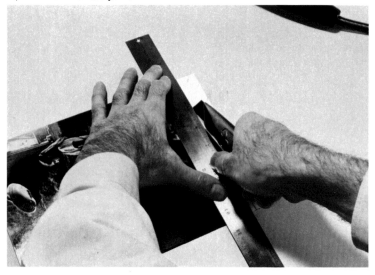

After removing the mounted print from the press
and allowing it to cool for a few minutes, trim the
edges with a firm, swift stroke. While the press is
still hot, use a cheesecloth to wipe it clean of any
adhesive that might have seeped out onto it.

8 | the finished print

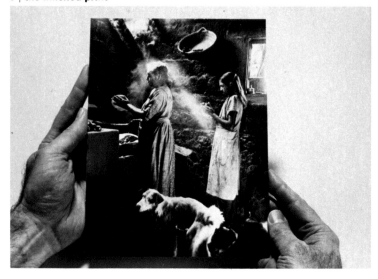

The print above—a Mexican mother and daughter
in their kitchen, by Leonard McCombe—is trimmed
to leave no border. But the image can as easily
be set off by arranging to leave a wide strip of
the white mat board to show around the print.

Dry Mounting with an Iron

For dry mounting photographs, a $15
clothes iron makes a perfectly satisfac-
tory substitute for the $100 press shown
on the preceding pages. The results
will be as neat and permanent as those
achieved with a special press so long
as care is taken and a number of pre-
cautions are observed.

To begin with, an iron that is used for
mounting must not be borrowed from
the laundry. If a retired laundry iron is
to be used for mounting, clean its bot-
tom carefully to remove any residue of
starch or water minerals, which can
damage prints. If it is a steam iron, like
the one shown here, do not put water
into it, and take care to keep the steam
holes in the base plate from leaving cir-
cular marks in the print—a problem
avoided by repeated light strokes with
the iron. Use a low temperature; the
thermostat's "synthetic fibers" setting,
which is about 230°, is hot enough to
serve for most mounting tissues. Ex-
cept for the iron, the materials needed
for this method are the same as those
shown on page 130.

1 | dry the materials

To be sure the print and mount board are completely dry, press all moisture out of them with the iron thermostat set for "synthetic fibers." When ironing the print, use a cover sheet of tracing paper over it to prevent scratches.

2 | tack the mounting tissue to the print

Using the tip of the iron, tack the center of mounting tissue to the back of the print. Turn the print face up, and tack two of the loose corners of tissue to the board. Lift the edges of the print gently to avoid marking its surface.

3 | seal the print to the mount board

With the cover sheet placed over the face of the print to provide protection, seal the print to the mat board with the iron, which should be at the "synthetic fibers" setting. Use light strokes and work from the center of the print outward.

4 | the finished print

The ironing technique requires some practice, but can yield the elegant results shown here, a display of Andreas Feininger's picture of a snake skeleton. In this case, the photographer left a wide border of mat board to frame the image.

A Mat to Set Off the Scene

1 | **T square**
2 | **metal ruler**
3 | **Art gum eraser**
4 | **sheet of tracing paper**
5 | **mat board**
6 | **mat cutter**
7 | **single-edged razor blade**
8 | **print to be displayed**
9 | **pencil**

1 | **measure the picture**

Measure the picture and decide on cropping. In this example, the picture measured 9 1/2 inches by 6 3/8 inches; it was cropped to 9 3/8 inches by 5 3/4 inches. Lightly mark the cropping lines on the front of the print with a pencil.

2 | **figure the dimensions**

To figure the dimensions of the mat add the dimensions of border and cropped image. In this example, the border of two inches on the sides, two inches on top and three on the bottom requires a mat 13 3/8 inches by 10 3/4 inches.

A mat is nothing but a cardboard rectangle with a hole cut in it; the cardboard, placed over a print that has been glued to a backing board, then provides a raised border around the photograph. But the hole must be cut with machine-like precision, and the material should be 100 per cent rag board, which protects the print since it contains relatively few harmful chemicals. Though a good picture needs no cropping, the mat offers an excellent way to mask imperfections without damaging the print. The result is a simple, inexpensive display as elegant in its own way as the most elaborate construction of sculpted wood and glass.

The gluing process is simpler than ordinary wet mounting, since the mat board and its backing help to hold the print securely. But cutting a mat perfectly is exacting work even for professionals, who charge accordingly. So it is well worth investing the $13 for the tools shown above, and taking some time to master the techniques. They are not hard, but spend some time practicing with scrap board to get the knack of cutting perfect, clean corners.

For the beginner, an essential aid is a mat cutter. A simple, heavy metal device designed to fit into the palm of the hand, it holds a knife blade that can be rotated to cut either a beveled (angled) edge or a perpendicular one. Mat cutters, like the other tools and materials shown above, are available at most art or photographic supply stores, and the investment of seven dollars can make the difference between a ruined board, cut freehand with an unbraced knife, and a perfectly cut mat.

3 | mark the mat board

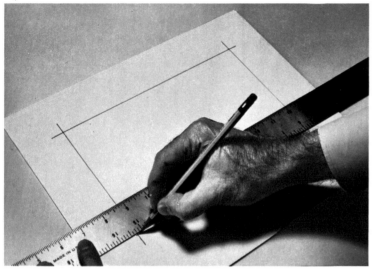

Mark the back of the board for the inner cut, using
the dimensions of the image that will be visible.
Measure with the ruler, but in drawing the
lines use the T square firmly braced to align with
the mat edge to be sure the lines are square.

4 | set the cutting blade

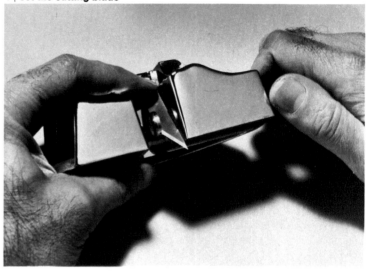

Insert the knife blade in the mat cutter, sliding it
into the slot on the inner end of the movable bolt.
Adjust the blade so that it extends far enough
to cut through the board, then tighten, using
the threaded knob on the bolt's outer end.

5 | secure the mat board

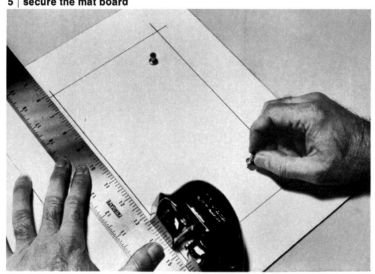

Before cutting, anchor the mat board with
pushpins to the worktable. The pins must be
driven through the part of the board that is
to be cut out, far enough apart to hold so that
it will not slip under the blade's pressure.

6 | cut the mat

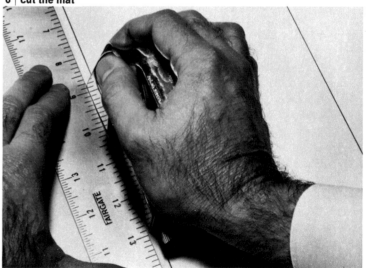

Get a firm grip on the mat cutter and brace it
against the ruler. Cut each of the inside edges on
a line, stopping short of the corners; finish the
corners with the razor blade; do not cut too far,
but take care to maintain the angle of the cut.

7 | position the print

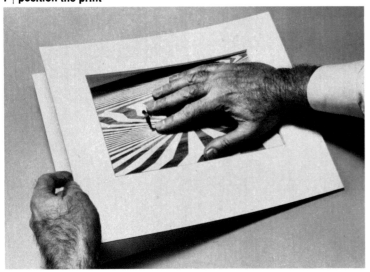

Having cut a second board—to be used as a backing—with dimensions that match the outer measurement of the mat board, slip the print between the two and position it. Align the cropping marks with the inner edge of the mat.

8 | mark the backing board

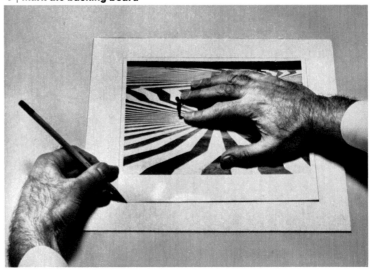

Hold the print down on the backing board in the position in which it is to be glued and lift off the top mat—simply hang it over one elbow for the moment. Then make light pencil marks of the edges of the print on the backing board.

9 | mount the print

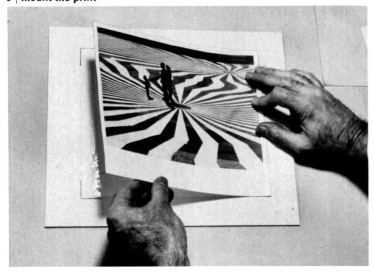

After brushing a thin layer of organic glue within the print's outline on the backing board, align one edge with the pencil mark; then use the rolling motion described for wet mounting (page 125) to lay the print down in the glue.

10 | roll the print

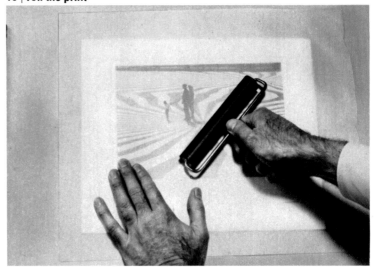

With a clean sheet of tracing paper laid over the print, press with a roller so that the entire back of the print is in contact with the glue. Work the roller in all directions from the center toward the outside edges to push out any air pockets.

11 | apply glue to the backing board

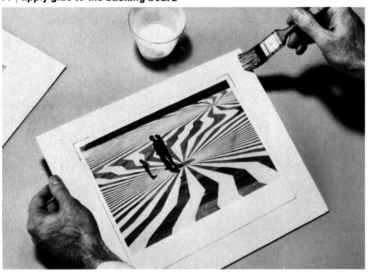

Carefully apply a narrow strip of glue to the backing board outside the print. Check to see if any glue has seeped from under the print; wipe it off at once, while it is still liquid, with a clean piece of moist cheesecloth or a damp sponge.

12 | place the mat

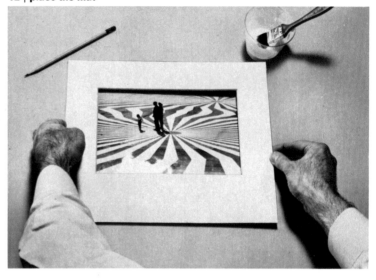

Holding the top mat by the edges, align it with the backing board, then lower it into the glue. Make sure the penciled cropping marks are covered by the mat, then press all four edges of the mat down into the glue firmly all the way around.

13 | weight the mat

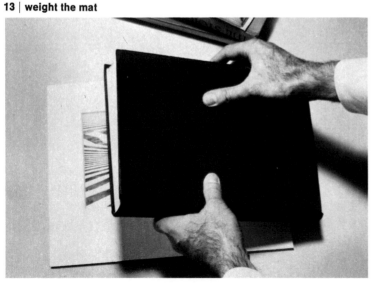

While the glue is drying the boards should be pressed for an hour or two under a heavy book. After removing the book, clean the mat thoroughly with an Art gum eraser; gently blow or brush off all loose particles of dirt with cheesecloth.

14 | the matted print

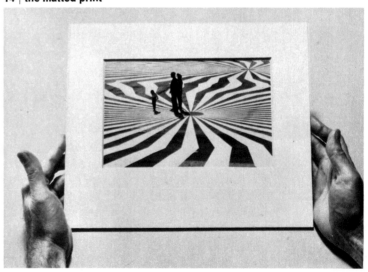

The matted print—like this scene taken in Montreal at Expo '67 by Michael Rougier—should be handled by the edges only, and not until the glue has dried for several hours. It can now be framed (pages 138-141) or displayed as is.

A Custom Frame, Homemade

1	100 per cent rag paper	9	1/16-inch drill bit	17	mat knife	
2	picture-hanging wire	10	tack hammer	18	steel tape measure	
3	nail set	11	Art gum eraser	19	wire cutter	
4	screw eyes	12	1/2-inch wire brads	20	miter box	
5	pencil	13	wood filler	21	backsaw	
6	corrugated cardboard	14	contact cement	22	1-inch glued paper tape	
7	glass	15	picture molding			
8	power drill	16	corner clamps			

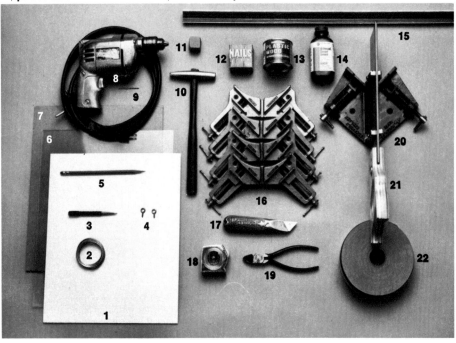

1 | measure the mat

Using a tape measure, make a note of the precise horizontal and vertical dimensions of the mat around the print. The dimensions of the mat shown in the demonstration on the preceding pages are 13¼ by 10¾ inches.

2 | figure the molding dimensions

Before cutting the molding, calculate the lengths of the pieces. They must be 1/16 inch longer than the mat dimensions to allow for the width of the mounting lip—cut along the inside of the molding—that holds the matted picture in the frame.

Putting a frame around a picture is a logical last step in preparing it for home display—a step often forgone because of the expense of commercial framing and the apparent difficulty of tackling the job oneself. Yet a good homemade frame can be prepared fairly simply, provided the proper equipment is used.

The principal difficulty in making a wooden frame is ensuring that it will have square corners, which require cuts of exactly 45° at the ends of each piece of molding. Essential for making such accurate cuts is a miter box, a device that not only holds the wood in the right position to be sawed but also holds the saw—a special stiff type called a backsaw—at a specific angle in relation to the wood. An ordinary carpenter's miter box will serve, but not all such boxes are sufficiently accurate for

frame work. Much more precise is the special miter box shown above, which is constructed for frame making and makes all cuts at exactly 45°; when two pieces of molding that have been cut with this tool are joined, they form a 90° angle, guaranteeing a neat and perfectly matched corner.

The framer's miter box and other necessary tools are standard items in art supply and hardware stores. Picture molding, which is made with a lip to hold the print in the frame, is sold by the foot in lumberyards; it is available in numerous designs. When buying molding, make a rough estimate of the amount needed, and buy a few extra feet to allow for mistakes in cutting. A hardware store or a glazier can cut a piece of glass to fit the inside lip measurement of the finished frame.

3 | cut the first end

Before transferring the measurements to the molding, clamp the piece tightly, front side up, in the miter box. Use the backsaw to make the first miter cut a few inches in from the end, being sure the mounting lip faces the handle of the saw.

4 | measure and mark the molding

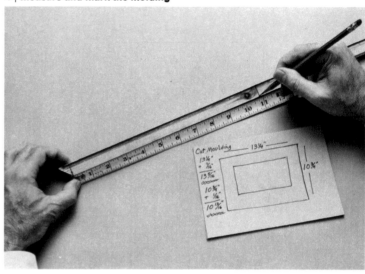

With a pencil, make a clear, straight line on the lipped underside of the molding, at right angles to its edge, at the inner end of the mitered cut. From the first pencil mark, measure and mark off the length for cutting the first piece.

5 | cut the second end

Having measured and marked the molding, make the other miter cut in the first piece; then proceed in the same fashion for the remaining pieces. Be sure the cuts in each piece angle in opposite—rather than parallel—directions.

6 | glue the ends

Use the applicator in the cap of the cement jar to brush cement on all eight mitered corners; if the wood seems to be absorbing the cement, add a little more. Let the cement set for a few minutes before joining the pieces together.

7 | put the frame in the clamps

Before pressing the glued ends together, place
the strips of molding in the corner clamps. Then
slide them together so that the ends are in firm
contact with each other, and tighten the clamps
enough to hold the corners but not dent the wood.

8 | bore holes for the brads

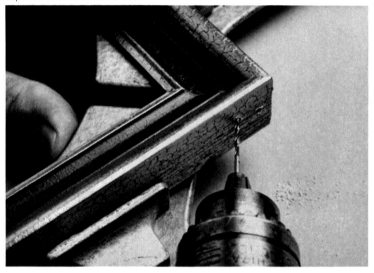

When the corners are braced in the clamps,
bore two 1/16-inch holes 1/4 inch from one
side of each corner. One hole should be drilled
perpendicular to the molding, the other at an
oblique angle across the grain, as shown above.

9 | nail the corners

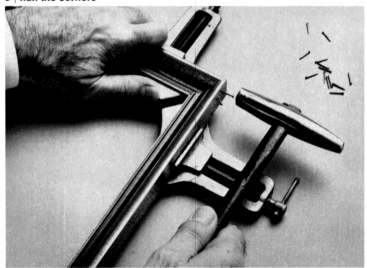

With the tack hammer, drive wire brads into the
drill holes. Hammer gently, using repeated
light taps, to avoid jarring the molding pieces
out of alignment. Take care not to bruise
the molding's finish with the hammer head.

10 | countersink the brads

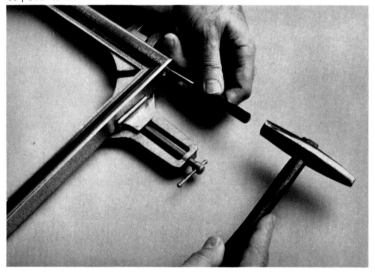

Using the nail set and tack hammer, countersink
each of the brads about ⅛ inch into the wood. Take
care not to sink them so far that they protrude
from the other side of the molding. Tap the nail
set gently so that it will not mar the molding.

11 | fill the countersunk holes

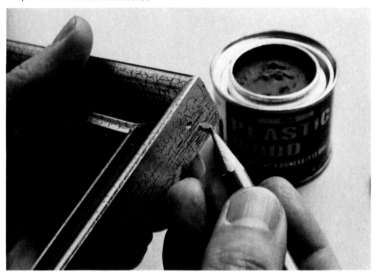

With a pencil point, force tiny blobs of wood-filler compound into each of the recessions made by the nail set. After the holes are filled and any excess filler is smoothed away with a thumbnail, the indentations will be virtually invisible.

12 | secure the print in the frame

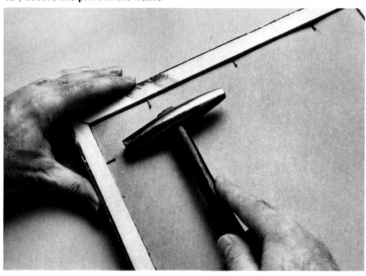

Remove the clamps, turn the frame face down and insert the glass, the matted print, a sheet of rag paper and corrugated board—in that order—all cut to the mat's dimensions. To secure them, drive brads partway into the rim of the frame back.

13 | seal the back of the frame

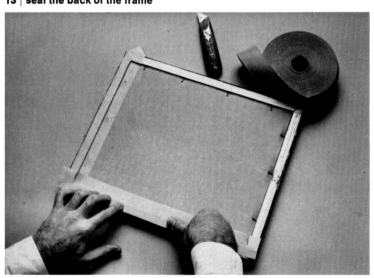

The print can be protected from dust and humidity by sealing the back of the frame with strips of moistened paper tape. For a tight, bulge-free seal, notch the strips at the corners to form a "V," and press the edges of the "V" down firmly.

14 | prepare the frame for hanging

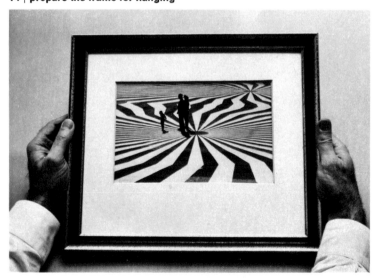

To hang the framed print, screw two eye hooks into the frame back about two inches down from the top of each side piece; string picture wire between the hooks and twist its ends tightly so it will not slip loose under the frame's weight.

A Wide Choice of Ready-made Frames

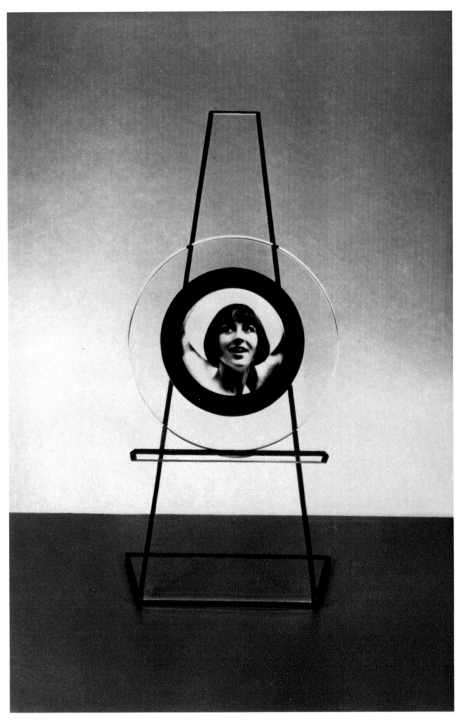

Choosing the right ready-made frame for a picture may be a vexing problem if only because of the diversity of frames available. Yet there are simple criteria that can make picking out an appropriate frame easier than it might seem.

The first rule for the shopper is so elementary that many people ignore it, to their regret: carry the picture with you to the shop so that it can be seen in several frames. This precaution prevents the purchase of an incorrect size and it also guards against an esthetic mistake. The style of frame should suit the photograph—a stark, angular image generally looks best in a simple rectangular frame, a rounded image in a curved frame—and the frame should not dominate the image.

It is also wise to examine a frame by feel. A wood frame, for instance, should have square, solid corners—if the construction is faulty, the joints will give when the frame is squeezed. Also important is enough depth and width in the rear of the wood molding to accommodate screw eyes to their full length; driven part way, screw eyes may wobble and fall out.

Inside a disk of clear plastic resting on a miniature easel, a heavy circle of black velvet repeats and underscores the curves of the subject's face and hat. The unusual design of this easel frame, only nine inches high, almost guarantees attention for the portrait it holds.

Frames appropriate to their images hold the six ▶ photographs at right: austere aluminum for a room interior and silhouetted trees; a wood frame for a wooden fence and house; and clear plastic for three pictures of people—two elderly women, a dancer with his children and a nun.

Each of the four traditional frames at left was selected to complement a black-and-white portrait. The clean line of a woman's profile (far left) is simply enhanced by a severe silver frame, and a period uniform and mustache are lightheartedly displayed in an antique frame of gilt filigree. Two ovals at top and bottom, one baroque, the other unadorned, frame a portrait of grandparents and the face of a girl.

Standing open atop a desk, a hinged plastic frame ▶ designed to accommodate family portraits (right) becomes an effective display for a different sort of picture: color photographs showing three views of a yacht. The blue frame was chosen to suggest the sea and to bring out the red, white and blue colors of the boat's wind-bellied sail.

Five color portraits, displayed in diverse standing frames, adorn a polished dresser top. The four contemporary, painted ceramic frames in the foreground rest in miniature brass easels. At the rear, beveled glass topped with filigree sets off the old-fashioned elegance of the photograph.

Made of crystal-clear Lucite, two geometric shapes—a cube and a trefoil—provide a compact tabletop display gallery for a dozen colored photographs. A mirror hanging on the wall behind the table reflects the rear images so that eight of the 12 pictures are visible at a single glance.

Pictures in Plastic for Close-up Enjoyment

As a rule, valuable photographic prints, like other graphic artworks, carry an invisible HANDS OFF sign. But if they are coated on front and back with hard plastic, they can be passed from hand to hand without risk of damage from thumbprints or scratches.

In the coating process, called lamination, the print is placed between two sheets of vinyl chloride, a clear plastic. The print-and-plastic sandwich is placed in a hydraulic press that heats to 280°F. The plastic melts into the fibers of the print, and when it cools, it hardens to make a tough, protective coating on both sides and around the edges of the picture.

Lamination must be done by a professional, but the cost of laminating an 8 x 10 print is two dollars or less, and for one as large as 21 x 25 inches, the price is well under $10. Any type of unmounted print, in color or black and white, can be laminated as long as it is in good condition.

Lamination is a permanent process; once a picture is coated, the plastic cannot be removed. But the technique is ideal for displaying pictures informally on a desk or tabletop where they may be picked up frequently and examined with no more than the ordinary care required in handling a book.

Permanently protected by clear laminated plastic, three enlarged scenic views lie on a coffee table. Such laminated photographs are virtually immune to most damage, and are handsome, highly accessible displays in the bargain.

The New Family Album

The shabby, crumbling family albums of childhood memory are a thing of the past. Contemporary photographers —more conscious of the fragility of their photographs, as well as of the casual treatment they are likely to get at the hands of both children and adults —have found better ways of exhibiting family pictures. On these pages are original, handmade display methods, but there are also many commercial albums to choose from—more protective of pictures, easier to use and priced from a few dollars to nearly $100.

Opening like an accordion, the folding panel (right) exhibits eight photographs of various sizes. It was constructed of prints dry mounted on heavy black cardboard; the mounts are hinged to one another by glued strips of cloth. Collapsible for storage, on display the panel is freestanding.

A selection of dry-mounted prints—taken on a photographer's trip to Greece—are plastic-bound to make a book. Though the binding must be done by a commercial bindery, the mounting can be done at home using the techniques demonstrated in the pictures on pages 124-127 and 130-133.

Contained in a handmade, hinged box (right), this portfolio of dry-mounted 3 x 5 prints was a gift from the photographer to his family. The portfolio stands upright, like a book in a bookcase, and its title refers to the number of photographs —eight—all taken during a summer trip abroad.

Dispensing with old-fashioned glues, many modern albums, like the one at left, hold a picture against a permanently sticky metallic foil page. A clear plastic sheet, pressed over it, is gripped by the adhesive exposed around the picture.

Ingeniously compact, a loose-leaf notebook has punched cardboard panels for pages; attached to each panel are 12 open-ended holders for prints. Each holder accommodates two pictures back to back, and flips up to reveal both sides.

The album at right serves as a convenient combination of display book and 35mm-negative storage file. The pictures slide under clear plastic for display, while negatives go into a pocket near the inner edge of each of its plastic pages.

This elegant album, a binder made of pigskin in Italy, has 20 clear plastic envelopes for pages. The photographs, which may be as large as 8½ x 11, are simply slipped into the openings provided on the inside edges of the pages.

LYN MANDELBAUM: *Constructed Print*, 1971

154

A Personalized Array

Twenty-three photographs, some of them new, others old snapshots from a family album, provide the components of the striking color montage at left. The composition comprises 49 separate frames—some images are repeated three or four times—and covers an area three by five feet.

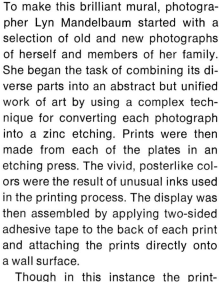

To make this brilliant mural, photographer Lyn Mandelbaum started with a selection of old and new photographs of herself and members of her family. She began the task of combining its diverse parts into an abstract but unified work of art by using a complex technique for converting each photograph into a zinc etching. Prints were then made from each of the plates in an etching press. The vivid, posterlike colors were the result of unusual inks used in the printing process. The display was then assembled by applying two-sided adhesive tape to the back of each print and attaching the prints directly onto a wall surface.

Though in this instance the print-making process was complicated, only the final step—arranging the pictures and attaching them to the wall—is necessary to achieve much the same effect with ordinary color or black-and-white prints. The technique can be varied by combining both color and black-and-white pictures, or images of varying sizes, into one mural. One of the special advantages of this method of display is that it invites audience participation: to create a new composition with the same components, the prints can be removed from the mounting surface, rearranged and stuck down again.

A Mural for the Home

The grandest of all photographic display techniques is the photomural—a single print enlarged to cover an entire wall. A mural can be the size of virtually any wall. Paper for black-and-white enlargements is sold in stock sheets 4 by 17 feet—for color enlargements, 40 inches by 12 feet. For an image larger than a single sheet, the print is made in sections and pieced together like wallpaper. Any black-and-white picture can be made into a mural, but the original must be extremely sharp to give a good image when it is greatly enlarged.

Making photomurals is generally left to commercial laboratories equipped with the necessary outsized enlargers and developing tanks. Many such labs, which charge $50 and up to prepare a small mural, use automated equipment to ensure that the separate pieces of a very large print will match precisely.

Mounting photomurals is also a job for professionals. A covering of linen is first attached to the wall with a compound resembling wallpaper paste. The mural is then pasted to the linen—from which it can be removed if the owner moves. A simpler method that also allows for removing the mural calls for wet mounting the prints on panels of stiff fiberboard. The panels are bolted to the wall—and can later be unbolted.

Enlarged to six by eight feet, a photomural of tree branches silhouetted against the silvery tones of a flooded meadow lends serenity to a game room in a Connecticut home. The huge enlargement was made from an extremely sharp 35mm negative.

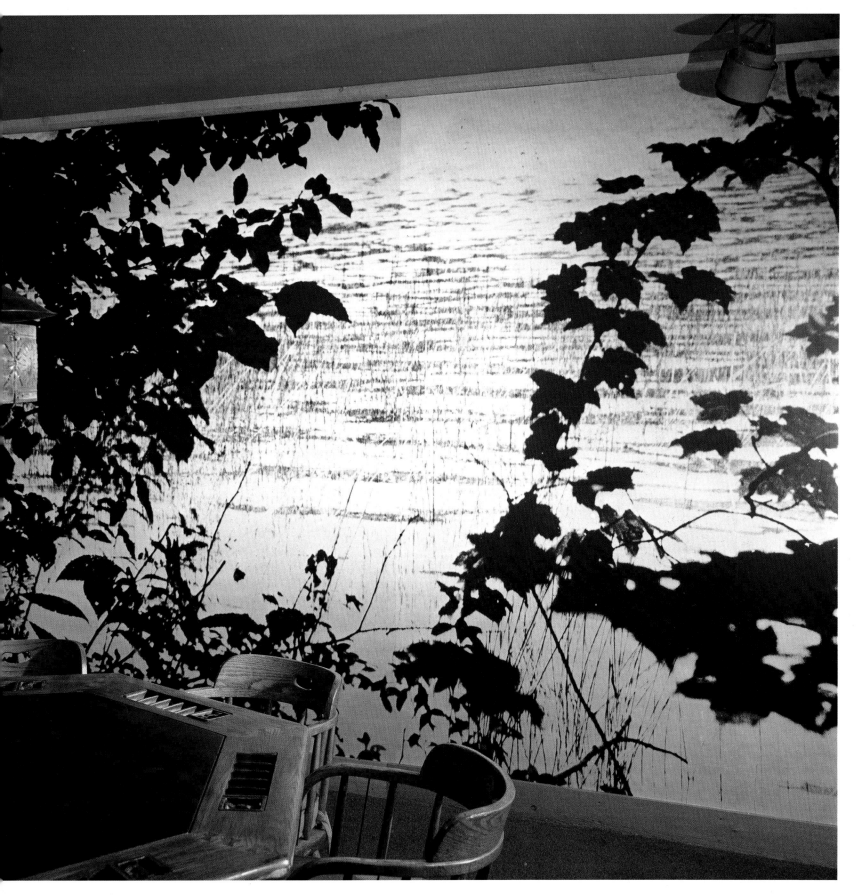

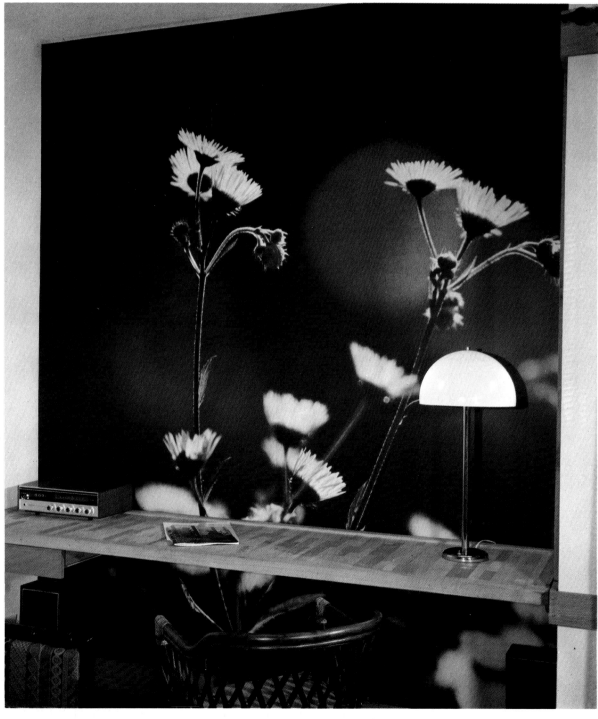

Behind a wooden work counter, a photomural of Japanese daisies gives the illusion of a window opening on a fantastic world of giant flora. Blown up 35 to 40 times their original size, the exaggerated stems of the daisies possess a luminosity that would be far less visible in a print of conventional 8 x 10 or 11 x 14 size.

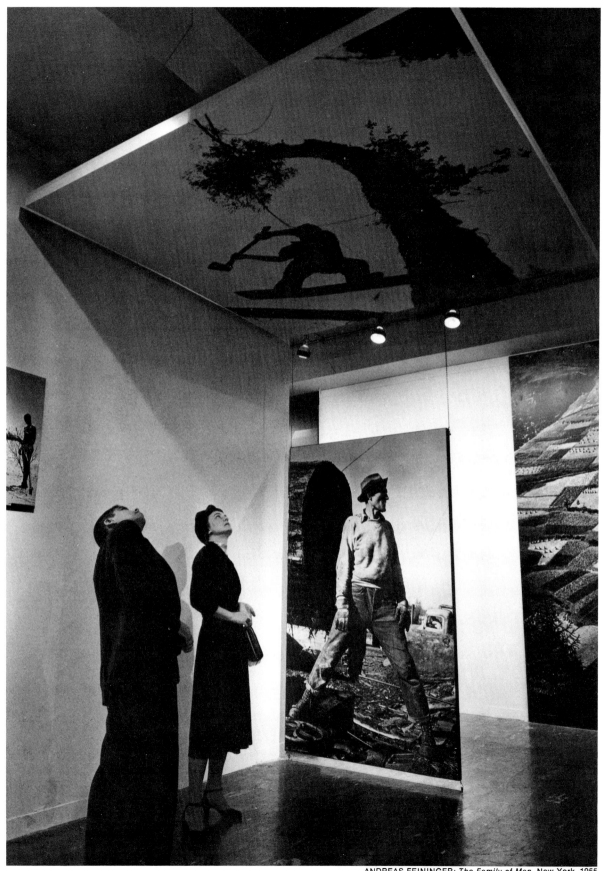

ANDREAS FEININGER: *The Family of Man*, New York, 1955

Pictures Organized for an Audience

Slide shows and photographic exhibits are the theater of photography; acts of showmanship designed for an audience, they depend, like a successful movie or stage play, on the artful combination of single details to form a structured display, in this case through the combined effect of a group of pictures. There are no hard and fast rules for assembling a slide show or exhibit; the subject matter and the pictures available (and in the case of the exhibit, the size and shape of the display area) influence the way the material is handled. But there are methods for organizing both types of photographic show—steps in the process of choosing, arranging and emphasizing photographs that lead to successful productions.

First, the organizer should find a theme easily grasped by the viewer—a thread that links the pictures together. It can be as broad as the collected work of a camera club's members, or as individual as the slides taken on a family trip; but every picture must support the theme, and at the same time enhance and be enhanced by its neighbors. This calls for ruthless editing, and the constant exercise of judgment and purpose. If a single picture makes a firm point, it is usually advisable to eliminate similar pictures, however fine, that might be repetitive; on the other hand, deliberate repetition can be used to build suspense. The pictures can be combined in ways that create surprise, arouse emotion or tell a story, and the pace—the variation of movement and feeling—quickened and slowed as the organizer intends.

Of the two methods of showing photographs, the slide show is the more theatrical; in fact, the steps involved in setting up a slide-show presentation are the same as those involved in making a movie. Both, of course, are shown on a screen. The slide sequence, however, is highly concentrated; it must make its point quickly, without benefit of movement or dialogue, and therefore every image must count. But, like a movie, it must have continuity: a beginning that introduces the subject, a middle part that enlarges upon it, and an ending that concludes the sequence. Slide shows tend to be documentary—the story of a vacation or the chronicle of a child's development. But they can also be galleries illustrating high points in a photographer's pursuit of a particular interest—shooting action-sports pictures, observing flowers—or even a record of the photographer's growing skill with the camera. Though it can be fun to assemble the pictures in a way that tells a story, no plot is necessary; but there must be a reasonable progression. When assembling a sequence it is best to begin with an easily comprehended, overall shot that introduces the subject and establishes the scene for the viewer. Remember that he must absorb a great deal of information, with no chance to refer back to a previous picture—the slide show sets its own pace.

Begin by scanning the slides and discarding those that do not relate to the sequence and those that seem otherwise unusable. Next, arrange them in

some kind of order. This may be chronological at first, but experiment may prove that another organizing pattern, such as flashback, is better. For changes of pace, alternate action shots with more tranquil pictures, and move in and out from long shots to close-ups. Run the show through the projector, rearranging the sequence until it seems both logical and varied. If the sequence involves two themes—if, for example, the action shifts from children playing in the backyard to a supper scene in the kitchen—try to separate the two situations with a transition picture; a shot of the back door might work or a picture of someone in the kitchen window holding up a pie. Narration, music and even sound effects add greatly to a slide show, and the showman can blend them all into a tape recording synchronized to his pictures. As confidence and technique grow, it becomes easier to visualize —and write—shooting scripts for slide shows, setting up introductory pictures as signposts, and arranging for scene setters and transition shots.

The rules for a photographic exhibition are somewhat different from those used in a slide show. Projected slides are seen briefly and consecutively, and the show's theme must be strongly conveyed if the audience is to grasp its point. In the exhibition the viewer travels at his own pace, free to study individual photographs as long as he wishes, to compare them with one another, and to draw his own conclusions. The structure can be more flexible; an exhibit needs no stronger theme than a standard of excellence. But in an exhibit with such a diffuse theme as a year's pictures from the local camera club, certain groupings of pictures by subject will suggest themselves. Even the massive Family of Man show *(pages 172-186),* in which every picture contributed to the overall concept of brotherhood, was broken into categories—subthemes based on aspects of human life, such as motherhood, work, and the joys of play.

Apart from picture selection, putting an exhibit together means solving a series of design problems, a process best begun in sketches. The organizer starts by arranging pictures in certain basic juxtapositions—contrasting verticals with horizontals, dark tones with light, large shapes with small ones. Then he must decide which pictures to emphasize by enlargement and which to print small. Finally, he must work out a system of placement—levels at which photographs are displayed—that suits the individual pictures and their groupings, and pulls the entire show together.

The grouping on page 182, captioned "Eat bread and salt and speak the truth," illustrates these principles; the larger-than-life panel of growing wheat, placed so that it seems to spring from the ground, states the theme of this segment: the staff of life. The next large photograph, showing people at a meal, elaborates the theme, and the smaller pictures hung at many levels act as counterpoint—staccato notes that recapitulate the concept. □

Showing Transparencies at Home

Permanently installed equipment adds greatly to the enjoyment of showing slides, eliminating the bother of assembling the components for a show and providing neat storage for slides, tapes and other necessities. And though a projection room in an ordinary home may at first seem as unlikely as a stable for polo ponies, in point of fact the equipment can be arranged so compactly that any large living or game room can double as theater.

How such a facility can be installed simply is demonstrated by the apartment of Robert Haymes, a producer of audio-visual presentations, who changes his pleasant living room to a viewing studio in minutes, merely by opening the doors of the wooden cabinet that houses his gear and drawing down the screen against the far wall. The screen, hung from ceiling hooks, is nearly invisible when it is raised, and the cabinet doubles as a room divider.

Within this space, Haymes has an impressive setup: 12 projectors, a four-track tape player to synchronize sound to changing slides, and six control units that cause every projected picture to emerge softly as the previous image fades. A great deal of Haymes's gear is custom-built, but similar equipment can be bought ready-made.

Peering intently through the open doors of his multipurpose storage and projection cabinet, audio-visual producer Robert Haymes checks the focus of one of six projectors he will use for a presentation. The custom-built cabinet contains all slide-show equipment except the screen.

To change his studio apartment into a projection room, Haymes pulls the screen out of its case suspended from the ceiling. The high-reflection screen gives brilliant images, and because it is so wide he can, when he chooses, simultaneously project a number of images onto it, side by side.

Haymes rehearses a slide show to make certain that everything is in working order before a presentation to an audience. On the top shelf are dissolve-control units, linked to projectors on the two shelves below. The large metal cabinets on the bottom shelf hold the necessary gear for taped sound accompaniment to the shows.

Stories in Slides

A successful slide show is first of all a show: a concentrated presentation that combines separate pictures to tell a story or explore a subject. Like any show it must hold its audience's attention by conveying an idea in an appealing manner, and the techniques for doing so are those that apply to other media—from lecture hall to TV screen.

Three successful slide shows are reproduced on these pages—a sort of triple feature. Though the subjects are very different, in each case the same organizing principles apply. Each picture within a sequence is related to the slides that precede and follow it, and all are arranged to effect continuity —from a well-defined introductory shot to a climactic finish. Title slides announce the beginning of each feature. In the examples shown, the printed titles were first photographed on high-contrast 35mm black-and-white film. Then a double exposure combined the opening slide and title negative.

Though a logical progression is important in a slide show, it is not enough; each group of pictures needs variations in pace, subject matter and point of view. In the Olympic games sequence, tension is suggested by introducing action pictures with a view of an official waving a starting flag. For the gallery of wild flowers, pace is provided by a succession of colors. The journey through Spain builds chronologically, following a pilgrim's route to a climax of religious festivities at the end of the trip.

The triple feature reproduced here includes a total of 31 slides requiring about 15 to 20 minutes to project. They illustrate what is perhaps the most important principle of all for a successful slide show: Keep it short.

1 | *The title picture of a sequence on the 1972 Olympic games in Japan combines a scene-setting shot with a ceremonial note—the opening parade of athletes.*

2 | *A close-up of chilly spectators reinforces the viewer's anticipation of the wintry spectacle to come.*

6 | *Skis in alignment, a racer descends in a blur of speed. Rapid projection adds to the drama of action pictures like these.*

7 | *After the competition a Swiss skier hails her teammate's winning jump.*

11 | *A close-up of cheering spectators signals the end of the race.*

12 | *A smiling skating champion with her gold medal provides a logical conclusion for this series of pictures.*

3 | *The excitement of action about to begin is suggested by an official shown waving a starting flag.*

4 | *A shot of a skier taking off begins a three-slide series of athletic events—ski jumps and downhill racing.*

5 | *Framed by parts of the linked circles of the Olympic emblem, a skier soars through space in mid-jump.*

8 | *A night shot brings the day's events to a close and ends a clearly defined portion of the show.*

9 | *A hurtling speed skater introduces the next day's action.*

10 | *A long-distance shot of skaters changes the scale of the figures and adds a new perspective to the scene.*

After the speed and excitement of the Winter Olympics sequence, a definite pause is needed before another little story is presented. Because the next presentation *(right),* a close study of high-altitude plant life, is very different in tone and subject, an intermission is called for. Whether the pause is long or short, the title superimposed over the next slide is a clear signal to the audience that a new sequence is beginning.

13 | *Wild flowers by a rushing waterfall introduce the subject of a series of slides taken in California's High Sierra.*

14 | *A close-up of a rare alpine plant: it makes clear that this sequence is going to be primarily a nature study.*

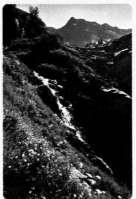

15 | *A landscape shot, showing peaks of the High Sierra in the background, establishes the setting of the pictures.*

16 | *The show now focuses on its main subject, close-ups of plants—here a stalk of grass imprisoned in ice.*

17 | *A brilliant spot of orange lichen provides a visual change of pace.*

Pauses are always needed between separate sections of a slide show. However, if the break is to be only a brief one, the change from one sequence to another can be made less abrupt by choosing transition slides that have at least a visual resemblance to each other. For example, the last slide of the High Sierra section resembles that of the mountain scene in the forthcoming sequence. Though the places and subjects are completely different, the similarity of the landscape in each helps the audience adjust to the new locale.

21 | *A fairy-tale castle establishes the locale of a brief story on Spain.*

22 | *An overall view of the town of Burgos shows the starting point of a tour along an ancient pilgrimage route.*

26 | *Now a series of pictures showing festivities begins; bright colors are the dominant features of all these shots.*

27 | *Papier-mâché figures of Moors and Christians are carried in procession.*

28 | *The plumage of the uniformed guards maintains the motif of bright colors in this part of the sequence.*

18 | *Alpine timothy and alpine aster are examined in this picture.*

19 | *A shot of wild mushrooms ends this close-up series—deliberately kept short to put emphasis on each picture.*

20 | *Pulling back for a view of mountains at sunset, the camera clearly leaves the subject and closes this sequence.*

23 | *A signpost announces the destination of the trip, and tells the distance that is still to be traveled.*

24 | *A view of terraced hills tells more about the countryside. In four slides the audience is given a carefully chosen sampling of scenery along the route.*

25 | *The pilgrim's destination is reached: the ancient and picturesque Cathedral of Santiago de Compostela.*

29 | *Spectators crowd the Cathedral steps to get a clearer view of the marchers in the procession.*

30 | *In the midst of the watching crowd, church officials wearing red vestments line up to take part in the parade.*

31 | *The festival—and the slide show —closes with a dramatic view of the Cathedral bathed in floodlights.*

A Landmark Exhibit

One of the greatest photographic shows ever mounted was "The Family of Man"—503 pictures occupying some 8,000 feet of wall space in New York's Museum of Modern Art. Planned and executed by Edward Steichen, one of the giants of modern photography, the exhibit opened on January 26, 1955. Apart from its size and complexity, The Family of Man owed its greatness to its broad-based theme—embodied in striking photographs depicting the breadth of human experience between birth and death and solidly rooted in Steichen's conviction that all men are brothers.

It is not likely that any private exhibitor—or many public ones—will ever emulate the example set by The Family of Man—if only because few could set aside two years, employ a trained staff of five, find the necessary cash —about $111,000 in 1954 dollars—root out thousands of picture sources, and have available a whole museum floor for display space. All were available to Steichen. However, because The Family of Man was so meticulously conceived, designed and mounted, it demonstrates every organizational step and presents every display opportunity that could conceivably arise in designing any show.

Steichen began by selecting his theme, which he derived from his belief that photography is a wonderfully effective language for explaining man to man. Then he issued a worldwide appeal for 8 x 10 black-and-white rough prints. Photographers were only too happy to respond, and over 2,000,000 entries deluged the museum.

Few exhibitors are likely to be embarrassed by such pictorial riches, but the basic sorting technique developed by Steichen and his staff was extremely workable—a good system for anyone. At the outset, all pictures were placed in one of three groups: "very good," "possible" and "unsuitable." The best were placed in subject folders arranged according to the logic of the theme. Copious notes were made on each picture—how it was taken, when and where—and each was also listed by photographer in a card file. The pictures were endlessly studied and compared; at the end of a year, they had been culled to a workable 10,000.

With the picture possibilities reduced to a manageable number, and the groupings, such as "children at play" and "women working," more or less defined, Steichen and his staff began pinning the pictures to the wall, juxtaposing them in various combinations. This process helped determine which pictures worked well together, and refined the choice even further.

During the final sorting and selection, Steichen and his staff began thinking seriously about the size each picture should be. Several factors were considered: what size best suited a picture, how the dimensions affected its relationship to its neighbors, and how the size influenced its contribution to the overall pace and variety of the show. These are complex decisions that

depend largely on taste; the creators of The Family of Man, however, relied heavily on such simple rules as avoiding overwhelming a few small pictures with many large ones. With assistance from architect Paul Rudolph, Steichen also used sketches of the display space, with scale drawings of photographs, to attack these problems; the worst mistakes were thus confined to paper. Sketches of wall space were supplemented by a floor plan, which made possible the arrangement of photographs so that the viewer would come upon them in the proper order; every display area, even a large square room, has a natural traffic flow. In the final planning stage, the Family of Man staff found an architectural model a necessity; the design was too complicated to risk making all decisions from sketches and blueprints.

Once it had been planned on a small scale, the exhibit was ready to be put together, with the prints prepared and mounted in actual size. Steichen and the museum staff knew that it is best to have all the pictures mounted in the same fashion—all framed, or all matted: this helps relate the parts of the exhibit to each other, even when their sizes and physical surroundings are diverse. The Family of Man pictures ranged from a 5 x 7 print to giant murals covering entire walls, but since all the prints were displayed without borders, the exhibit had an appearance of uniformity.

Almost all exhibitions require captions: Steichen felt that quotations from world folk culture would reinforce the Family of Man theme.

Hanging the exhibit was the final stage—and all the steps went as planned; there were few last-minute changes. In the hurried moments before the show opened, however, Steichen's assistant Wayne Miller, acting on a belated impulse, hung about 25 copies—some large, some tiny—of a print that showed a happy boy playing the flute. Spotted at random throughout the show, the picture added a joyful, repeated grace note to the entire exhibit. □

Questions of Choice

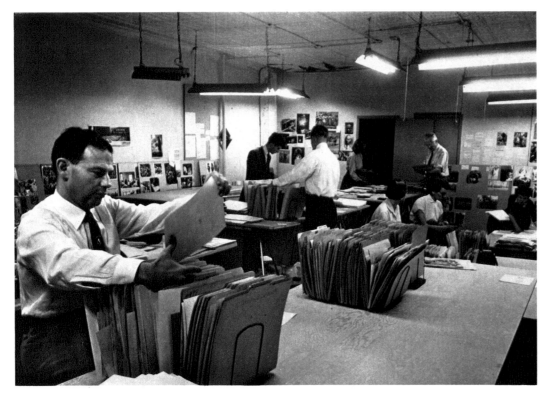

Edward Steichen had a vision of what he wanted The Family of Man to be—it would force the viewer to recognize his own kinship with all mankind—and to achieve that end he chose a journalistic approach. Each section would be as self-contained as a magazine story, yet together all of the sections would re-inforce the message of brotherhood. Large pictures would form the exhibit's backbone; smaller ones would amplify points or emphasize moods. The Her-culean task of sorting and evaluating the 10,000 pictures that were consid-ered for the exhibit was done in a large, unheated loft over a honky-tonk club; when the staff worked late into the night, musical thumps from below en-livened their task.

As Steichen (rear, center) and his staff choose from a group of photographs pinned up for evaluation, a visitor riffles through other pictures in category folders. Outside opinions were welcomed—though not necessarily heeded.

Lying on the floor for a close look, Steichen studies a group of candidates carefully—as he did with each strong possibility. The picture of children running, at Steichen's right elbow, weathered his scrutiny and appeared in the exhibit.

Blueprint for a Traffic Pattern

In the planning of The Family of Man, the related processes of selection and positioning of pictures in groups went on until the show opened. These processes were continually being refined. Three months before the opening, Steichen called in architect Paul Rudolph to draw the floor plan shown on the opposite page—a crucial step in determining the overall arrangement of pictures. To give the show pace and rhythm, Steichen and Rudolph wanted to be sure that people saw the pictures in a certain order—large, keynote pictures alternating with contemplative images, sorrowful subjects interspersed with lighthearted ones. The two men sketched and resketched until they had a blueprint that matched natural traffic flow to the structure of the exhibit. The blueprint also provided for the use of existing wall space as well as for the construction of supplementary panels—which not only increased the available display area but also functioned as conduits for the flow of traffic.

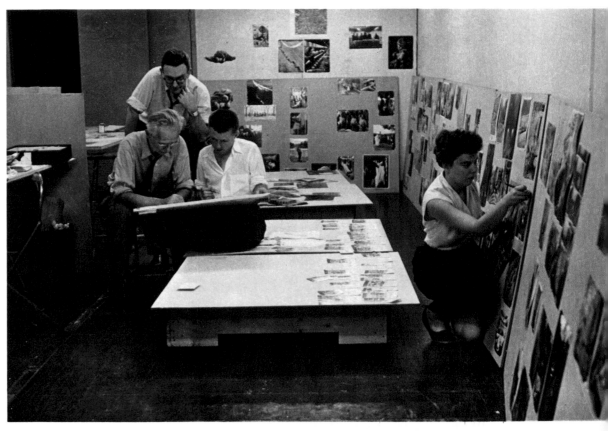

As assistant Wayne Miller looks on, Steichen examines architect Paul Rudolph's preliminary sketch for the layout of the show (a close-up of the sketch and their hands appears at right). As the pictures were selected, Kathleen Haven tested them in various positions on a panel.

In architect Rudolph's sketch, arrows indicate planned traffic flow. The viewing areas were arranged to vary the pace, emphasize certain points or to create a mood for the viewer.

Uses of a Model

Indispensable though they were, the floor plans and sketches of the physical layout for The Family of Man by no means completed its planning stages. A project of such complexity demanded a reduced scale model so that the planners could see a small but full version of the show. When Steichen and Rudolph were satisfied with the preliminary drawings, Rudolph built the model of heavy cardboard and wood on a rigid fiberboard base.

In this miniature laboratory, Steichen tested his arrangements of pictures. The photographs were reduced proportionately and positioned in the model; Steichen could then see the pictures juxtaposed in relative size. When adjustments were called for, the pictures could be repositioned and altered in size; entire panels could be moved around to establish new relationships among groups of pictures. Finally, operating on the principle that most of the keynote pictures should be placed close to eye level, and using a movable paper sculpture of a man scaled to average height, Steichen was able to determine how the level of a picture in its group might affect the viewer.

Scrutinizing the half-constructed model, Steichen stoops for an eye-level view before positioning scaled pictures. Wayne Miller (standing) checks the overall appearance of the model; meanwhile architect Rudolph works at the drawing board.

Like a modern Gulliver surveying his wood-and cardboard Lilliput, Steichen moves a scaled paper puppet around in the model. By marching around the miniature exhibit he ensured that pictures were placed at a good viewing angle.

Big Prints, Mounted to Be Seen

Like a theatrical producer, Steichen fussed with the details of his show until the last possible moment. Only when he was sure that there was no more time to make revisions in his model or his floor plan did he proceed to the next step: printing and mounting the pictures.

The format for the Family of Man prints was both simple and elegant: for the sake of uniformity and ease in hanging, all the prints, large and small, were mounted without borders.

Then, with meticulous attention to the model and floor plan that had served as the show's major planning tools, workmen of the museum staff constructed panels to supplement existing wall space and help direct the viewers through the exhibit.

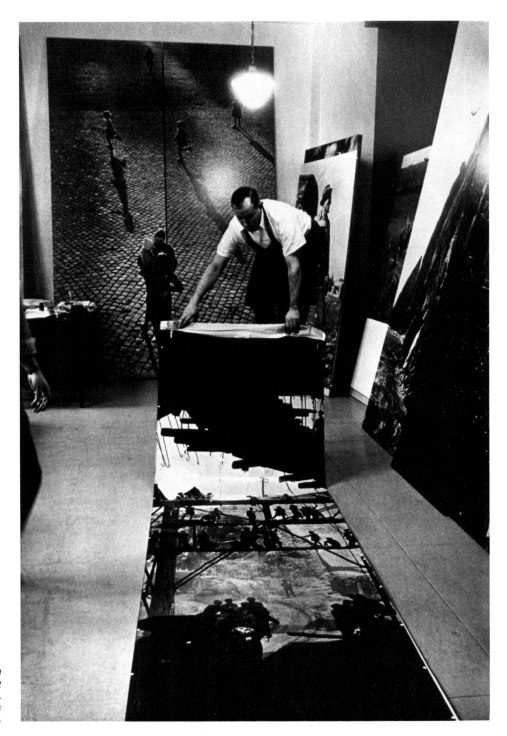

A technician at the laboratory that printed and mounted The Family of Man *checks a strip of print for flaws before gluing it to a fiberboard panel. This photograph of workers at a dam in India was so large it had to be mounted in three sections.*

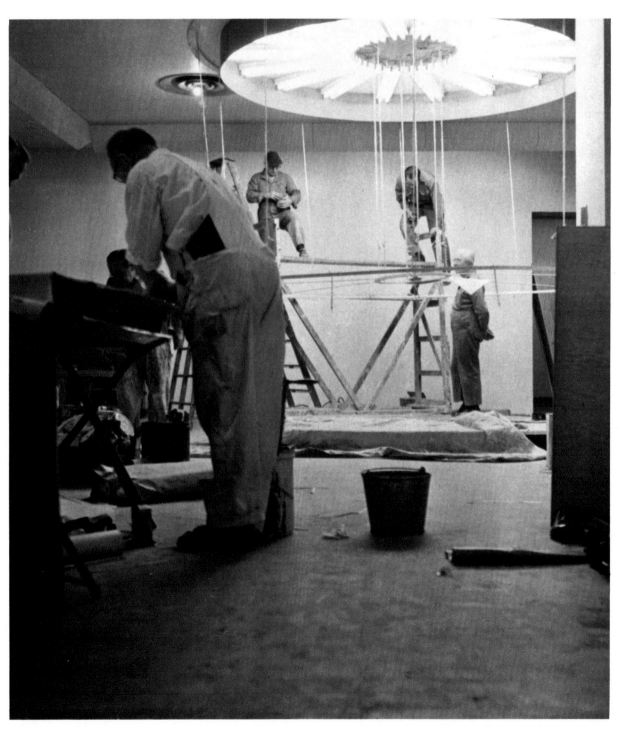

Constructing the exhibition viewing areas at The Museum of Modern Art called for a crew of expert carpenters, shown erecting the first structure that the viewer saw: the semicircular pavilion housing the pictures on the theme of birth, identifiable in the floor plan shown on page 175.

Words to Explain the Pictures

"A camera testament, a drama of the grand canyon of humanity, an epic woven of fun, humor and holiness—here is the Family of Man!" This final sentence of Carl Sandburg's introduction for the show, written after the poet had seen the pictures, was only a part of the concerted effort to find words to go with the photographs in the exhibit.

Once the basic groupings had been decided on, three museum staff members spent months sifting through quotations drawn from the wisdom of the world's peoples, written and spoken throughout the ages. When quotations were matched as captions with groups of pictures, the result was not only a reinforcement of the visual by the verbal but also a blending of human eras and cultures that was often highly effective. For example, near a group of photographs depicting 20th Century poverty—American sharecroppers and an English tramp—was a quotation from the First Century B.C. Latin poet Vergil: "What region of the earth is not full of our calamities?"

When the captions were written, the show was ready to be installed. Paradoxically, this was the least creative part of the process: the really hard work had already been done. The final step was, however, the first chance to see the real thing—and the last chance to make minor adjustments.

Shown at the typewriter, poet Carl Sandburg, Steichen's brother-in-law and lifelong friend, helped him choose captions from the material provided by the museum staff. The captions —quotations drawn from the world's religions, literature and folklore—guided the visitor through the exhibit, underscoring the show's message as stated by Sandburg: "I am not a stranger here."

Supervising installation, Steichen, Wayne Miller and Paul Rudolph check blueprints against the work in progress. As it turned out, planning, construction and hanging had been so expert that the show went up with scarcely a hitch.

A workman positions a photograph high on a wall as an assistant stands by to hand him the next picture. The photographs, which covered approximately 8,000 feet of wall space, were hung on wires attached to the fiberboard backing.

181

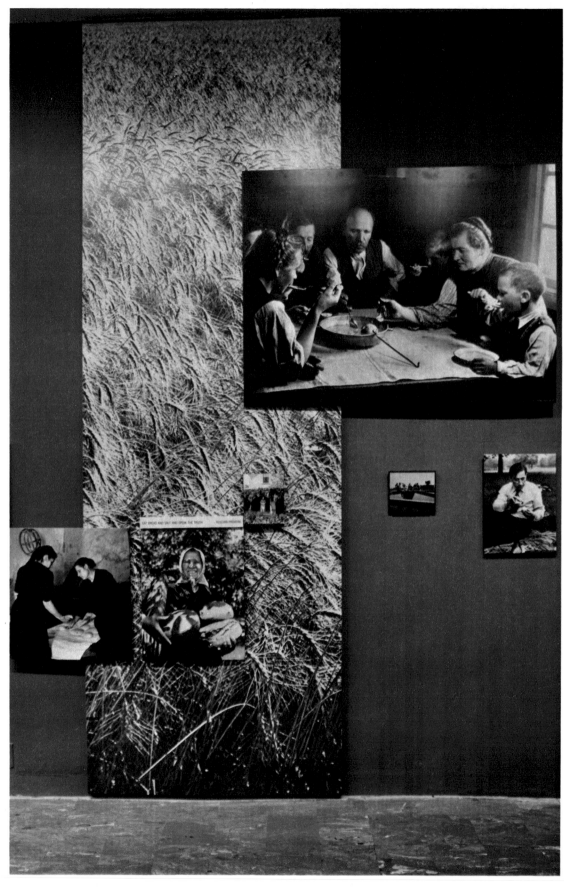

The theme of the grouping at left, the ritual of daily bread, is stated by the vertical panel of wheat, seemingly growing from the earth—and reinforced by its caption, a Russian proverb: Eat Bread and Salt and Speak the Truth. All the other photographs in the group enlarge upon the subject. To move the viewer's eye, Steichen contrasted verticals and horizontals, large and small panels, and a variety of levels.

Frequently, the subject suggested the appropriate ►
display technique: children's round games (1) are similar the world over, and the carousellike frame reinforces the theme. An enormously enlarged arm (2), symbolizing man's strength, introduces a section devoted to labor. The pictures of swings and people swinging (3 and 4) are reverse sides of one panel; the panel itself swung to and fro.

1

2

3

4

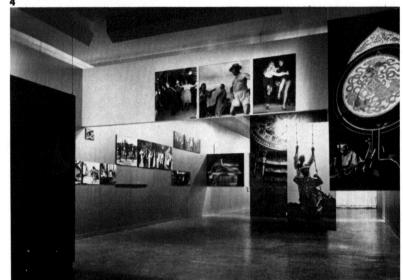

"The Family of Man" around the World

The Family of Man opened at The Museum of Modern Art in January 1955. Public response was overwhelming; by the time the exhibit closed in New York in May, 270,000 visitors had seen it.

The show had also been widely reported all over the world; in response to the demand created by its publicity, The Family of Man, packed in custommade felt-lined cases, went on the road in June. The show proved highly adaptable to almost any gallery space. Elevations and scale drawings were sent to exhibitors, along with extremely detailed installation instructions. But the museum made it clear that each exhibitor was free to set up the show in the manner best suited to his gallery space and individual taste, so long as the thematic scheme and overall visual effect remained true to Steichen's and Rudolph's original design.

Both full-scale and small-scale copies of the show were circulated; the reduced versions contained only 115 panels compared to the full show's 503, but all the photographs were included. In one version or another The Family of Man was exhibited in the United States until 1959.

During the same years, and in fact until 1963, other versions—and eventually the original—were exhibited in Europe, South America, Africa and Asia under the sponsorship of the U.S. Information Agency. Foreign exhibitors were given the same free hand to adapt the show as were exhibitors in the United States. Though the original version was badly damaged during an uprising in Beirut in 1958, and subsequently had to be junked, a full-scale copy will soon be permanently installed in Luxembourg—Steichen's birthplace.

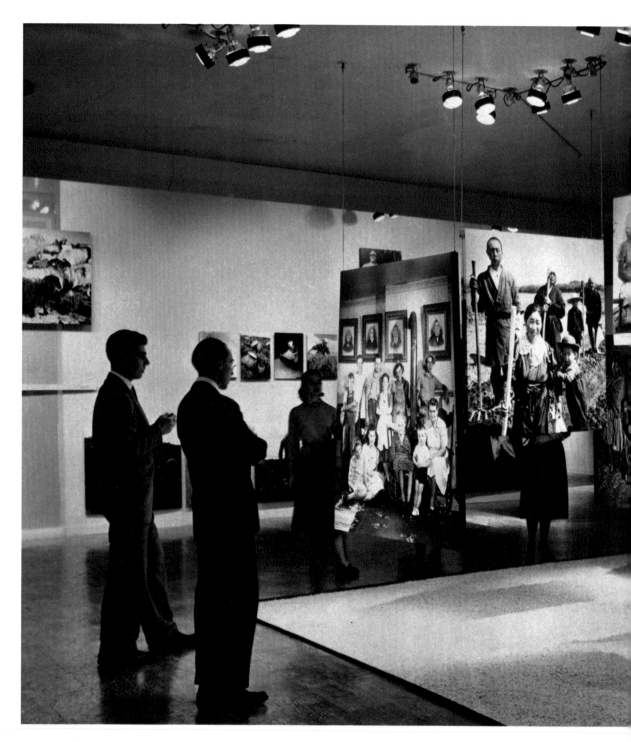

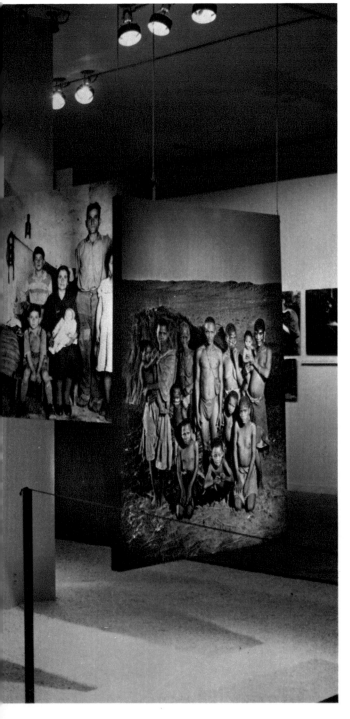

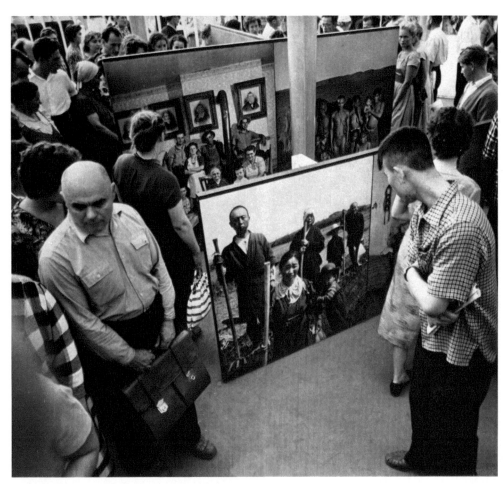

In Moscow (above) viewers see the family group from close up—the arrangement that was best suited to available display space when the show traveled to Russia in 1959 under United States government auspices. Though thematic groups remained intact, exhibitors everywhere were allowed great flexibility in arranging pictures. The picture of the Japanese family rested on the floor in Moscow—though it had originally been hung at eye level in the New York show.

◄ At New York's Museum of Modern Art, visitors contemplate the heart of the exhibit, the central family grouping. The public circulated freely around this installation, which was placed in a dramatic setting—a floor-level bed of gravel that also protected the pictures from being touched.

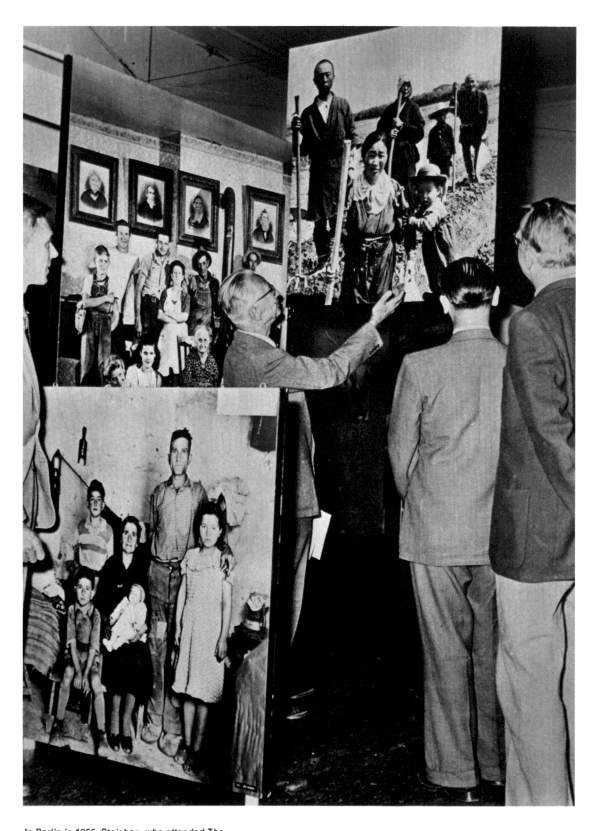

In Berlin in 1955, Steichen, who attended The Family of Man there, points to a detail in the Japanese family photograph—this time placed well above the viewer's eye level in another arrangement of the central group of pictures.

Bibliography

General

Focal Press Ltd., *The Focal Encyclopedia of Photography.* McGraw-Hill, 1969.
Morgan, Willard D., ed., *The Encyclopedia of Photography.* Greystone Press, 1967.

History

Eder, Josef Maria, *History of Photography.* Columbia University Press, 1945.
Friedman, Joseph S., *History of Color Photography.* Focal Press, 1968.
Gernsheim, Helmut, *Creative Photography: Aesthetic Trends 1839-1960.* Faber & Faber Ltd., 1962.
Gernsheim, Helmut and Alison:
The History of Photography from the Camera Obscura to the Beginning of the Modern Era. McGraw-Hill, 1969.
**L. J. M. Daguerre: The History of the Diorama and the Daguerreotype.* Dover Publications, 1968.
Mees, C. E. Kenneth, *From Dry Plates to Ektachrome Film: A Story of Photographic Research.* Ziff-Davis, 1961.
Newhall, Beaumont:
The Daguerreotype in America. New York Graphic Society, Ltd., 1968.
The History of Photography from 1839 to the Present Day. The Museum of Modern Art, Doubleday, 1964.
†*Latent Image: The Discovery of Photography.* Doubleday, 1967.
ed., *On Photography: A Source Book of Photo History in Facsimile.* Century House, 1956.
Pollack, Peter, *The Picture History of Photography from the Earliest Beginnings to the Present Day.* Harry N. Abrams, 1969.
Snelling, Henry H., *The History and Practice of the Art of Photography.* Morgan & Morgan, George Eastman House, 1970.
Stenger, Erich, *The March of Photography.* Focal Press, 1958.
**Taft, Robert, *Photography and the American Scene: A Social History, 1839-1889.* Dover Publications, 1964.
Wall, E. J., *The History of Three-Color Photography.* American Photographic Publishing Co., 1925.

Photographic Art

Abbott, Berenice, *The World of Atget.* Horizon Press, 1964.
Friedlander, Lee, and John Szarkowski, *E. J. Bellocq: Storyville Portraits.* The Museum of Modern Art, New York Graphic Society, Ltd., 1970.
Morgan, Murray, with photographs by E. A. Hegg, *One Man's Gold Rush: A Klondike Album.* University of Washington Press, 1967.
Newhall, Beaumont and Nancy, *Masters of Photography.* Bonanza Books, 1958.
†Steichen, Edward, *The Family of Man.* The Museum of Modern Art, 1955.
Talbot, William Henry Fox, *The Pencil of Nature.* Da Capo Press (facsimile edition), 1969.
Trottenberg, Arthur D., ed., *A Vision of Paris: The Photographs of Eugène Atget; The Words of Marcel Proust.* Macmillan, 1963.

Photographic Science

Eaton, George T., *Photographic Chemistry in Black-and-White and Color Photography.* Morgan & Morgan, 1965.
James, T. H., and George C. Higgins, *Fundamentals of Photographic Theory.* Morgan & Morgan, 1968.
Mees, C. E. Kenneth, and T. H. James, *The Theory of the Photographic Process.* Macmillan, 1966.
Neblettè, C. B., *Photography: Its Materials and Processes.* D. Van Nostrand, 1962.
Pittaro, Ernest M., ed., *Photo-Lab-Index.* Morgan & Morgan, 1970.
Rhode, Robert B., and Floyd H. McCall, *Introduction to Photography.* Macmillan, 1971.
Spencer, D.A.:
†*Color Photography in Practice.* Focal Press, 1966.
Photography Today. Oxford University Press, 1955.
Thomson, C. Leslie, *Colour Films: The Technique of Working with Colour Materials.* Chilton, 1969.

Special Subjects

Adams, Ansel, *The Print.* Morgan & Morgan, 1967.
American National Standards Institute:
American National Standard Practice for Storage of Processed Safety Photographic Film other than Microfilm, PH 1.43-1971. American National Standards Institute, Inc., 1971.
American National Standard Specifications for Photographic Film for Archival Records, Silver-Gelatin Type, on Cellulose Ester Base, PH 1.28-1969. American National Standards Institute, Inc., 1969.
American National Standard Specifications for Photographic Film for Archival Records, Silver-Gelatin Type, on Polyester Base, PH 1.41-1971. American National Standards Institute, Inc., 1971.
Eastman Kodak:
ABC's of Toning, Pamphlet No. G-23. Eastman Kodak, 1972.
B/W Processing for Permanence, Pamphlet No. J-19. Eastman Kodak, 1970.
Cementing Kodachrome and Ektachrome Transparencies to Glass, Pamphlet No. E-34. Eastman Kodak, 1972.
Copying, Professional Data Book M-1. Eastman Kodak, 1971.
Filing Negatives and Transparencies, Pamphlet No. P-12. Eastman Kodak, 1967.
Kodak Color Films, Publication No. E-77. Eastman Kodak, 1968.
Kodak Dye Transfer Process, Pamphlet No. E-80. Eastman Kodak, 1969.
Mounting Slides in Glass, Pamphlet No. AE-36. Eastman Kodak, 1971.
Notes on Tropical Photography, Publication No. C-24. Eastman Kodak, 1970.
Prevention and Removal of Fungus on Prints and Films, Pamphlet No. AE-22. Eastman Kodak, 1971.
Processing Chemicals and Formulas for Black-and-White Photography, Professional Data Book J-1. Eastman Kodak, 1966.
Retouching Black-and-White Negatives, Pamphlet No. O-10. Eastman Kodak, 1967.
Retouching Color Transparencies, Pamphlet No. E-68. Eastman Kodak, 1968.
Stains on Negatives and Prints, Pamphlet No. J-18. Eastman Kodak, 1952.
Storage and Care of Kodak Black-and-White Films in Rolls, Publication No. AF-7. Eastman Kodak, 1969.
Storage and Care of Kodak Color Films, Pamphlet No. E-30. Eastman Kodak, 1968.
Storage and Preservation of Microfilms, Pamphlet No. P-108. Eastman Kodak, 1965.
Storage of Microfilms, Sheet Films, and Prints, Pamphlet No. F-11. Eastman Kodak, 1955.
Three-Color Separation Prints, Pamphlet No. E-47. Eastman Kodak, 1968.
Fritsche, Kurt, *Faults in Photography: Causes and Correctives.* Focal Press, 1968.
*Hertzberg, Robert E., *Photo Darkroom Guide.* Amphoto, 1967.
Towler, John, *The Silver Sunbeam.* Morgan & Morgan (facsimile edition), 1969.
*Wilhelm, Henry, *Procedures for Processing and Storing Black and White Photographs for Maximum Possible Permanence.* East Street Gallery, 1970.

Magazine Articles

Deschin, Jacob, "Barbara Morgan: Permanence through Perseverance." *1971 Popular Photography Annual,* pp. 6-24, 170-171.
Ostroff, Eugene, "Early Fox Talbot Photographs and Restoration by Neutron Irradiation." *The Journal of Photographic Science,* Vol. 13 (1965), pp. 213-227.
Ostroff, Eugene, "Preservation of Photographs." *The Photographic Journal,* Vol. 107, No. 10 (October 1967), pp. 309-314.
Tice, George A., "The Lost Art of Platinum." *Album,* No. 11 (December 1970), pp. 12-13, 23.
Vestal, David, "Are Your Prints Fading Away?" *Popular Photography,* Vol. 64, No. 4 (April 1969), pp. 67-69, 106-109.
Wilson, William K., "Record Papers and their Preservation." *Chemistry,* Vol. 43, No. 3 (March 1970), pp. 8-12.

†Also available in paperback.
*Available only in paperback.
**Also available in hardback.

Acknowledgments

For help given in the preparation of this book, the editors thank the following: Carol Appelman, Nikon House, New York City; Henri Bendel Inc., New York City; Martin Bennett, President, Lenco Products, Inc., a subsidiary of GAF Corporation; Roloff Beny, Rome; Blondelle Frames, New York City; Mr. and Mrs. Gerald Bouchard, South Glens Falls, New York; Peter C. Bunnell, Curator of the Department of Photography, The Museum of Modern Art, New York City; James O. Burns, President of Print File Inc., Schenectady, New York; Walter Clark, Rochester, New York; Design Research, New York City; James L. Enyeart, Curator of Photography, The University of Kansas Museum of Art, Lawrence, Kansas; Evan Evans, Leatherhead, Surrey, England; Henry Fassbender, Supervisor of Photographic Chemistry Process Development, Paper Service Division, Eastman Kodak Co., Rochester, New York; Al Freni, New York City; Marie Frost, Administrative Assistant for the Exhibition Program, The Museum of Modern Art, New York City; General Electric Housewares Division, Bridgeport, Connecticut; Gucci Shops Inc., New York City; David Haberstich, Assistant Curator of Photography, The Smithsonian Institution, Washington, D.C., Harriet Hall, Acquisition Officer, United States Information Agency, Washington, D.C.; Harrison Inn, Heritage Village, South-bury, Connecticut; Kathleen Haven, New York City; Robert Haymes, New York City; Richard W. Henn, Photographic Research Division, Kodak Research Laboratories, Rochester, New York; Arvia Higgins, Assistant, Photographic Studio, The Metropolitan Museum of Art, New York City; Hans Holzapfel, Director of Field Programs, United States Information Agency, Bonn; Ira Itkowitz, Royaltone Camera Stores, New York City; Georg Jensen Inc., New York City; Rose Kolmetz, Consultant, International Program, The Museum of Modern Art, New York City; Barbara Kulicke, Kulicke Frames Inc., New York City; Marchal E. Landgren, Washington, D.C.; Ken Lieberman, Berkey K + L Custom Photographic Services, New York City; Samuel Locker, Vice President, Royaltone Camera Stores, New York City; Tom Lovcik, Curatorial Assistant, Department of Photography, The Museum of Modern Art, New York City; Jerald Maddox, Curator of Photography, The Library of Congress, Washington, D.C.; Mark Cross Co. Ltd., New York City; Grace M. Mayer, Curator, The Edward Steichen Archive, The Museum of Modern Art, New York City; Wayne Miller, Orinda, California; Modern Age Photographic Services Inc., New York City; Pearl L. Moeller, Supervisor of Special Collections in the Library, The Museum of Modern Art, New York City; Robert D. Monroe, University of Washington Libraries, Seattle, Washington; Richard Nast, Vue-All Inc., New York City; Margaret P. Nolan, Chief Librarian of the Lending Collection, The Metropolitan Museum of Art, New York City; Doris O'Donnell, New York City; Ismael A. Olivares, Photographic Research Division, Kodak Research Laboratories, Rochester, New York; Eugene Ostroff, Supervisor of the Department of Photographic History and Curator of Photography, The Smithsonian Institution, Washington, D.C.; William F. Pons, Manager of the Photograph Studio, The Metropolitan Museum of Art, New York City; Print Processes Display Ltd., London; William H. Puckering, Technical Editor, Professional, Commercial and Industrial Markets Division, Eastman Kodak Co., Rochester, New York; Paul Rudolph, New York City; F. Edward Sclafani, New York City; Joel Snyder, Chicago, Illinois; John Szarkowski, Director of the Department of Photography, The Museum of Modern Art, New York City; Gene Thomas, Photographic Coordinator, United States Information Agency, Washington, D.C.; George A. Tice, Colonia, New Jersey; Tiffany & Co., New York City; Richard Tooke, Supervisor of the Rights and Reproduction Department, The Museum of Modern Art, New York City; Henry Wilhelm, East Street Gallery, Grinnell, Iowa; Harvey S. Zucker, New York City.

Picture Credits *Credits from left to right are separated by semicolons, from top to bottom by dashes.*

COVER: Robert Colton; Al Freni; copied by Eugene Ostroff, courtesy Smithsonian Institution.

Chapter 1: Pages 11 through 43 except pages 24 and 25 are courtesy Smithsonian Institution. 11—Joel Snyder. 20—George C. Cox, copied by Eugene Ostroff. 21—Joel Snyder. 22—Joel Snyder—diagram by Adolph E. Brotman. 23—George C. Cox, copied by Eugene Ostroff. 24,25—William Henry Fox Talbot, from the collection of Eugene Ostroff. 26—William Henry Fox Talbot, copied by Eugene Ostroff. 27 through 30—Joel Snyder. 31—William Henry Fox Talbot, copied by Eugene Ostroff. 32,33—William and Frederick Langenheim, copied by Eugene Ostroff. 34—Copied by Eugene Ostroff. 35 through 38—Joel Snyder. 39,40—Copied by Eugene Ostroff. 41—Joel Snyder. 42,43—Copied by Eugene Ostroff. 44—From the collection of Rodney Congdon, copied by Herb Orth. 45,46—Al Freni. 47—From the collection of Rodney Congdon, copied by Herb Orth. 48,50,51—Eugène Atget, printed by George A. Tice, courtesy The Museum of Modern Art, New York. 49—Sebastian Milito. 52,53—E. J. Bellocq, from the collection of Lee Friedlander. 54,55,57—Eric A. Hegg Collection, courtesy University of Washington Library. Page 54 copied by Al Freni. 56—Al Freni. 58,59—D. Craig Johns. 60 through 63—Al Freni. Original photographs: 60,61—Edward Albert. 64,65—Hugo Jaeger, courtesy LIFE, copied by Herb Orth. 66,67—William Vandivert, courtesy LIFE, copied by Herb Orth.

Chapter 2: 71—Frederick H. Evans, from the collection of George A. Tice, copied by Herb Orth. 75 through 79—Al Freni. Original photographs: 77—Evelyn Hofer. 78—Top left Evelyn Hofer, bottom left Julian Wasser, right Alfred Eisenstaedt for LIFE. 80,81—Sebastian Milito. 82,83—George A. Tice, from *Paterson,* Rutgers University Press, 1972. 84,85—George A. Tice. 86—George A. Tice—Frederick H. Evans, copied by George A. Tice. 87 through 90—Sebastian Milito. 91—Frederick H. Evans, printed by George A. Tice. 92,93—Frederick H. Evans, printed by George A. Tice, courtesy Witkin Gallery. 94—Douglas Faulkner. 95—Douglas Faulkner, separations and matrices courtesy Berkey K + L Custom Services Inc. 96—Douglas Faulkner, print by Berkey K + L Custom Services Inc.

Chapter 3: 99—Al Freni. 101—Sheldon Cotler, copied by Al Freni. 102 through 118—Al Freni. Original photographs: 104—John Olson for LIFE; Alfred Eisenstaedt for LIFE. 118—Diagram by Adolph E. Brotman.

Chapter 4: 121—Robert Colton. 124 through 141—Ken Kay. Original photographs: 124-127—Margaret Bourke-White for LIFE. 128,129—Loomis Dean for LIFE. 130,131,132—Leonard McCombe for LIFE. 133—Andreas Feininger for LIFE. 134-141—Michael Rougier for LIFE. 142 through 149—Robert Colton. Original photographs: 142—Henry Grossman. 143—John Loengard for LIFE—Kosti Ruohomaa from Black Star—Courtesy Library of Congress; John Dominis for LIFE; Ralph Crane for LIFE. 144—Larry Burrows for LIFE—John Loengard for LIFE; courtesy Mrs. Arnold Holeywell—Harry Benson from Black Star. 145—George Silk for LIFE. 146—Toni Frissel, courtesy Library of Congress—Rodney Congdon—Suzanne Szasz. 147—Eliot Elisofon for LIFE and John Loengard for LIFE. 148,149—William M. Meares III—Jay Maisel—George Silk for LIFE. 150 through 153—Ken Kay. Original photographs: 150,151—Bill Ray—Constantine Manos from Magnum; Lee Hassig. 152—Allan Grant for LIFE; Bill Ray for LIFE—Ralph Crane for LIFE. 153—Top left page D. Craig Johns except top right Ralph Morse for LIFE; top right page D. Craig Johns; Ralph Morse for LIFE—Ralph Morse for LIFE—Ralph Morse for LIFE—Ralph Morse for LIFE; Ralph Crane for LIFE—bottom Ralph Morse for LIFE. 154,155—Construction by Lyn Mandelbaum, copied by Herb Orth. 156 through 158—Photomurals by Robert Beckhard, copied by Paulus Leeser.

Chapter 5: 161—Andreas Feininger for LIFE. 164,165—Richard Meek. 166,167—George Silk for LIFE. 168—Top row George Silk for LIFE—second and third rows L. Robert Tschirky. 169—Top row George Silk for LIFE—second and third rows L. Robert Tschirky. 172,173—Wayne Miller from Magnum. 174—Homer Page, courtesy Wayne Miller. 175—Diagram by Paul Rudolph. 176—Homer Page, courtesy Wayne Miller. 177—Wayne Miller from Magnum. 178—Erich Hartmann from Magnum. 179—Shirley Burden. 180—Wayne Miller from Magnum. 181—Shirley Burden. 182—Andreas Feininger for LIFE. 183—Ezra Stoller © Esto. 184—Andreas Feininger for LIFE. 185—Carl Mydans for LIFE. 186—Courtesy USIS Bonn—The Museum of Modern Art, New York.

Index *Numerals in italics indicate a photograph, painting or drawing of the subject mentioned.*

X

Printed in U.S.A.